New on Earth

Baby Animals in the Wild

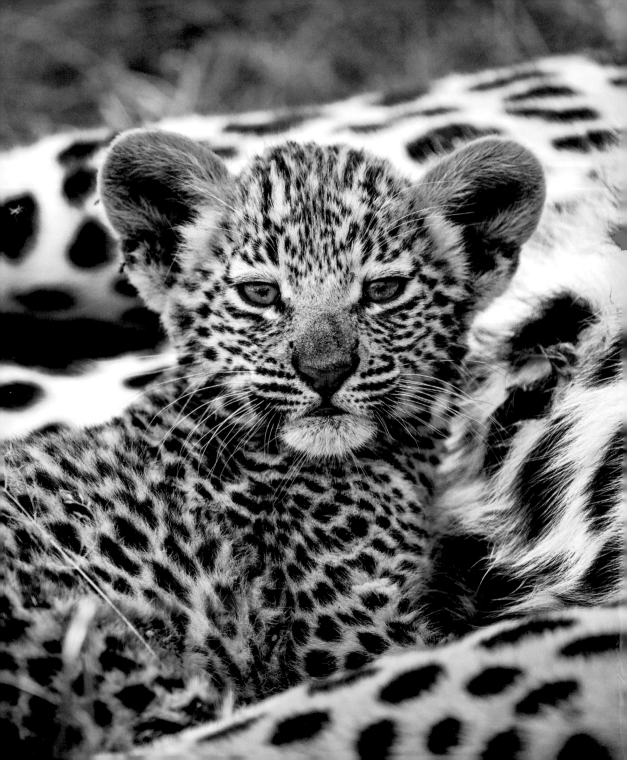

New on Earth

Baby Animals in the Wild

PHOTOGRAPHY BY SUZI ESZTERHAS

EARTH AWARE

SAN RAFAEL • LOS ANGELES • LONDON

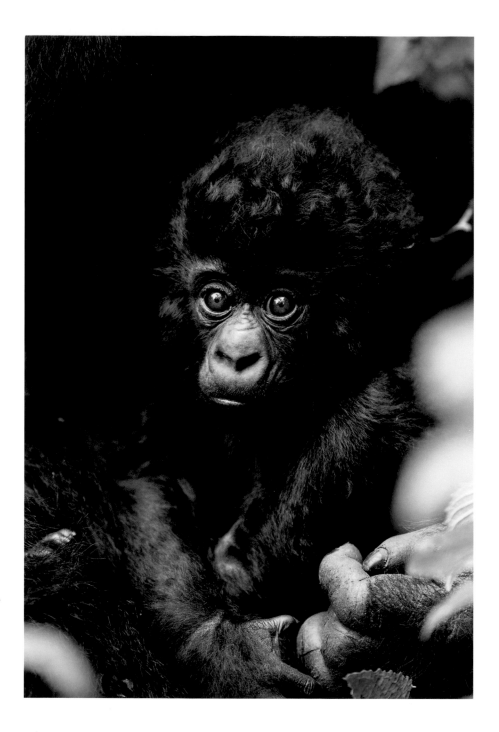

Preface

I MET SUZI SEVERAL YEARS AGO at a fundraiser to support the conservation of African cheetahs. Baby cheetahs may be the most adorable offspring in the animal kingdom—I'll leave you to be the judge of that, with the help of this book.

Since that time, Suzi has become a close friend to Wildlife Conservation Network (WCN) and has shared her talents, time, and passion generously. Over the years, she has donated much of her photography to WCN, and you'll often find her beautiful images on our website and in our newsletters and communications. It is an honor to be introducing Suzi's collection in *New on Earth*, where one can delight in the wonder and awe of newborn wildlife.

At Wildlife Conservation Network, we hope that all animals are born into a world where they can flourish. Our mission is to ensure a future for all species: from elephants in Kenya and penguins in Argentina to snow leopards in Mongolia and mountain lions in the United States. WCN supports the work of entrepreneurial field conservationists who develop grassroots solutions in their home countries that enable people and wildlife to coexist and thrive. Creative avenues for coexistence are more important than ever today, on an increasingly crowded planet and with habitats under unprecedented pressures from development. There has never been a time more critical than the present to support the efforts of environmental and wildlife stewards around the world.

WCN was founded on the belief that every single person can make a difference. Suzi's talented eye and incredible imagery have delighted thousands around the world with the beauty and wonder of wildlife, creating an emotional connection with animals that can inspire people to protect them. We are grateful to Suzi for generously donating a large portion of the proceeds from this book to our wildlife conservation efforts. Most of all, thank you for holding this book in your hands, making it possible to protect these incredible creatures in the wild.

Charles Knowles
Co-Founder and President, Wildlife Conservation Network

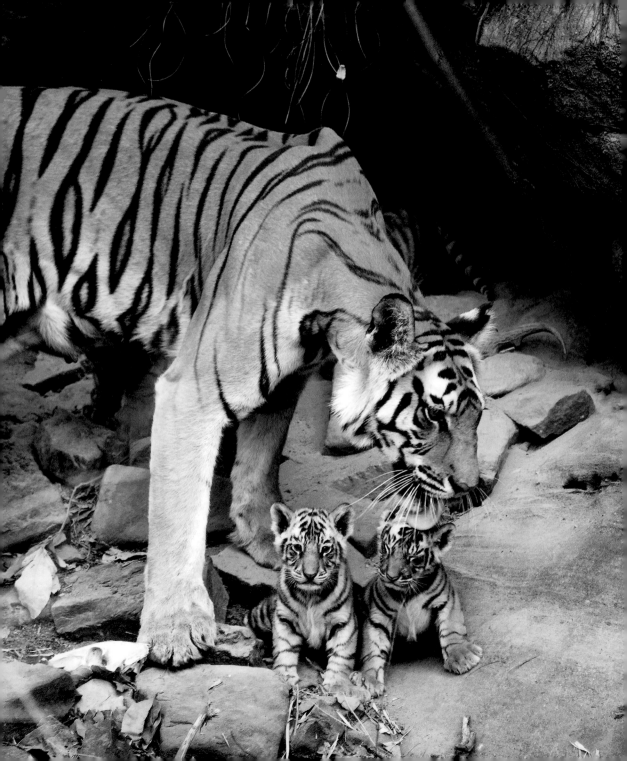

Contents

INTRODUCTION
9

Jungle & Rainforest
13

Mountain & Forest
77

Polar & Ocean
153

Savanna & Grassland
199

ABOUT THE AUTHOR
347

ACKNOWLEDGMENTS
349

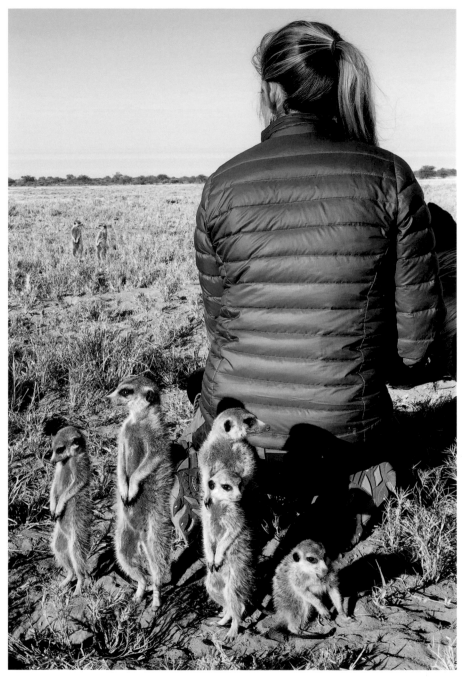

Introduction

FOR THE LAST 20 YEARS I HAVE BEEN ON A QUEST to capture and share inno-cence and beauty in the natural world. It's actually a journey that began in my childhood. I've often been asked why I chose baby animals. To be honest, I feel like they chose me. My earliest memories are of my obsession with baby animals in the wild. When I was 6 years old my parents bought me a point-and-shoot camera, which I used to photograph my cats in my backyard and then later told people that they were lions on the African savanna or tigers in the jungle. Later, I would tear photos of baby animals out of magazines and cover my walls with them. I don't know what it is like to live life and not want to do this work.

What is it about baby animals? In a word, they are irresistibly cute. "Cute" is a word that repels some because it instantly pulls at the heartstrings, but the fact is that cute is innocence and vulnerability, both fragile qualities that are much too scarce in modern society. Cute pries even the most cynical and closed heart open and makes it receptive. Cute has incredible power to arouse compassion and love.

Humans protect what they love. It is one of our most basic instincts—our children, our homes. Nothing gives me greater pleasure than to know that my imagery can inspire someone to love and to take an action, no matter how small, to care for our planet, to help save an endangered species, or to live a life of kindness.

In the course of my work, I've seen things that most people only dream of, and for this I feel truly blessed. By being patient, and working diligently and gently to understand my subjects and gain their trust, I've witnessed some of nature's most intimate moments: a cheetah nursing her tiny 4-day-old cubs in a secret hideaway in the savanna, a mountain gorilla cradling her newborn twins, a sloth with a baby clinging to her chest while she climbs high above the rainforest canopy. My photography spans seven continents and some of the most remote corners of the earth.

My work is so much more than just taking pictures—in fact the photography isn't the hard part. It's the respectful connection with an animal that is the real work. In order to photograph truly intimate moments in an animal's life, they have to trust that you mean them no harm. This trust is not usually easy to get. Animals are like humans in that each individual has a unique personality. They have moods. They have good days and they have bad days. Some are instinctively shy of humans, while others are more relaxed. But nearly all animals with newborns can be wary and on high alert, even the most relaxed ones. To gain a mother's trust you must approach her with compassion, respect, and unrelenting patience. And you have to try to get inside the animal's mind and put yourself in her shoes, so to speak, to try to understand what might frighten her, and what you might do (or not do) to make her feel safe.

This is not an easy task, nor one that can be undertaken on a brief holiday safari. It can take weeks or months of working from sunrise to sunset. My goal with every subject is to cultivate a presence in which the animal is so relaxed around me that they may not even notice or care that I am there. I just become a piece of the landscape—a part of their habitat.

Many of these images took extensive planning and patience to capture. I am often on call, waiting for a birth for as long as 3 years. In a matter of days I must hop on a plane and travel to remote parts of the world where the fieldwork begins. In the case of cheetahs, I spent nearly 18 months of my life following five different cheetah families. For jackals, I spent 17 days getting a jackal family used to my presence and then spent 5 months with my jeep parked outside of their den every day, watching their seven pups grow up. And for tigers, I spent nearly 2 months in India's grueling heat with a young tigress and her litter of four.

At the end of fieldwork, the most important part of my job begins as I find ways to share these images with the world. I believe that if I can bring to an audience even a fraction of the beauty, fragility, and magic of these moments, then my job has a purpose that goes beyond clicking the shutter. I feel that my path of service to the world is to share these experiences with others, so that they too may fall in love with my subjects as I have.

Many of my subjects are endangered species, and with extinctions occurring at a shockingly rapid pace, it's easy to become demoralized. But I believe that this imagery of new generations in the wild should give us hope and show us that nature is resilient, if we just give her a chance. Somewhere, at this very moment, one of the last tigers on earth is raising a litter of bright-eyed, bouncy cubs. Against all the odds, there is new life. And this precious new life needs our protection.

I hope that these images touch you and inspire you—they certainly have me. I hope you'll join me in working to secure a future for so many critically endangered species.

By buying this book, you have already made a difference: the Wildlife Conservation Network will receive a large portion of my proceeds from this book. To learn more about their work, visit www.wildnet.org.

Thank you,

Suzi Eszterhas
Petaluma, California

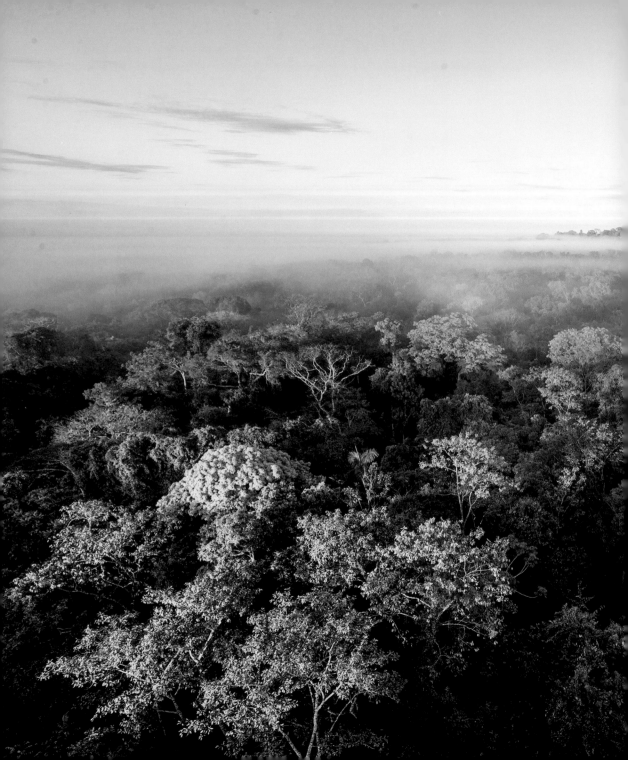

Jungle & Rainforest

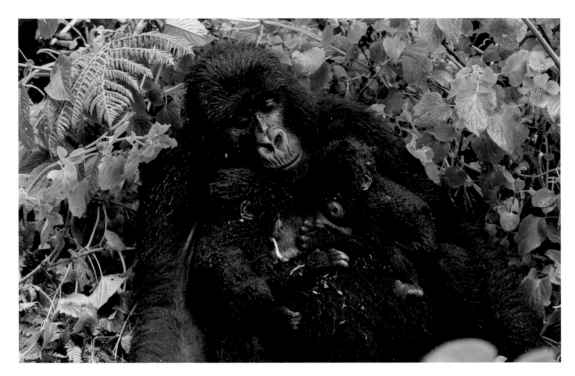

Gorilla

In Volcanoes National Park, high in the Virunga Mountains of Rwanda, the park staff know the resident mountain gorillas by name. These gorillas are wild, but habituated to humans, unafraid to carry out their day-to-day lives in the presence of conservation tourists. My experience meeting Kabatwa, and her twins Isango Gakuru and Isango Gato, was one of the most magnificent moments of my career. Twins are exceedingly rare among any of the great apes. I remember it was raining lightly that day. Kabatwa was holding the twins close to keep them warm. I felt like she could sense my reverence, and my fierce hope for her twins' survival. They have since grown to become only the second known surviving pair of mountain gorilla twins.

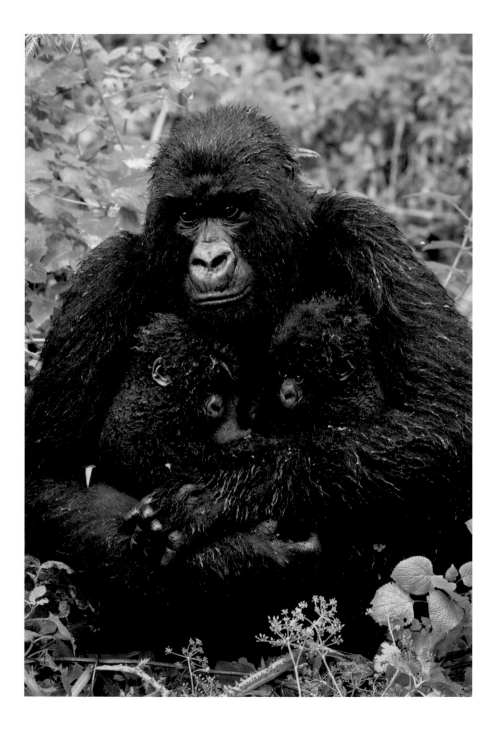

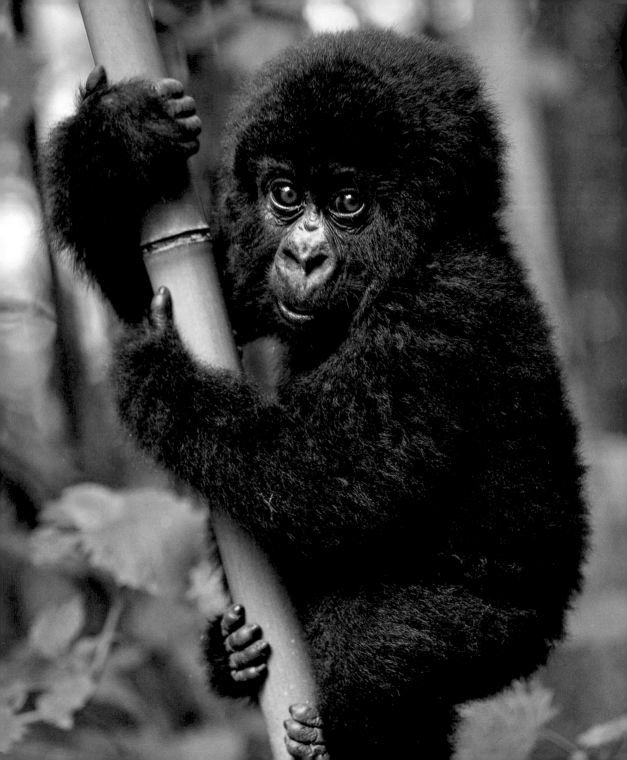

I will never forget this moment. It was my first trip to Rwanda, to Volcanoes National Park, and this 10-month-old mountain gorilla climbed up a bamboo stalk to about my eye level, then stopped and looked straight at me. The memory of sharing such a rare and intimate encounter with a baby gorilla still gives me shivers today. To me this image is about vulnerability and how this gorilla's future is in our hands. With habitat protection, anti-poaching programs, and a lucrative eco-tourism opertation, mountain gorillas have come back from the brink of extinction: In 2018, the most recent census, their numbers had risen to 1,063, a 20 percent increase.

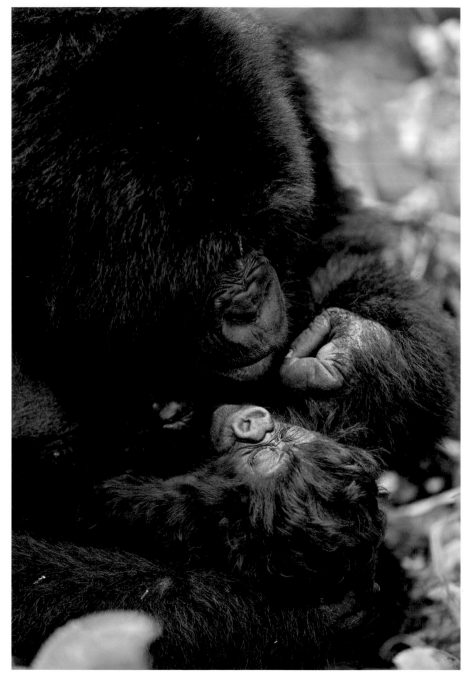

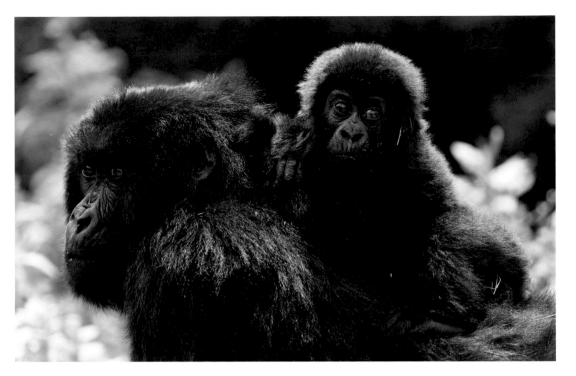

(Left) All the mothers of all the wildlife I've worked with are tender with their young. But mountain gorilla moms are the most tender. They cradle their babies just as humans do. Also like humans, they groom the baby, which is what mom's doing here. She's picking an insect from her newborn's hair and eating it. She'll also remove forest debris from baby's hair. It's a time-consuming, painstaking process that's important for the infant's health, and mom does it so gently, with so much tenderness. Her baby clearly loves it. He's practically in a trance.

Male mountain gorillas frequently interact with the group's infants; sitting beside them, playing with them, and doing what appears to be general babysitting. What struck me about the scene in the photograph on the right was that the adult male pictured is the silverback—the group's dominant male. The silverback is the oldest, the strongest, and, as the group's protector, the most fierce. Yet he was so gentle and tolerant with the baby. I remember baby was quite boisterous, literally bouncing on the silverback's belly and rolling around on him. It was really sweet to watch.

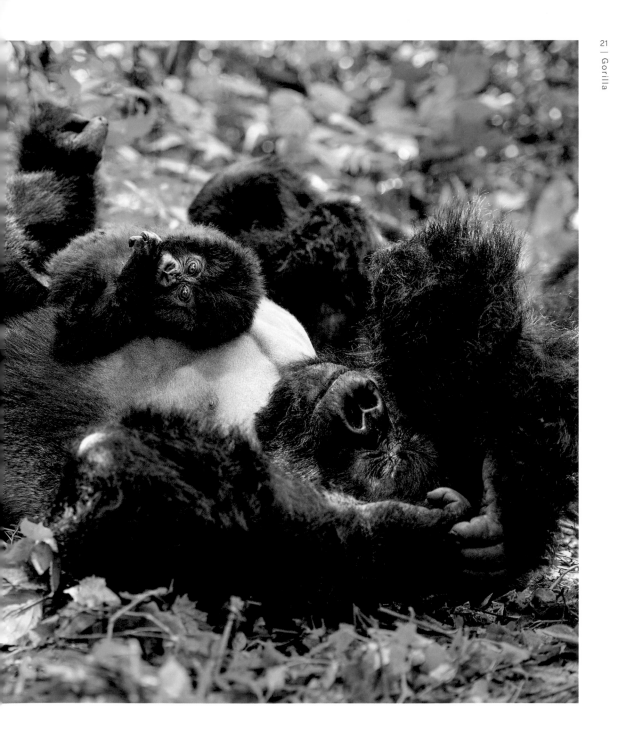

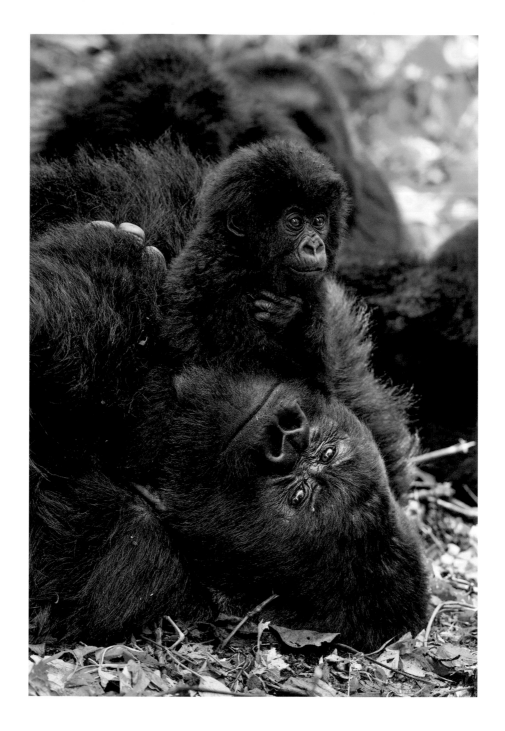

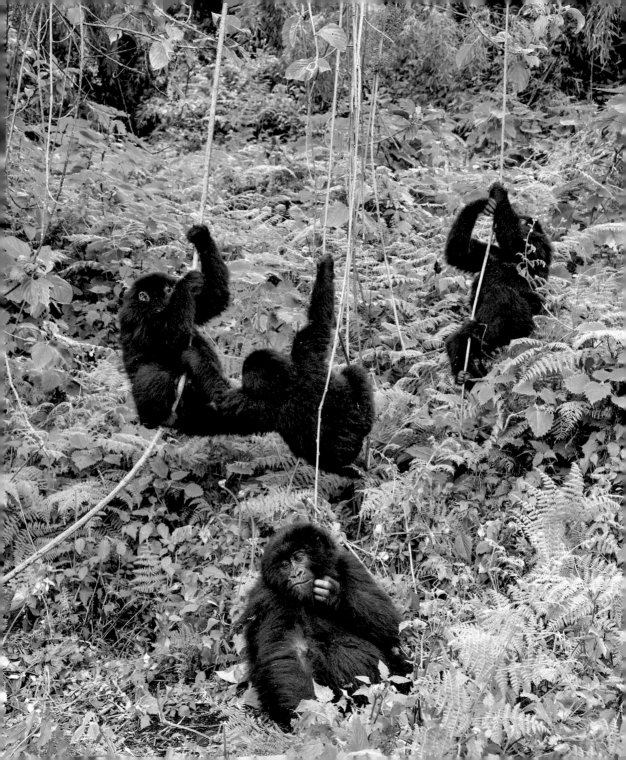

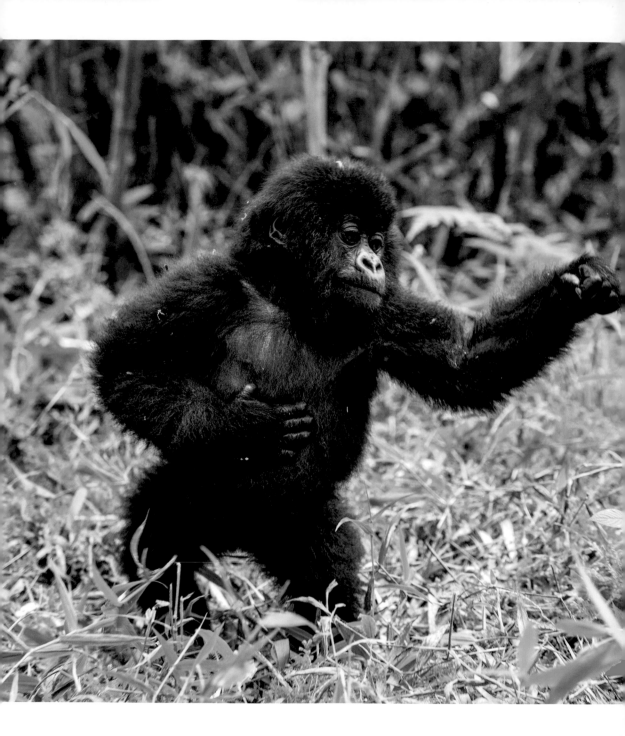

(Page 23) These juvenile mountain gorillas are enjoying the natural playground of the jungle. They're extremely energetic at this age, between 3 and 6 years old. The rest of the family group was napping and grooming infants while the juveniles made a ruckus swinging on vines, careening down slippery hillsides, and wrestling. I can still hear their play chuckle—little grunts, like a very hoarse *ha*, *ha*, *ha*, used to express fun and joy.

(Left) What a treat for me to catch this 1.5-year-old male mountain gorilla beating his chest—his species' most famous gesture. Gorillas are similar to humans in that they learn by observing and imitating their parents. The little guy must have seen his father, the silverback, doing it, and was giving it a try. He did it during a play session with other youngsters, who didn't seem especially impressed. At his age, it's adorable. As an adult, it will be a powerful display of strength and aggression. Silverbacks will fight to the death to protect their family group from another silverback or a predator.

Orangutan

Goofing around isn't just for human children. This 1.5-year-old Sumatran orangutan is having fun dangling and spinning in Gunung Leuser National Park. For the first six months of his life, he was either cradled in mom's arms or attached to her body. He's a little more independent now, but still, his doting mom, named Jackie by the staff, sits just outside the photo frame. Jackie was rescued from the exotic pet trade and rereleased into the wild. She will spend about eight years rearing this little guy—one of the longest parenting commitments in the animal kingdom.

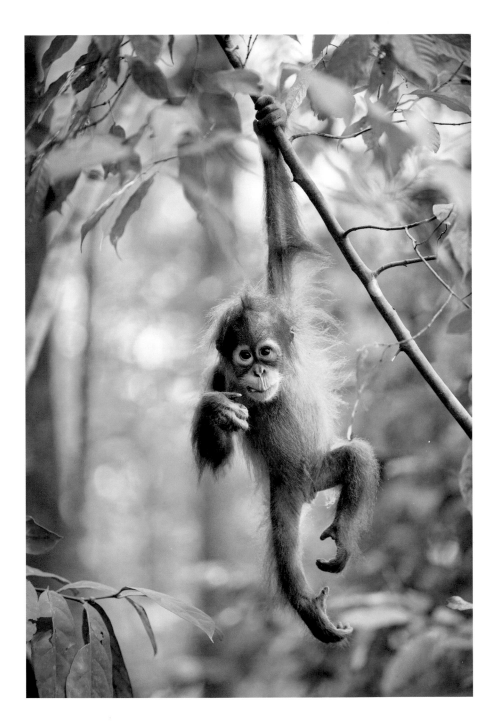

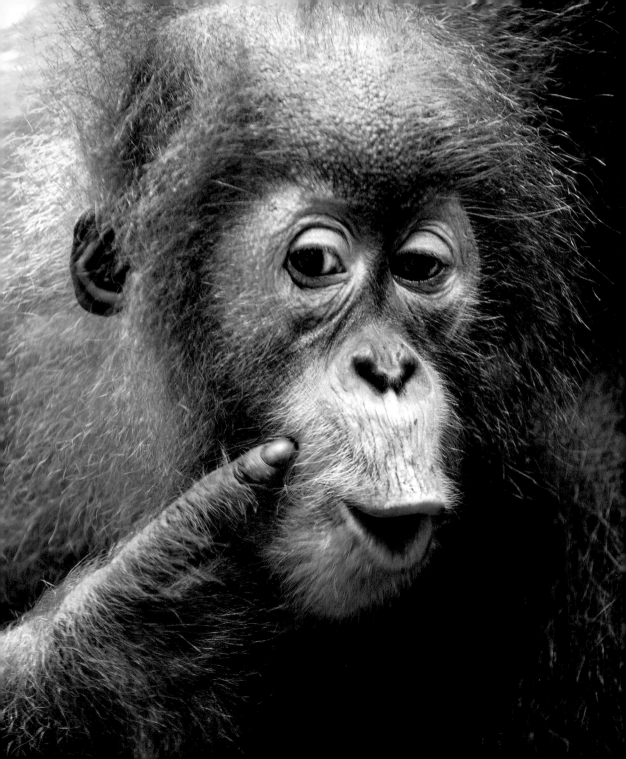

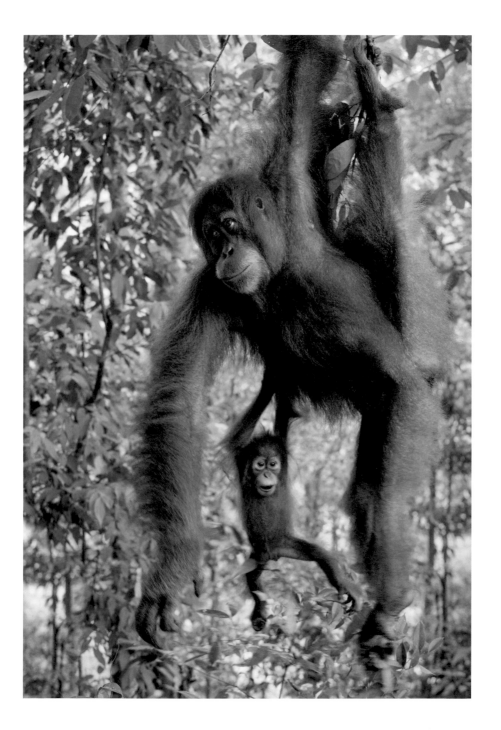

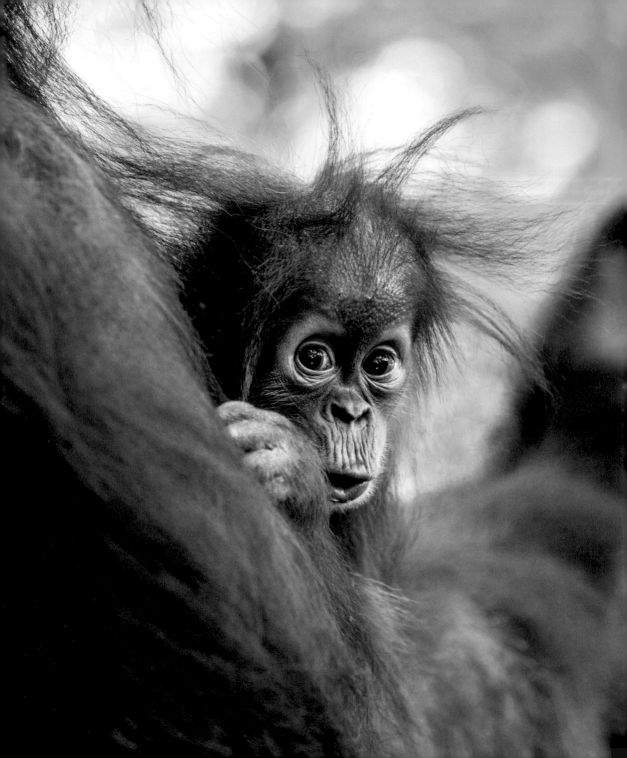

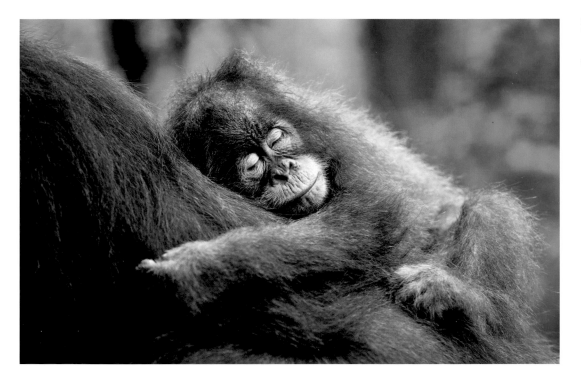

(Left) In Gunung Leuser National Park, on the Indonesian island of Sumatra, a 9-month-old Sumatran orangutan peeks around mom's shoulder to get a good look at me. I was smiling when I took this photo because she's having the quintessential baby orangutan bad hair day—sweaty tufts sticking out in all directions. Orangutans are critically endangered due to deforestation from the palm oil industry. While I work with many threatened and endangered species, I feel a special affinity for these highly intelligent animals, who exist only on the island of Sumatra. I am proud to serve as an ambassador for the Sumatran Orangutan Society.

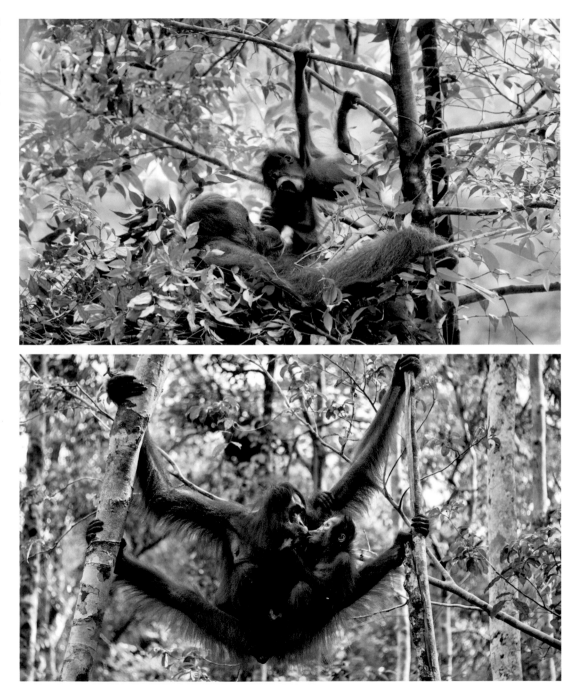

(Top) Sumi, the mom in this photo, is another rescue from the exotic pet trade who was rereleased into the wild. She'd built a lovely day nest for a siesta, but baby was more interested in playing. Mom's calm reaction is typical of orangutans; they are one of the most Zen creatures I've ever worked around. They sit in trees for long periods of time just staring, which was once mistaken for a lack of smarts. Scientists have since proven that like the other great apes, orangutans are extraordinarily intelligent, among the smartest of all nonhuman animals ever to have evolved on land.

(Bottom) Like the Sumatran orangutan, the Bornean orangutan is found only on its eponymous island in Indonesia, and is endangered due to deforestation from the palm oil industry. I encountered this mom and baby in Tanjung Puting National Park. It looks like they're kissing, but it's actually lunchtime. Mom had mashed up food in her mouth and was feeding it to baby, who is about 2 years old. There's an abundance of flora to eat in the jungle, but some of it's toxic to orangutans. Mom teaches what's safe by offering a first taste delivered straight from her mouth.

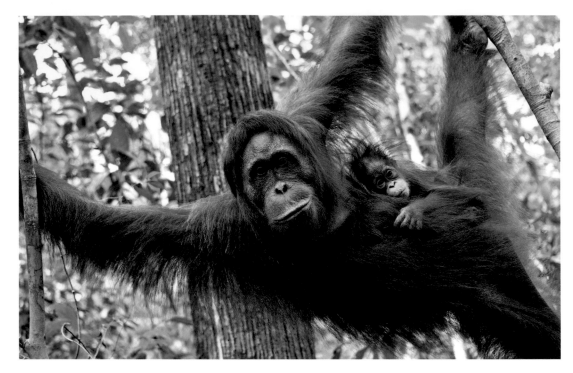

(Right) I'll never tire of locking eyes with a wild animal, in a gaze devoid of fear or aggression, sharing a moment of mutual curiosity and respect. It's a spiritual experience. Doubly so for this moment when a Bornean orangutan and her 2.5-year-old baby made eye contact with me. I remember marveling at their very humanlike posture, with baby riding on mom's shoulders. From what I've seen, baby orangutans climb all over mom by grabbing fistfuls of her hair. She doesn't seem to mind. And it's quite cute to watch, the way they move across her like little spiders.

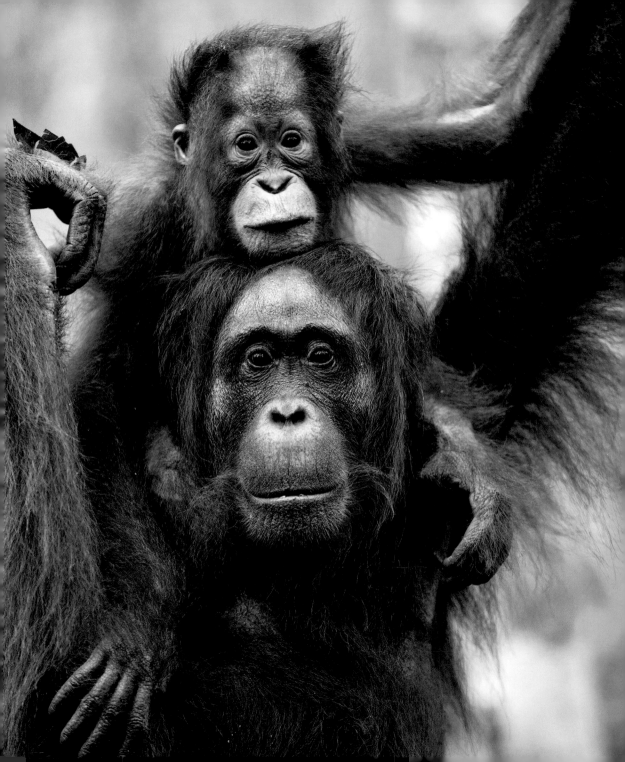

Proboscis Monkey

Proboscis monkeys are found only on the island of Borneo, and are also endangered due to the palm oil industry. In this photo, baby is grabbing mom's nose, which made me laugh out loud because the species is named for its schnoz: A "proboscis" is a long nose belonging to a mammal. The reason these monkeys have such big noses is sexual selection; i.e., females think it's sexy.

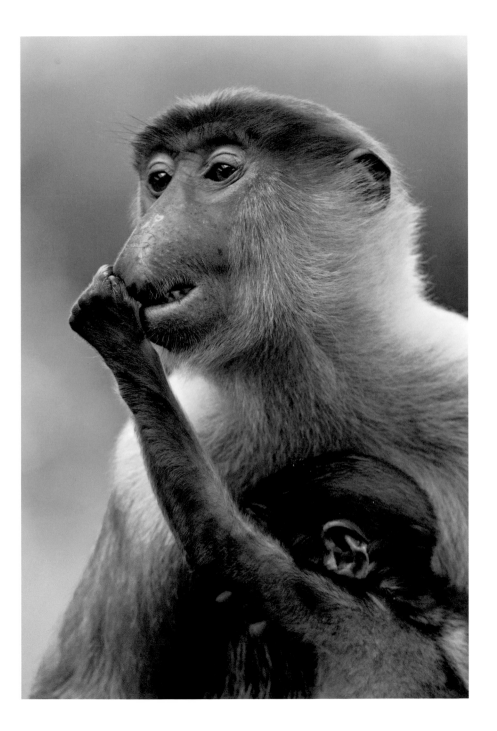

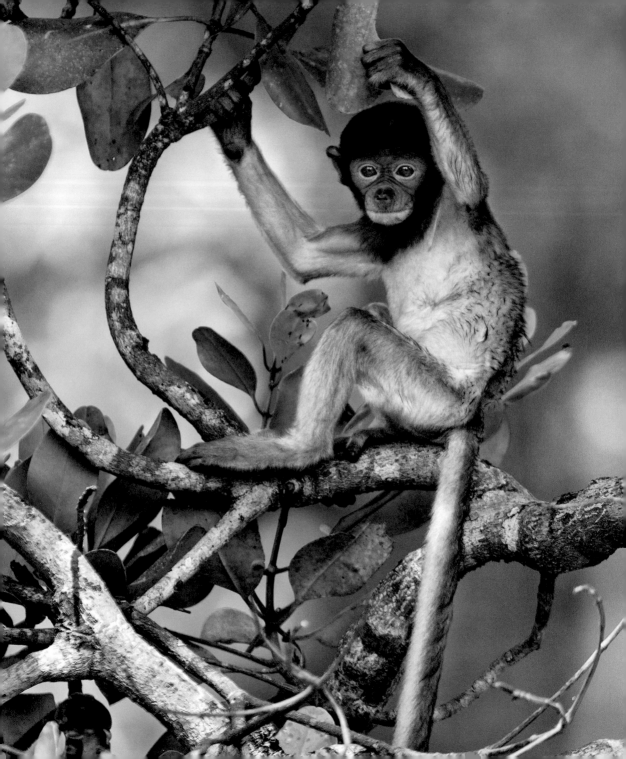

Infant proboscis monkeys are born with tiny, upturned noses and blue faces, which are adorable. Proboscis monkeys of all ages are highly energetic, which made them really fun to photograph.

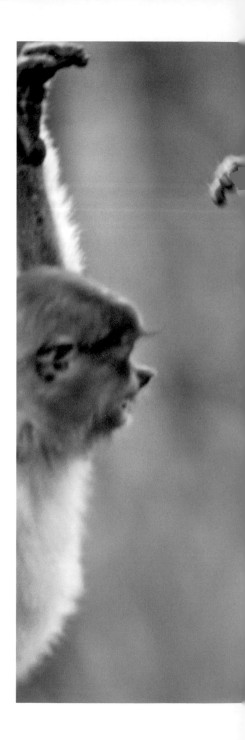

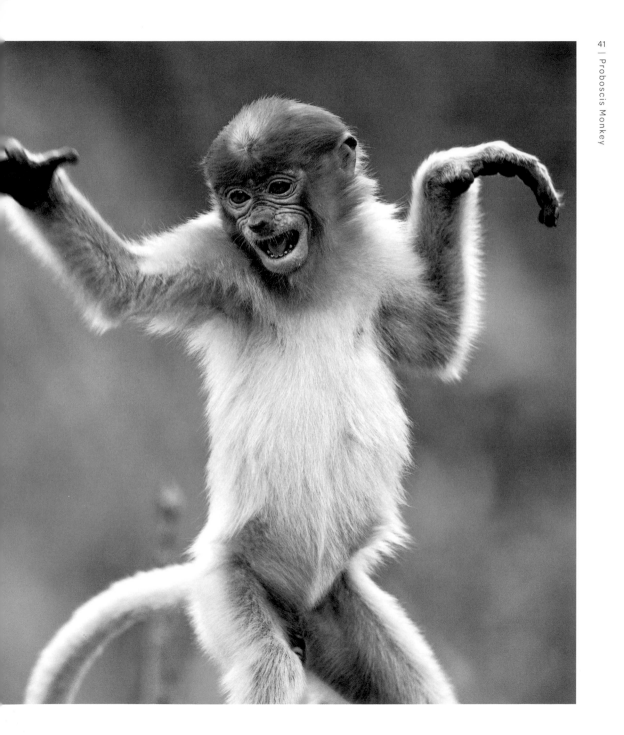

Pangolin

Pangolins use their long tongues to raid ant and termite nests. Their tongues start all the way back in their chest cavity and when fully extended, will span the pangolin's entire body length plus about 16 more inches! This mom and baby are Sunda pangolins. When I took these photos, baby was 2 weeks old and they were living at a wildlife rehabilitation center in Cuc Phuong National Park in Vietnam. Mom had been pregnant when she was rescued from poachers. A few months later, when baby was bigger and stronger, they were released together into the national park.

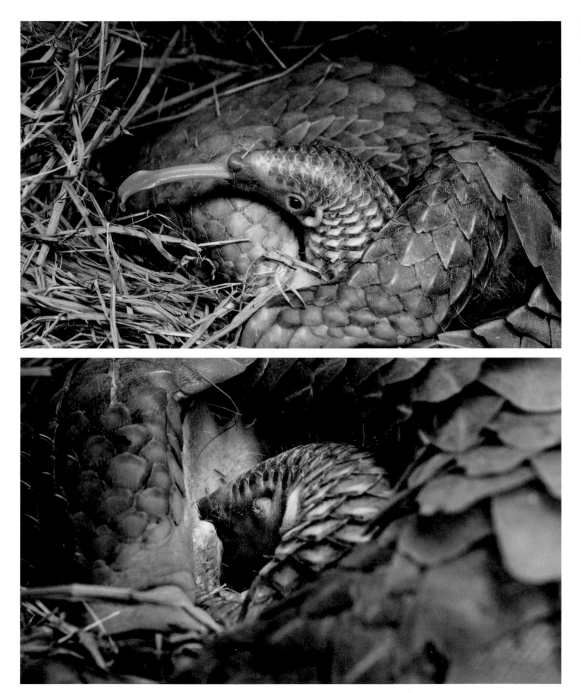

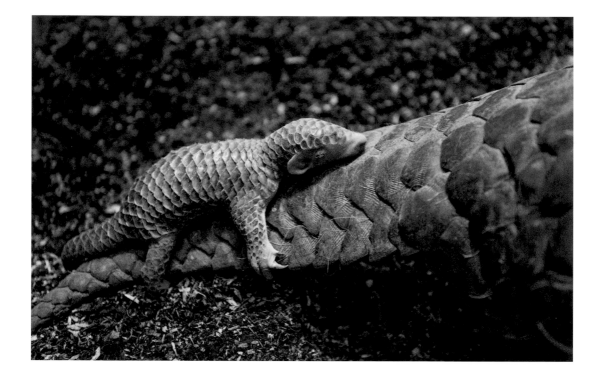

I traveled to Taiwan for these photos, to the Taipei Zoo, which is at the forefront of a conservation effort to breed pangolins rescued from poachers. This newborn Chinese pangolin pup is taking a nap on mom's tail. Baby is 2 weeks old and 12 inches long. As she grows, she'll move further up the tail, and eventually to mom's back.

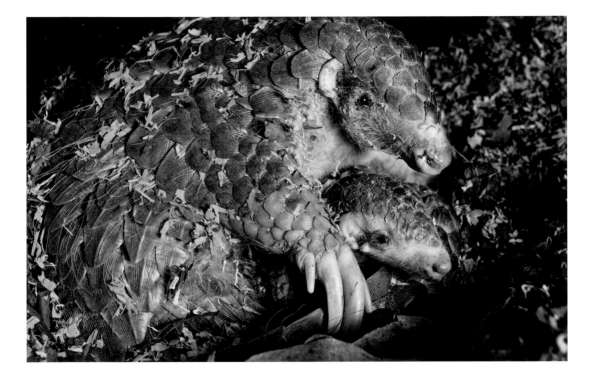

Pangolins are the most trafficked mammal on earth, mostly for their scales, to use in Chinese medicine. What impacted me most about seeing these bizarre creatures in real life was how vulnerable they are. When presented with danger, their only defense is to roll up into a ball.

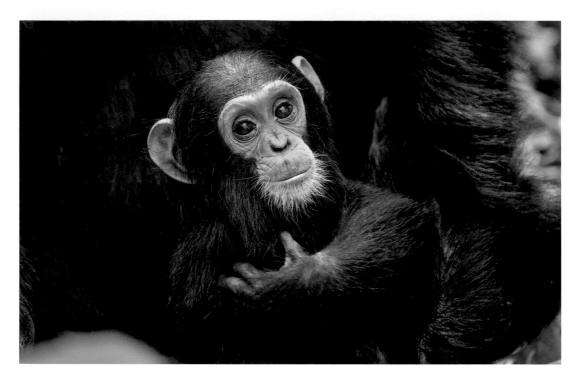

Chimpanzee

(Right) All the chimpanzees shown are part of the same community in Kibale National Park in Uganda. This 4-month-old is suckling, and will continue to do so until she's about 4 years old. Chimps and humans share 96 percent of the same genes, and I really noticed the similarities while photographing this scene. Mom was snuggling her baby so tenderly, and looking down at her so sweetly. I learned that this is typical behavior. The researchers even discovered that baby female chimps will use pieces of bark, wood, and other forest debris as dolls that they carry around and cuddle.

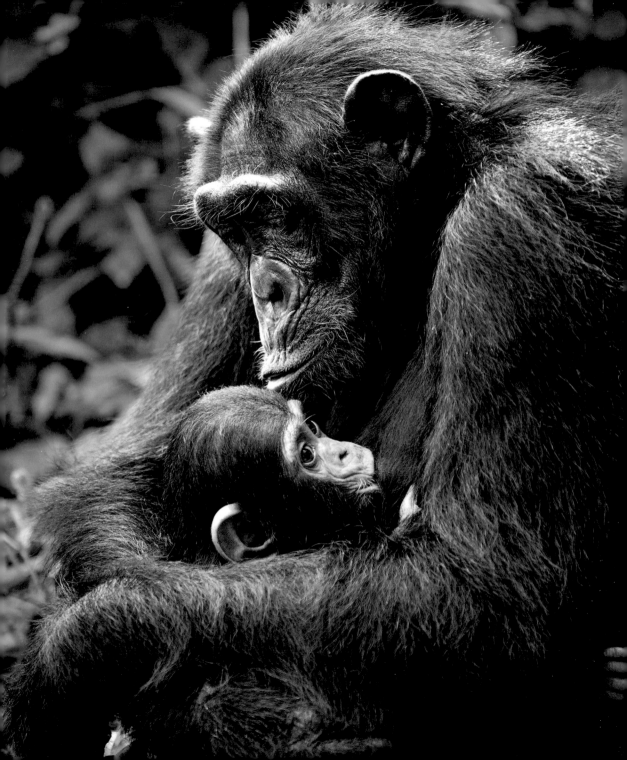

(Top) I call this shot the Family Photo. It's the same mom and 4-month-old from the previous page, plus an older sibling who is about 5 years old. Unlike gorillas, chimp dads aren't as involved with their young, so he's not typically around. Both youngsters still have their peach faces, which will gradually fade with age. I love the way mom is so elegantly lounging, like she doesn't have a care in the world. She seemed quite content. I remember it was midday, when temperatures spike and a siesta beckons. The entire community was quiet and peaceful.

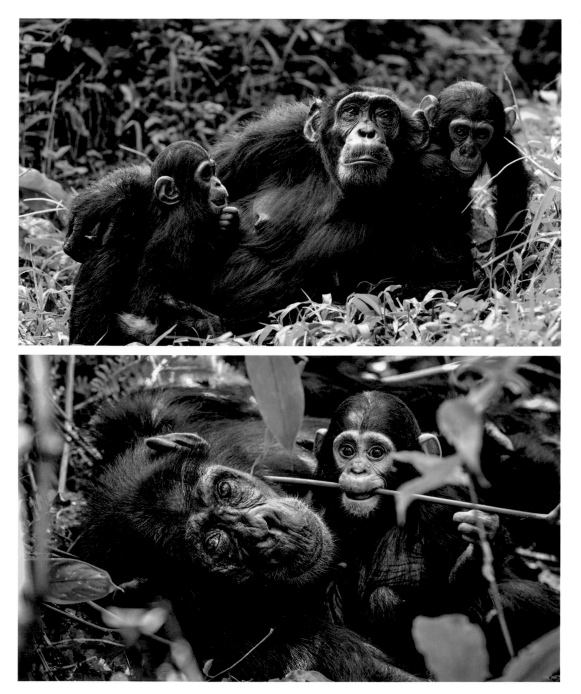

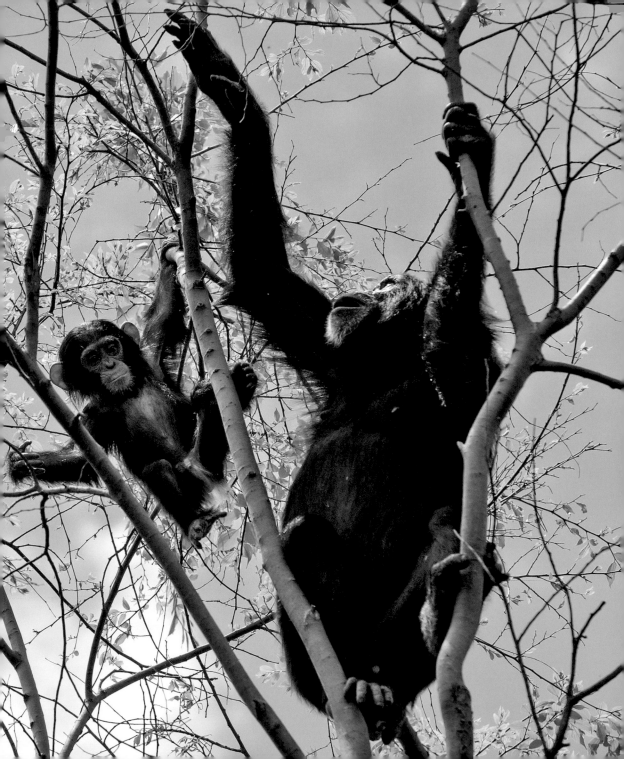

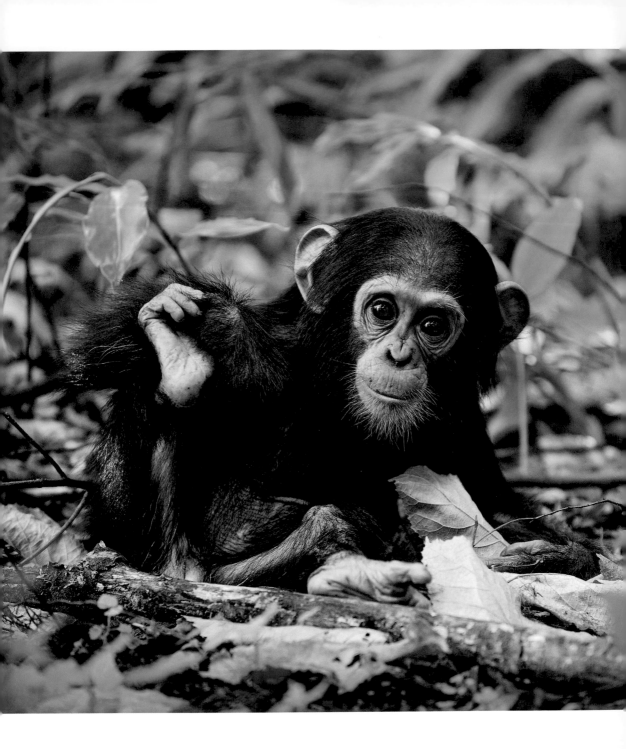

Chimpanzees are born with peach faces, and looking them in the eye feels very human. This little guy is about a year old. He had been playing on the jungle floor with leaf litter and his own feet when I snapped his photo. Working with this particular community of chimpanzees in Uganda's Kibale National Park was amazingly intimate. Dr. Richard Wrangham and his team of primatologists have been studying them for 30 years, and the chimpanzees are so habituated that they sometimes got too close to me. I would need to step back to protect them from catching my human germs.

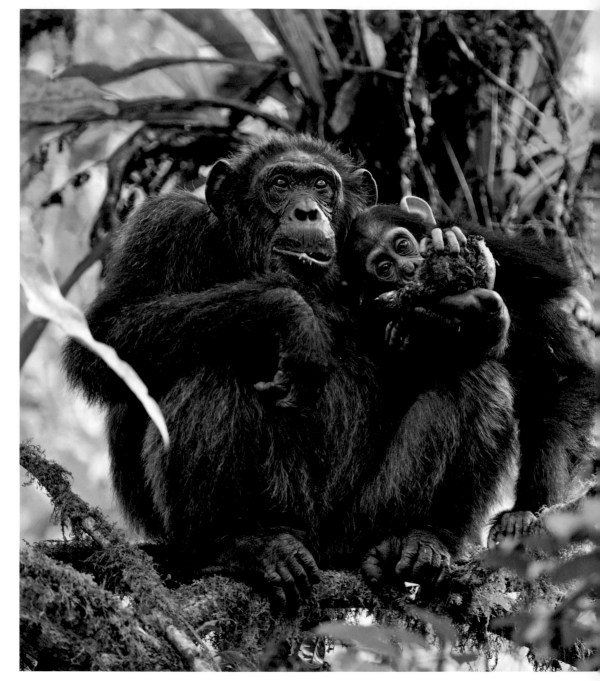

Sloth

My first time working with sloths in Costa Rica, I was photographing them in a rescue center. Then, in a stroke of luck, a staff member spotted a brown-throated three-toed sloth with a newborn in the rainforest just outside the center. Sloth researcher Dr. Rebecca Cliffe, who went on to found the Sloth Conservation Foundation, and I spent two weeks observing them. I never thought I'd have the opportunity to photograph a baby sloth in the wild. It was like a dream, and started my major love affair with sloths. I've since photographed five of the six species, and become a trustee for Rebecca's organization.

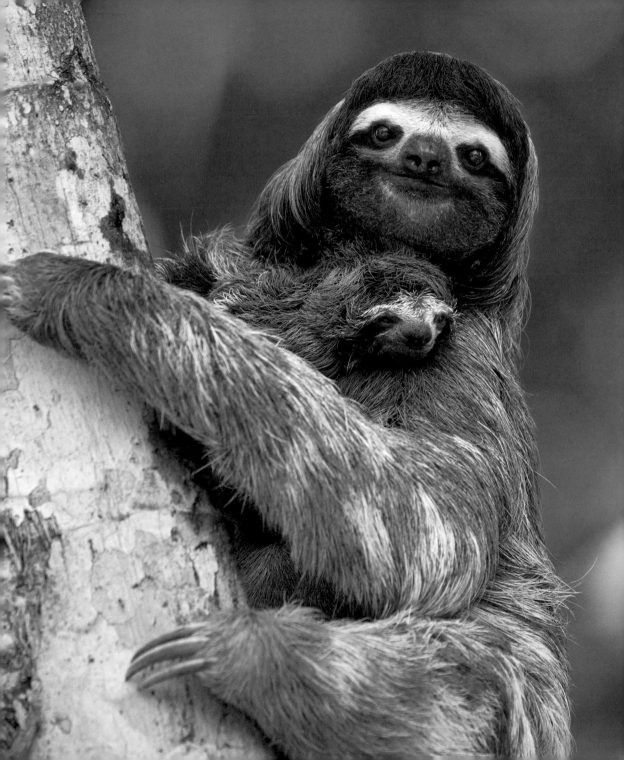

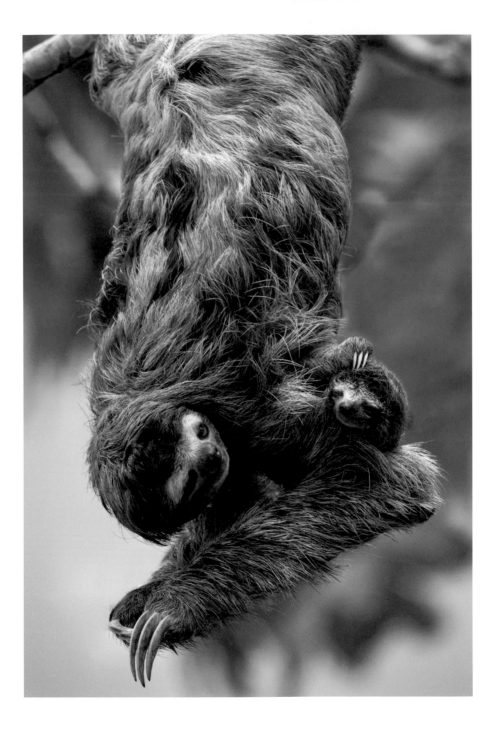

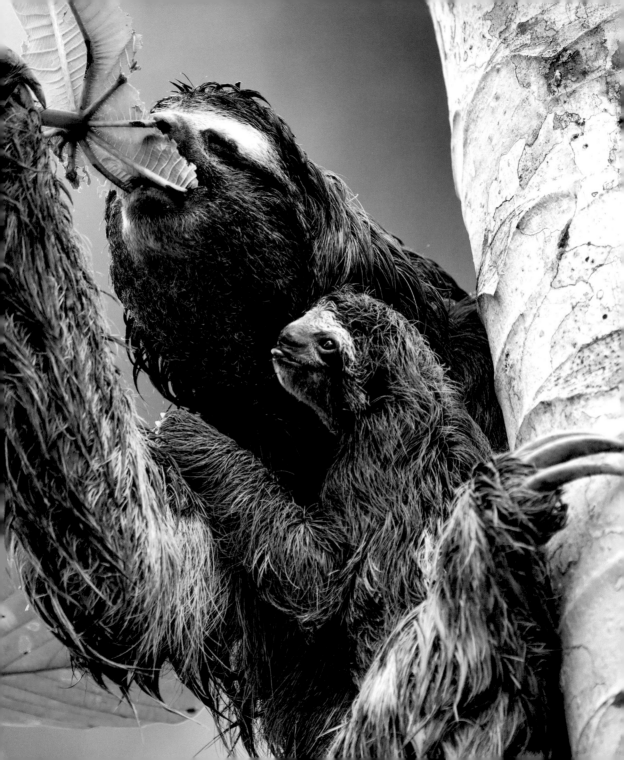

(Page 58) Newborn sloths stick to mom like Velcro. Mom will climb, eat, and move through the trees with the little one attached. In this shot, baby is scratching herself just like mom does, like a Mini-Me. I found it precious. And a great visual of their claws, which are three to four inches long as adults. Sloths use their claws to hang from trees. Fun fact: Sloths have historically been designated as either two-toed or three-toed, but they all have three toes. It's the fingers that differ—either two or three. Dr. Rebecca Cliffe is working to officially correct the misnomer.

(Right) The rare pygmy three-toed sloth is found only on Isla Escudo de Veraguas, an island off the coast of Panama. This one is about 4 months old and not yet independent from mom, who was in the next tree. They are critically endangered and unique, and I was thrilled to photograph them. They are the smallest species of sloth, about 40 percent smaller than the mainland species, and are vegetarians who eat leaves primarily from the red mangroves that surround the island. All sloths can technically swim, but this is the one species that swims regularly.

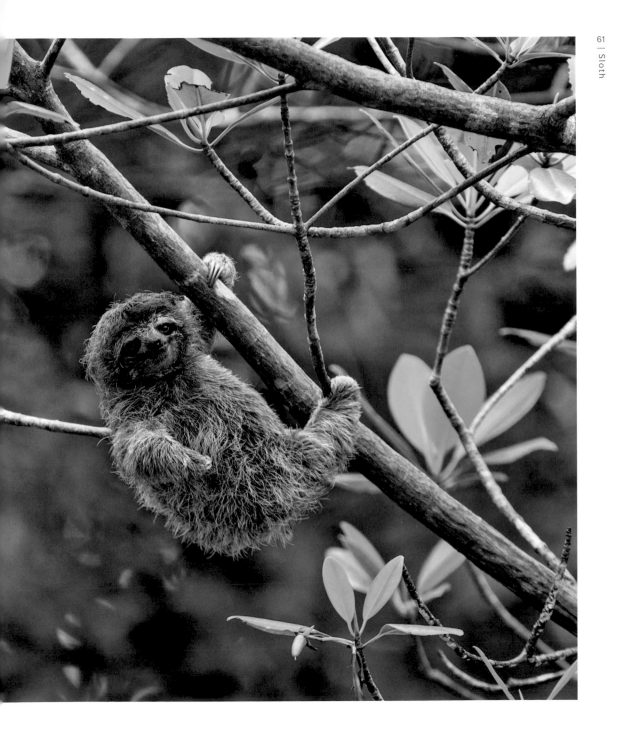

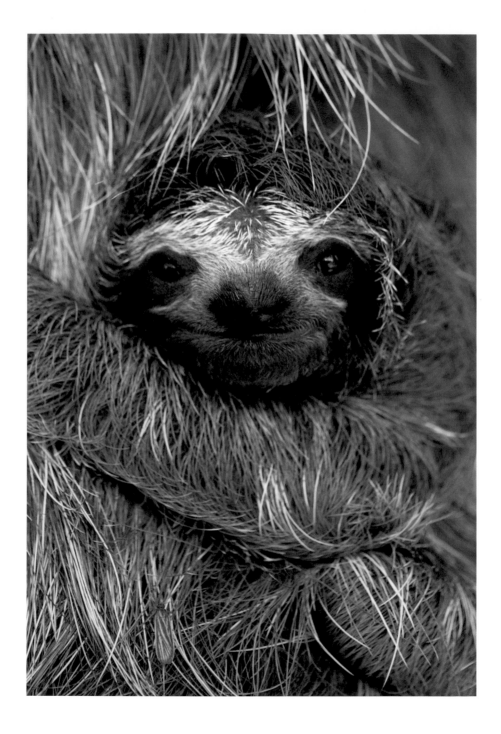

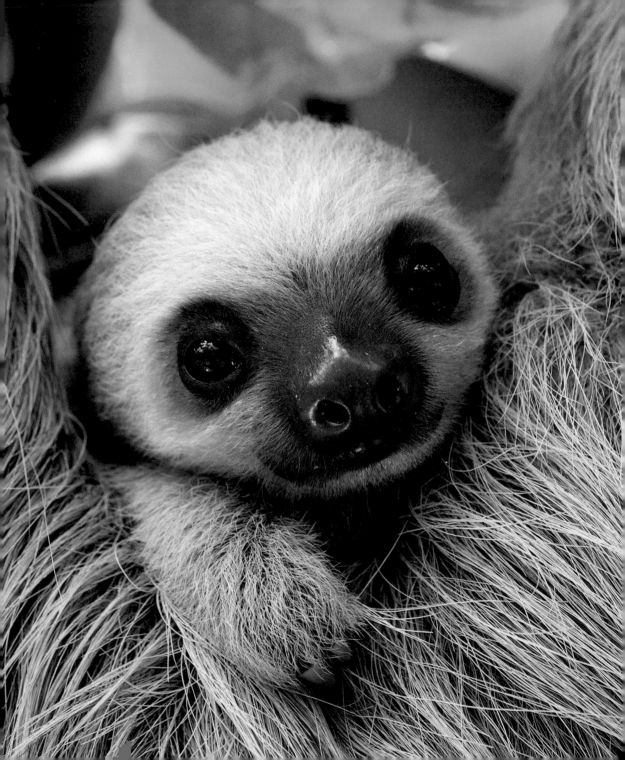

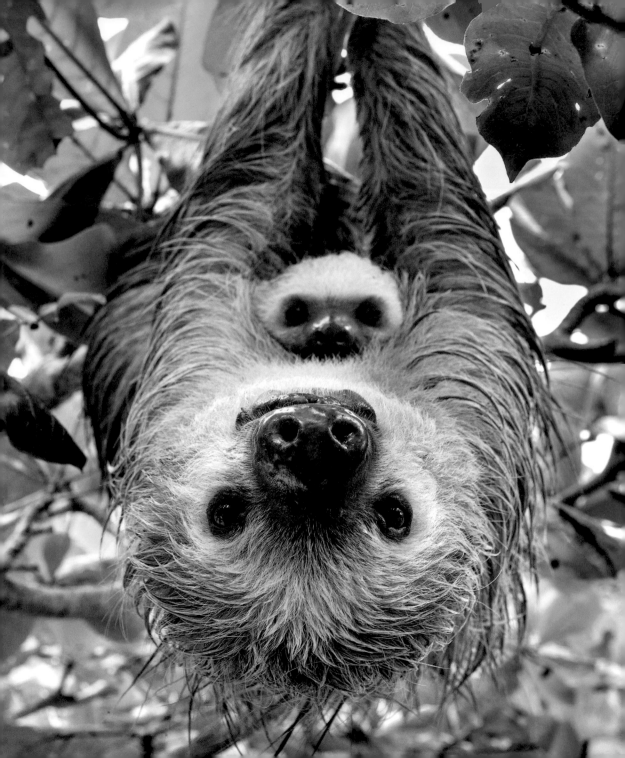

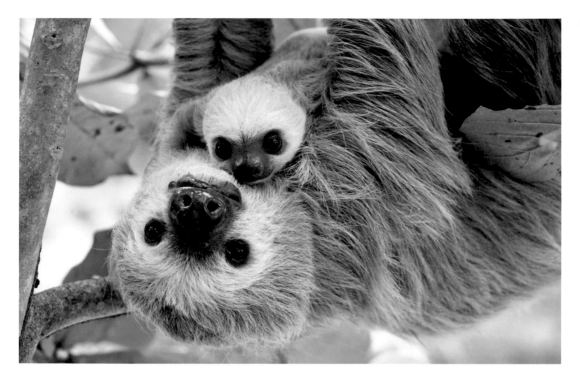

(Left) I photographed this Hoffman's two-toed sloth and her baby near Cahuita National Park in Costa Rica. Sloths have just one baby at a time, and that baby sticks to mom, literally, for the first six months of its life. Sloths are endearing for many reasons, one being that their mouths are shaped in what appears to us as a grin. In this case, I think they really were smiling. Mom and baby had lost their home tree to logging, and were rescued and rehabilitated by a local sloth sanctuary. I took this photo shortly after they were released back into the wild, in an area permanently safe from logging and other forms of deforestation.

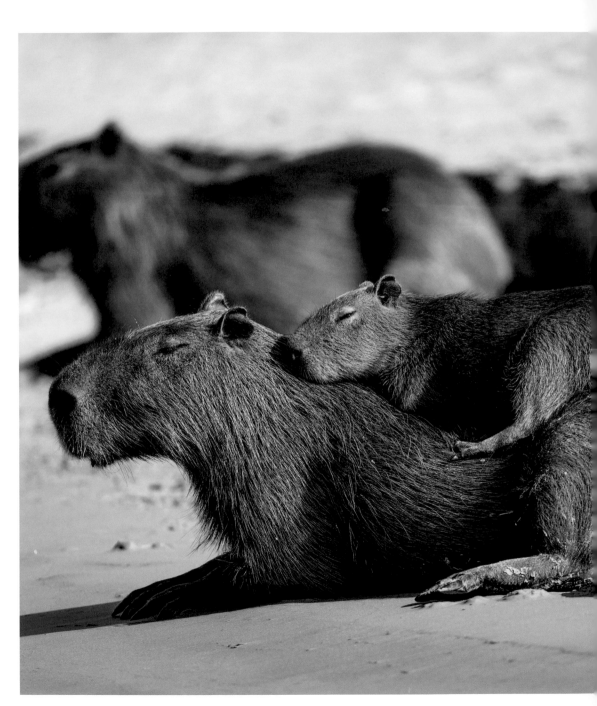

Capybara

Capybaras are also called water pigs because they live near freshwater—in this case, on a bank along the Cuiabá River in Brazil—and because people used to think they were a type of pig. They are actually the world's largest rodent. This 2-month-old baby will grow up to be about 4 feet long, 2 feet tall, and 150 pounds. It's typical for babies to lie on or beside mom while napping. And it doesn't even have to be mom: Capybaras live in groups and practice alloparenting, a system where adults other than the parents help raise the young.

Cotton-Top Tamarin

(Top) These cotton-top tamarin twins are riding on the back of an adult male at a reserve in Colombia. Among primates, their upbringing is unique. Only the alpha female reproduces, and she typically has twins. Then the entire group works together to raise the twins. Both adult males and females assist in grooming and general caretaking, and both sexes will carry the twins on their backs. Cotton-top tamarins are very small (they weigh less than a pound) and very rare, limited to the tropical forests of northwestern Colombia where they're critically endangered due to habitat loss and the illegal pet trade.

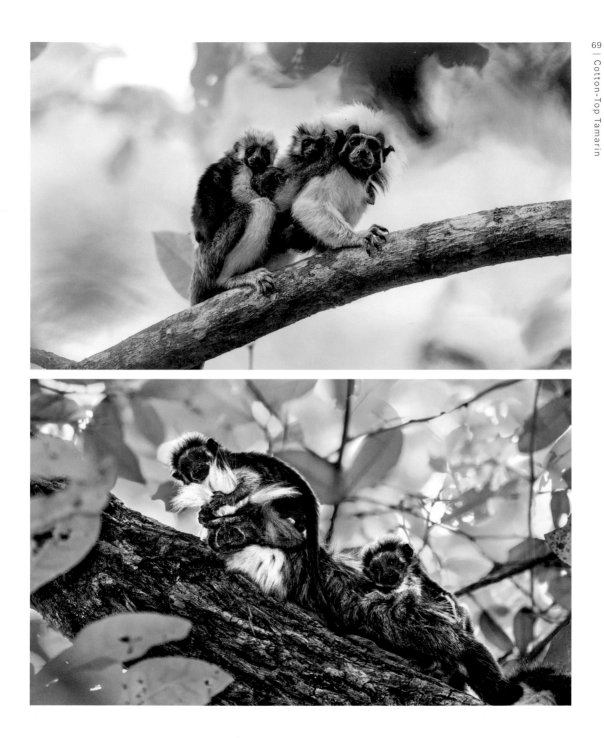

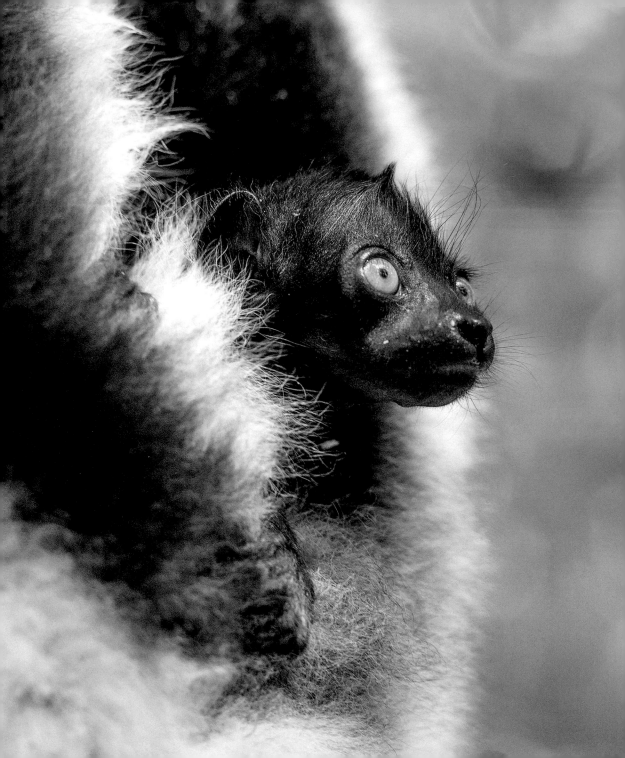

Indri

Indris, a species of endangered lemur in Madagascar, are the first animals with green eyes I've ever photographed. I encountered this little jewel, who is about 2 weeks old, in Andasibe-Mantadia National Park. Indris are known as the teddy bear lemur for their rounded ears and fuzzy fur. They live high in the trees, but are quite curious and habituated to people in protected areas, which is how I got this photo—mom had climbed down to check me out. I was incredibly moved the first time I heard them sing: a beautiful, almost haunting sound that suddenly rings out from on high.

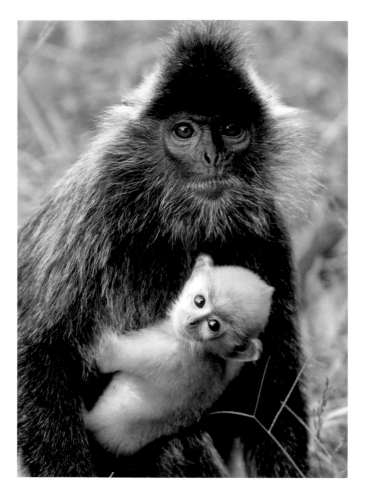

Langur

(Left) Silvered langurs are born radiant orange. They turn to silver at 3 months. This little gal is about 2 weeks old, and lives on the north side of the island of Borneo.

(Right) This red-shanked douc langur is about 2 months old. I had the privilege of photographing her at the Endangered Primate Rescue Center in Cuc Phuong National Park in Vietnam.

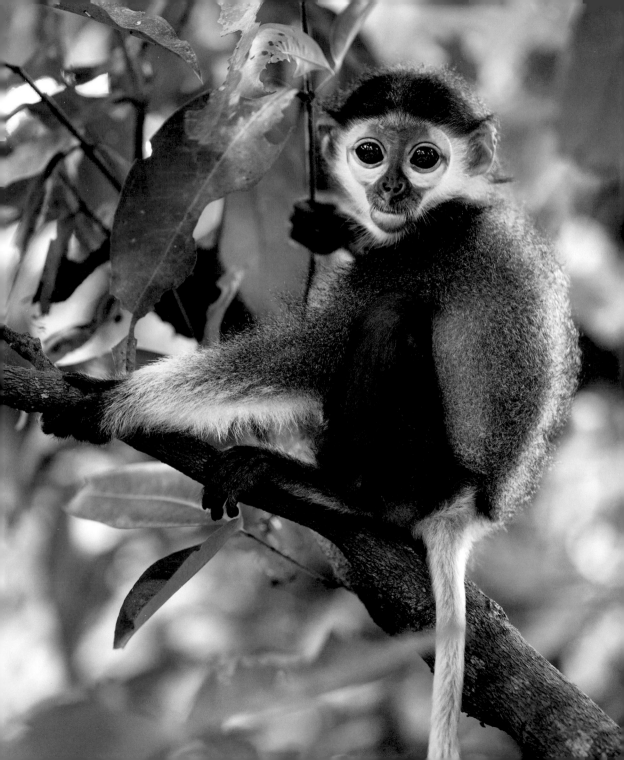

Spider Monkey

I encountered this newborn black-handed spider monkey hanging out with mom in the rainforest of the Osa Peninsula in Costa Rica.

In the primate world, monkeys are always overshadowed by the great apes, in both the public consciousness and in conservation funding. Which is tragic to me because monkeys rate among the most visually striking animals I've ever photographed. And because they desperately need our help. Sixty percent of primate species are now threatened with extinction. Many of the smaller monkeys I didn't even know existed before I began my career are already at risk of disappearing forever. Photographing new babies gives me hope that it's not too late.

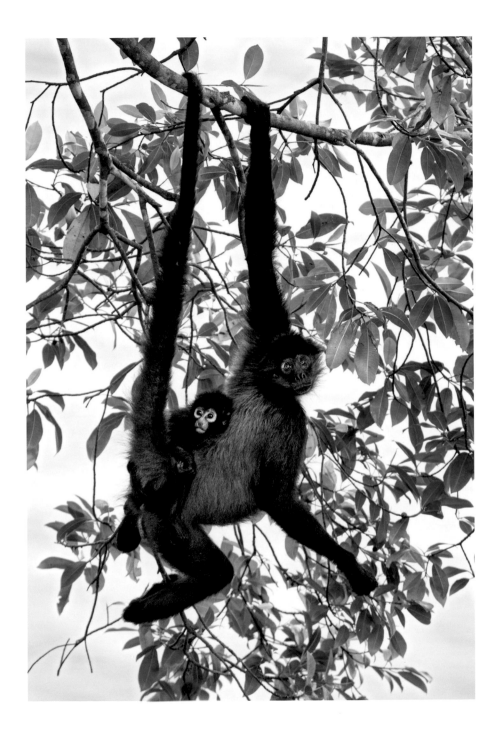

Mountain
& Forest

Brown Bear

(Top) These cubs, like all brown bears, were born in a den sometime between December and March while mom was hibernating. At birth, they were blind, toothless, and weighed less than a pound each. They would have wiggled up mom's belly fur to suckle, and stayed there until she emerged in April or May. I took all the bear photos in this section in Alaska's Katmai National Park, where these two cubs were fresh out of the den, experiencing the world for the first time. They were excessively playful, full of energy and the urge to chew (as evidenced by the missing bark on the log).

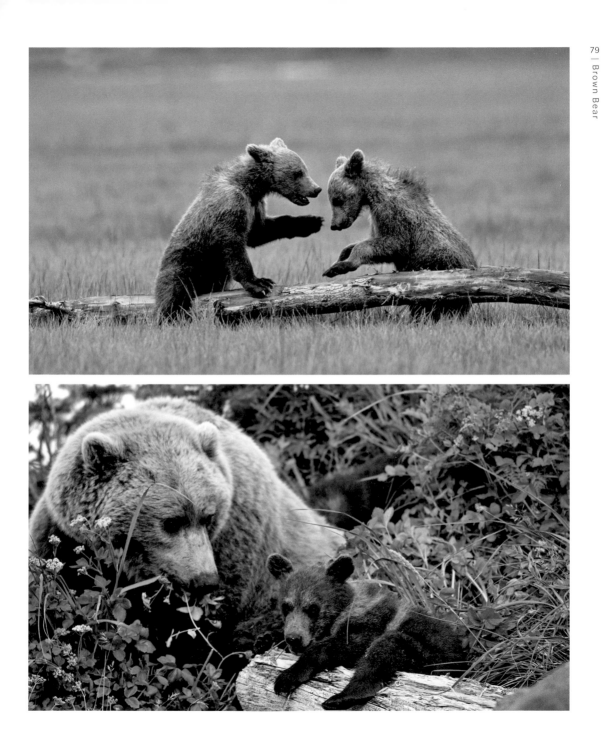

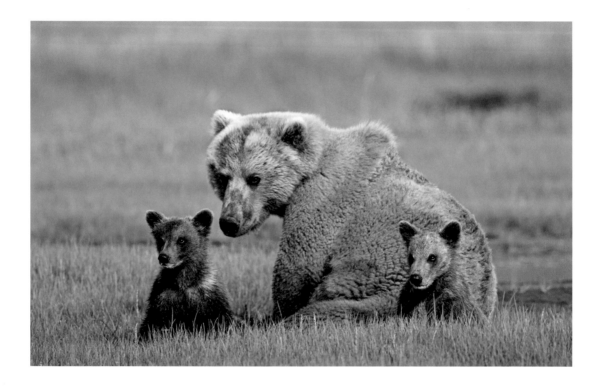

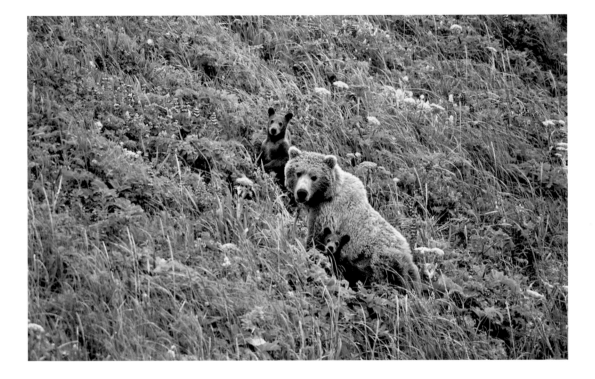

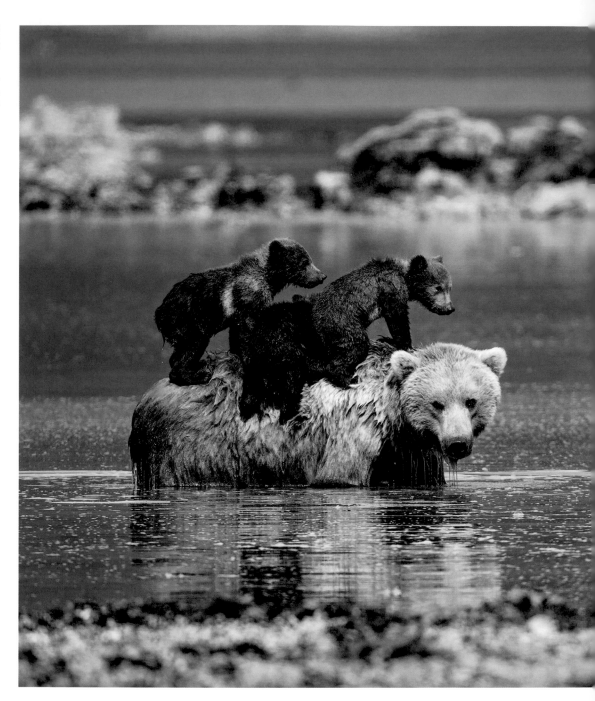

(**Left**) I've seldom seen triplet brown bear cubs; singles and doubles are far more common. I'd been tracking this adorable trio for several days in Katmai National Park, and was delighted to capture the cubs' first time in the sea. It was June, and mom was looking to cool off. At first the cubs, who were about 5 months old, followed her in, then quickly clambered onto her back as they began to submerge. During my time with this family, I got to witness the cubs experiencing all kinds of firsts, from their first time seeing other bears to their first time clamming.

(**Pages 84–85**) People call this my dancing bear shot. Bears tend to jump up on their hind legs when feeling inquisitive— which is often for new cubs. I remember mom was out digging for clams and the cubs were scampering around and getting into everything. With four cubs, the maximum litter size, mom had her hands full. It's her job to feed and protect them, and to teach them everything she knows about how to be a bear. This includes keeping them far from adult males, who, during summer mating season, will kill cubs to get mom to mate again (she won't if she already has a litter).

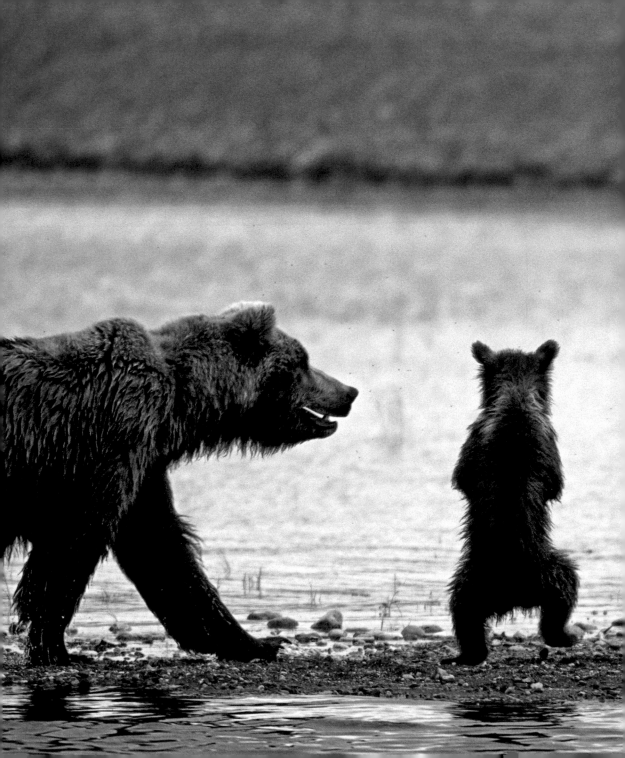

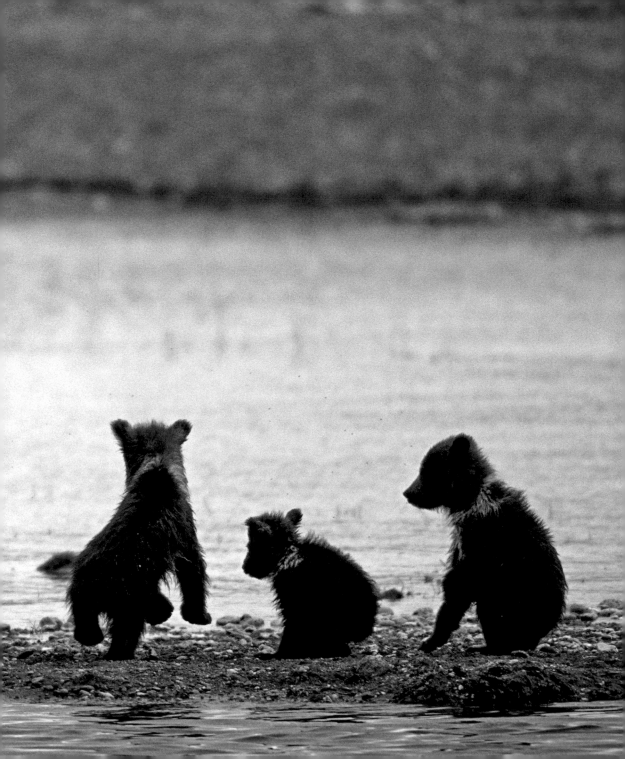

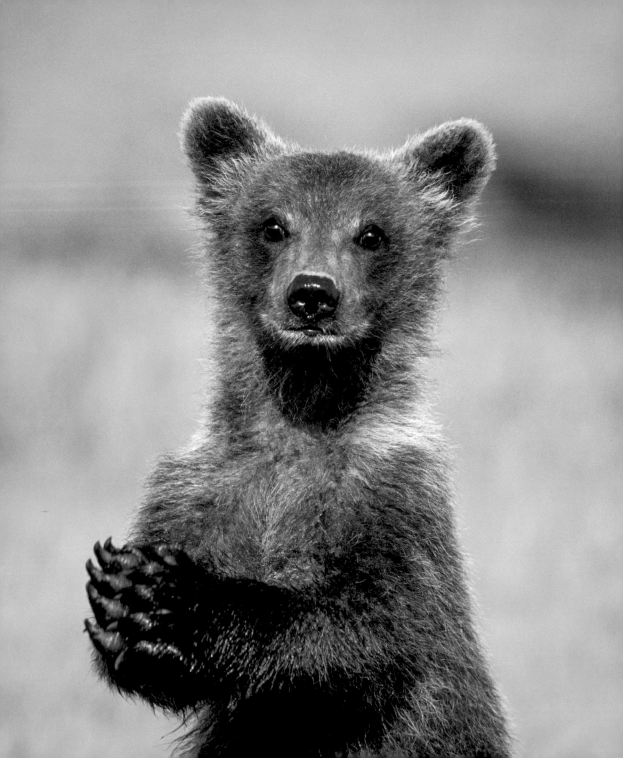

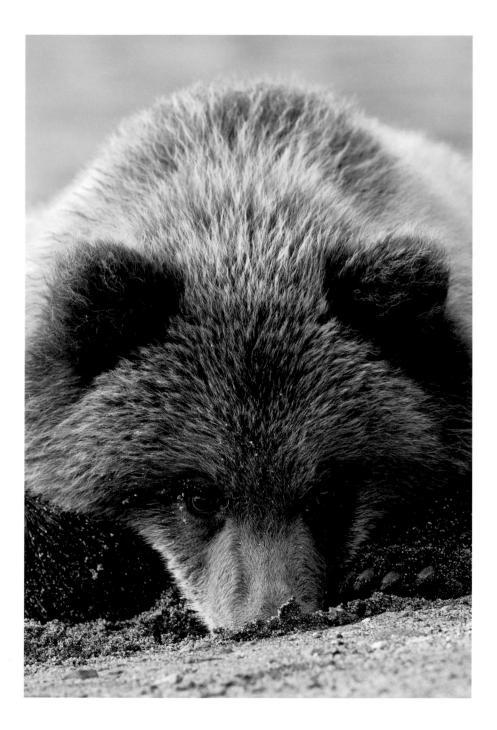

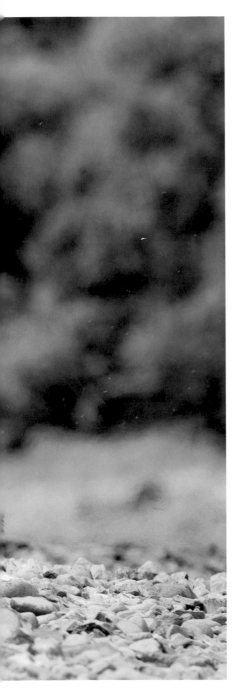

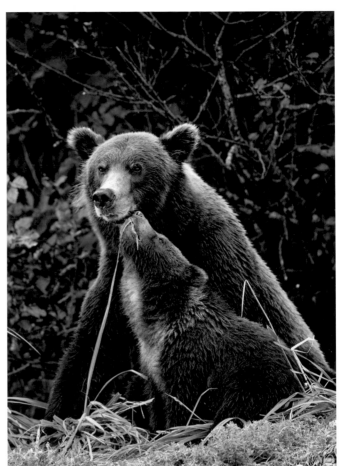

(Left) At the end of the summer in Katmai National Park, salmon return to the rivers to spawn. It's a feeding frenzy for brown bears, who spend the fall bulking up on the fatty fish in preparation for winter hibernation. Watching cubs steal mom's salmon is always entertaining. The mom in the photo was one of the more patient moms I'd seen. She barely grumbled before letting her cub have the fish. It's worth noting that when salmon are overfished by humans (or their spawning rivers destroyed by mining), brown bear populations suffer. Most brown bear conservationists are also salmon conservationists.

Hallo Bay, a meadow beneath the glaciated peaks of the Aleutian Range in Katmai National Park, is brown bear central. Brown bears prefer to eat salmon, but in the summertime before the spawn they'll eat berries and sedge grass. I've counted as many as 30 brown bears grazing here at once. It was surreal; they almost looked like bison. In this photo, mom and her 1.5-year-old cub have stopped for a drink as they cross the stream. The magnificent light is courtesy of the sunset, which doesn't happen until after midnight during summer in the Far North.

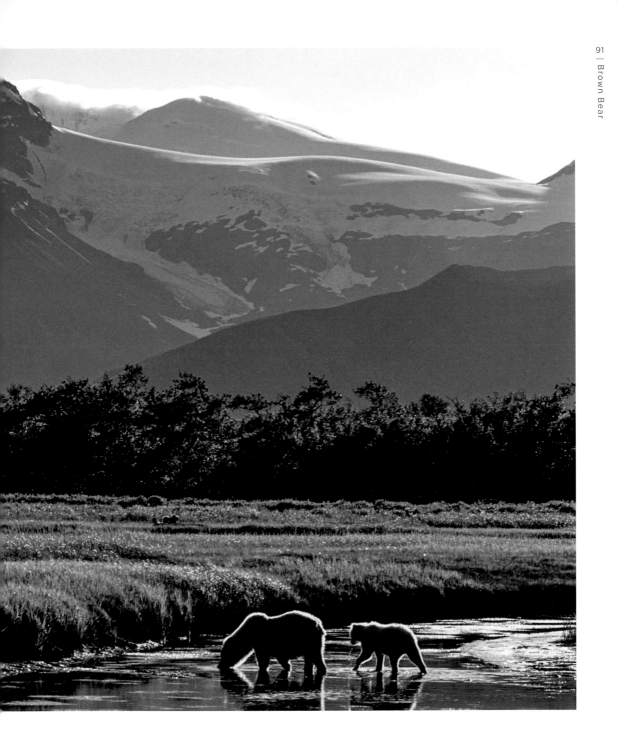

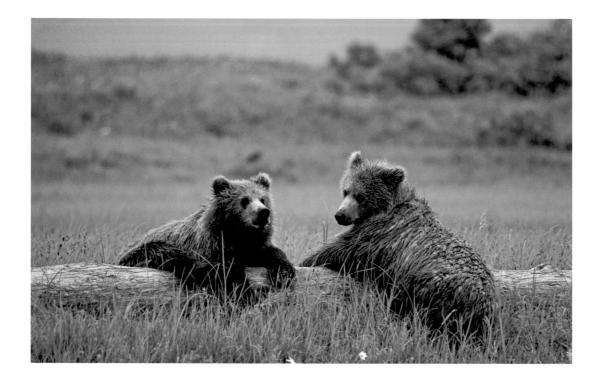

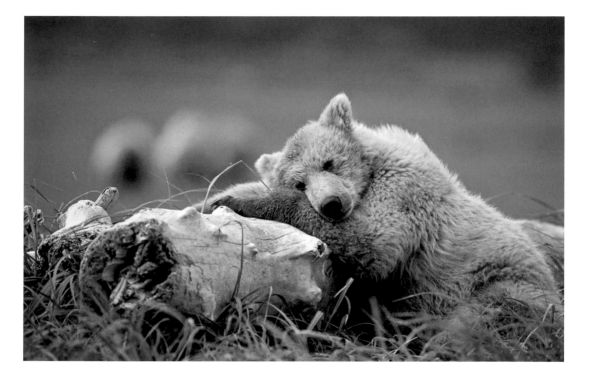

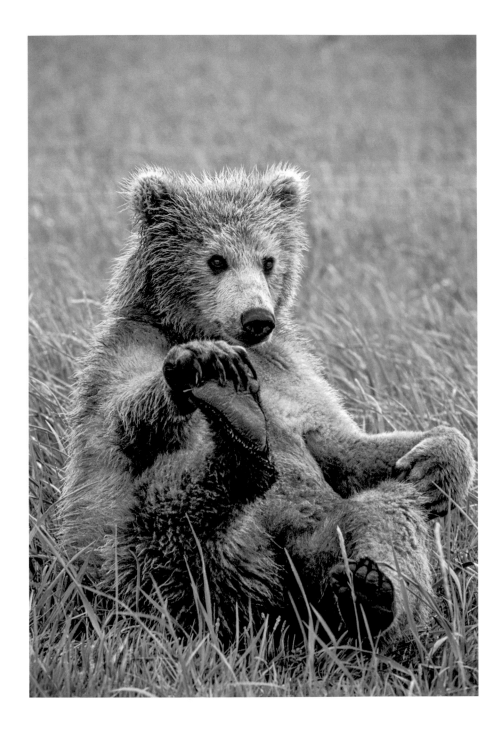

Brown bears vary in color from nearly black to blond. This handsome guy is 2.5 years old and a subadult, which means he's independent from mom but not yet fully grown. Much like human teenagers, subadult bears are the most likely to get into trouble and push boundaries. Just before I took this photo, he began approaching me. I knew I needed to stand my ground, but also find a way to communicate to him to back off. I grabbed my rain jacket and shook it at him. It worked. He stopped, sat down, and started goofing off.

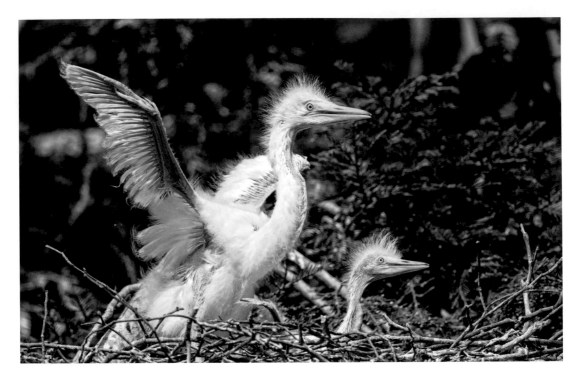

Egret

Great egrets nest in communities known as rookeries. In Santa Rosa, California, some 300 nests are tucked into a group of trees in the median of a roadway. I used a bucket truck borrowed from an arborist friend to raise myself up to nest-level. In this family portrait, mom had just landed. I love that great egrets are the symbol of the National Audubon Society. It's well deserved. The elegant waders made an amazing comeback—aided and abetted by devoted conservationists—in the early 1900s after being hunted nearly to extinction for their feathers, used to adorn hats.

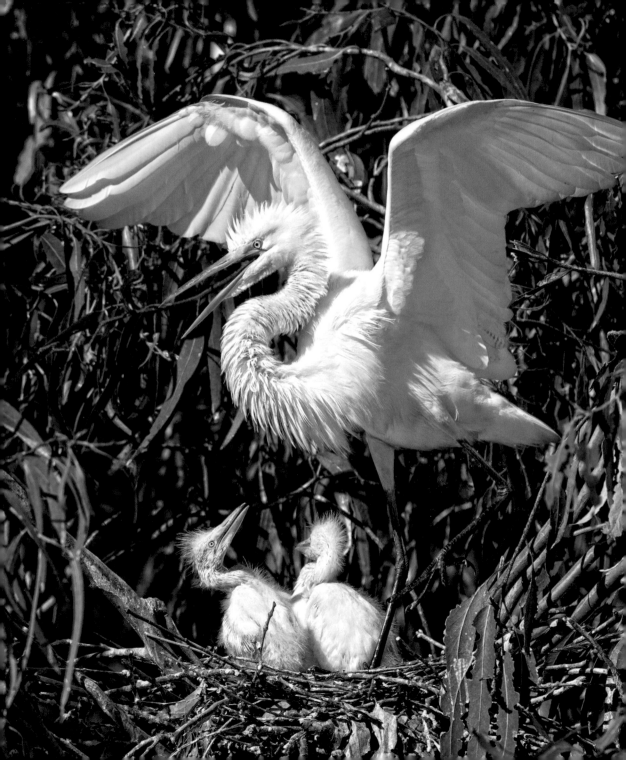

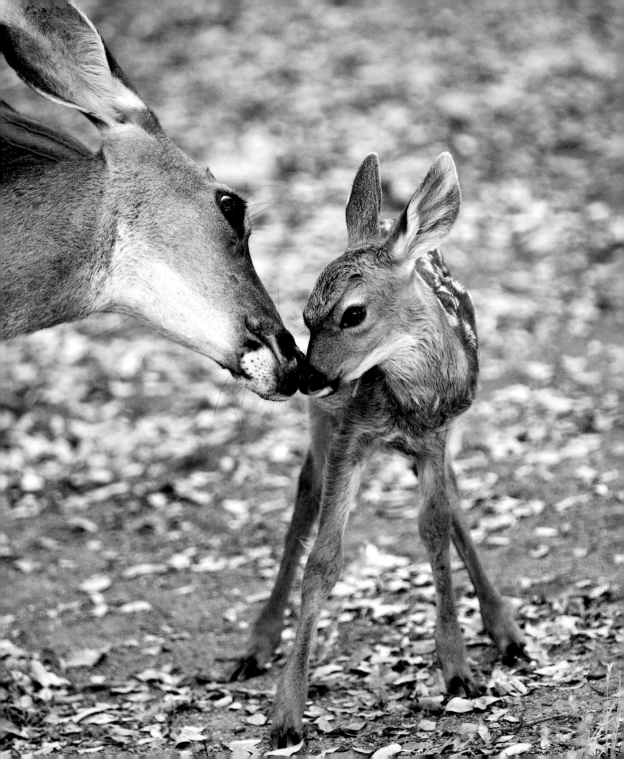

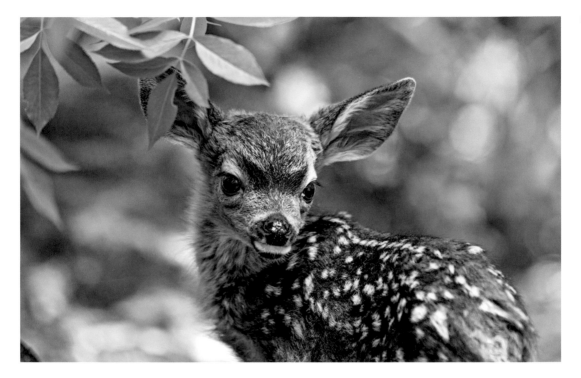

Deer

When I was growing up in California, deer were plentiful in the coastal woodlands. That's not the case anymore, so I was really excited when I got the call that a black-tailed deer had just given birth on private property in Loomis, California. In the photo on the left, mom is nuzzling her fawn, who is just 2 days old and still wobbly. The fawn in the photo on the right, taken at Kindred Spirits Fawn Rescue, is a week old. Fawns stay mostly hidden for the first 7 to 10 days of their lives as they gain strength and stability. Their darling spots are part of their camouflage.

Beaver

Baby beavers are called kits, and this one is 3 months old,
enjoying lunch in the Napa River in California. She was able to
swim within 24 hours of birth, but like all kits, gets some extra
help from her upright tail—it's what's helping her float as she
munches vegetation. When I was a kid, beavers were nearly
wiped out in North America by trapping for their pelts. It's great
to have them back. Fun fact: Beavers have vanilla-scented
butts. They secrete oil from their anus to mark their scent that
smells exactly like vanilla.

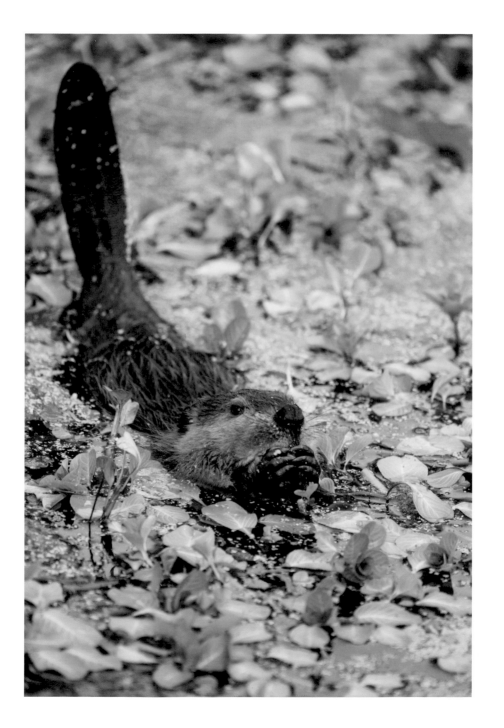

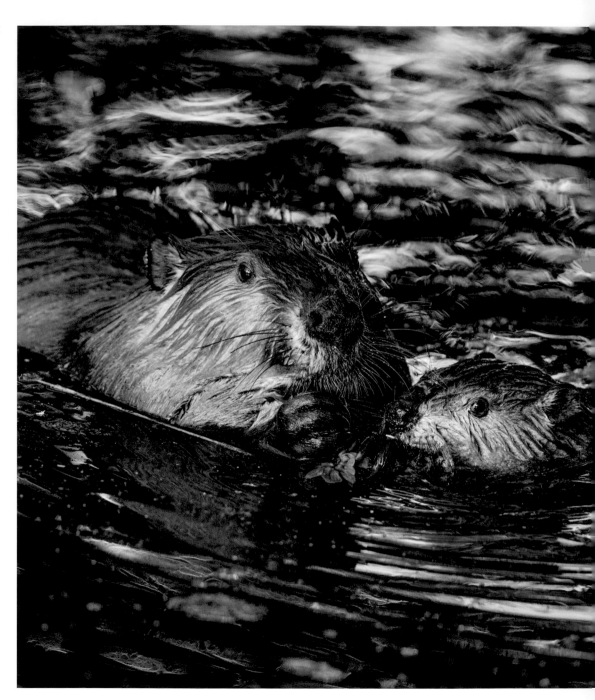

Bison

With baby-animal play, the parents don't always appear to appreciate the encounter. But many, like this female bison in Yellowstone National Park in Montana, clearly enjoy it. Mom went head-to-head with baby for several minutes, much to my delight. Adult bison butt heads for a couple reasons, most commonly males competing with other males over females, and in self-defense (bison have been known to ram humans with their heads). The calf is 1 month old, weighing in at less than 100 pounds compared to mom's scale-tipping 1,000 pounds, so it's hardly a fair match. Luckily, it's all for fun.

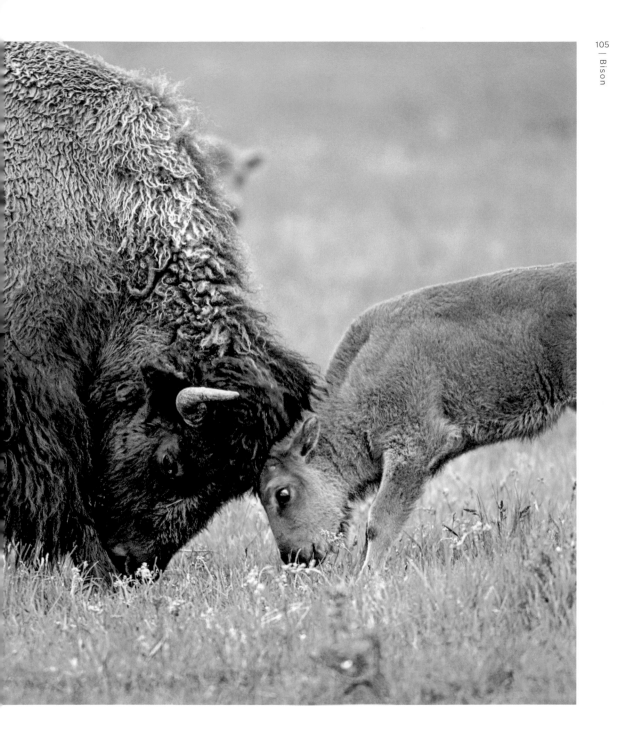

Koala

Thanks to the Australian Koala Foundation and the Currumbin Wildlife Sanctuary's breeding program, I had the enormous privilege of a close-up experience with koala moms and their joeys. Joey is 7 months old, and in what I like to call the peeking phase, where he starts to peek out from mom's pouch and even climb out for a few minutes before popping back in. Eventually he'll start riding on her back, and sometimes even her head.

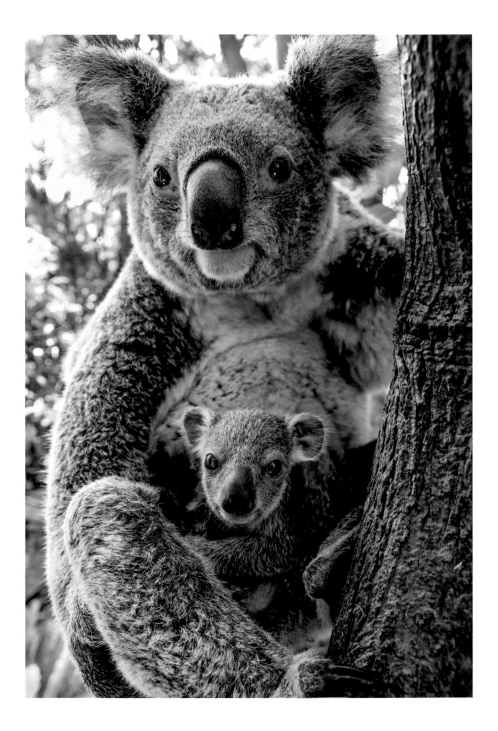

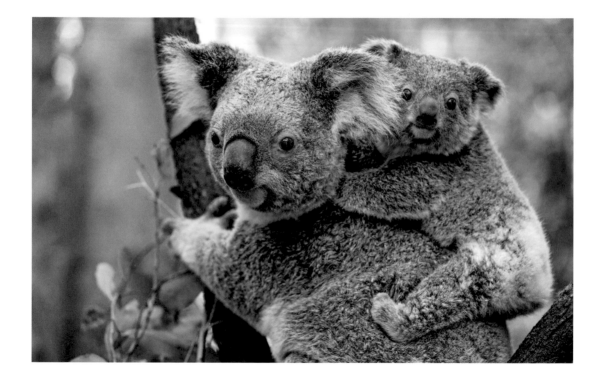

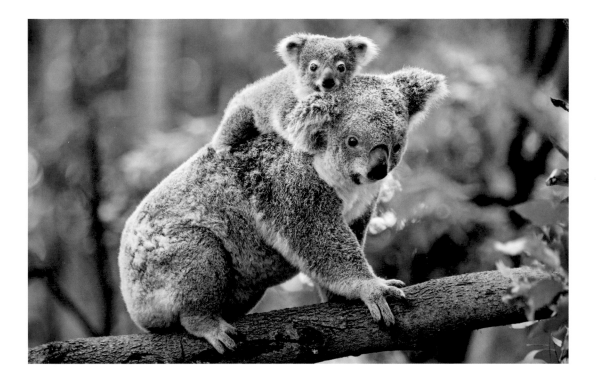

Koalas sometimes hold their joeys in their arms, which scientists say is to keep them warm, but I think is about so much more.

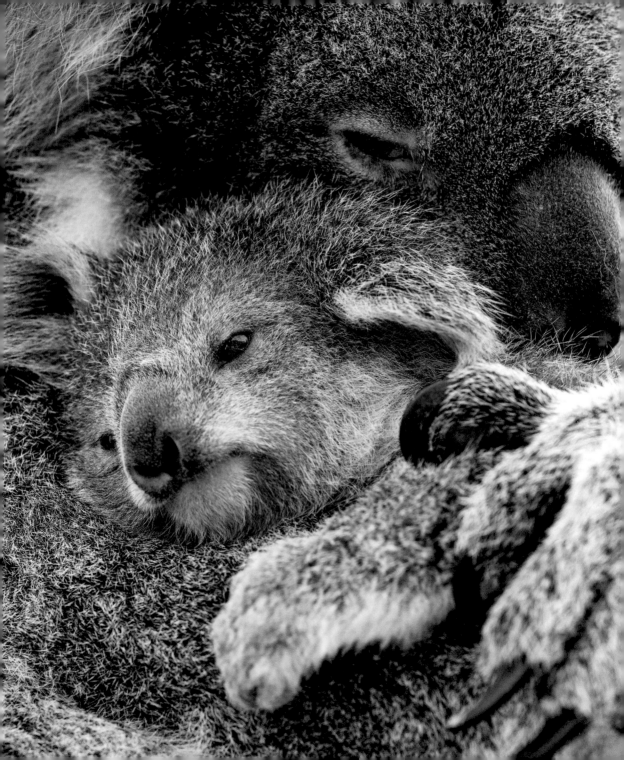

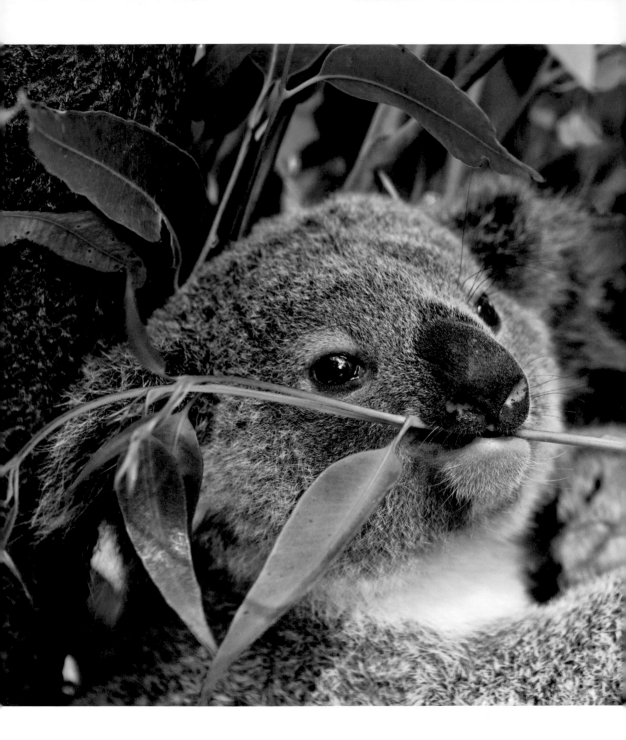

Here, an older joey of 11 months is dining on eucalyptus leaves, the koala meal of choice. It's the perfect arrangement, considering koalas live in eucalyptus forests. What amazes me is that joeys aren't born with the ability to digest eucalyptus; in fact, the leaves are toxic to most mammals. Joeys must first ingest a unique bacteria that will flourish in their guts to allow them to digest eucalyptus. This bacteria can be found in adult koalas' digestive tracts, so when joeys are about 6 months old, koala moms begin excreting it for their joeys to eat. Scientists call the substance pap.

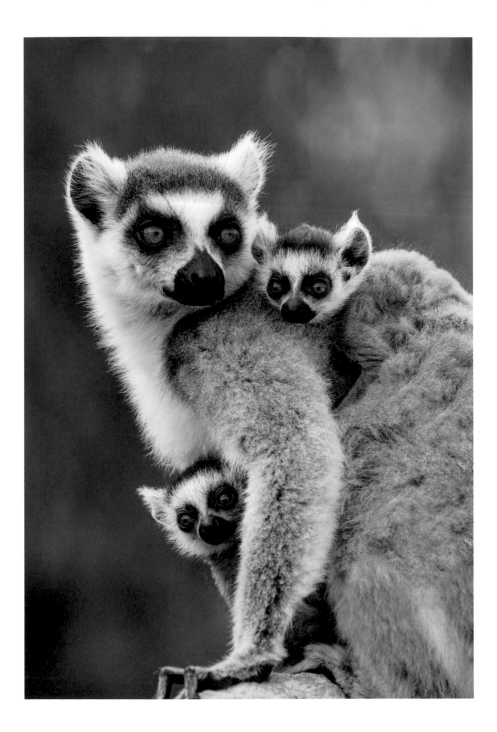

Ring-Tailed Lemur

Ring-tailed lemurs are enchanting little primates and unfortunately endangered, as are most lemurs. They're super high energy and very social, in near-constant contact with one another. Their family groups are called troops and the females are in charge. I photographed them in Berenty Private Reserve in Madagascar, where they live in semiarid spiny forests. The mom in this photo had twins, which is uncommon and extra special to be around. They are 1 to 2 weeks old. Like orangutans, baby lemurs are clingers who stick to mom like glue. All lemurs have those cosmic eyes, in either bright yellow, orange, or green.

(Bottom) When I took this photo, the troop had been sunbathing—which is a classic lemur behavior. They sit upright, face the sun, and lean back. It's precious. Much social interaction occurs during this time, including social grooming, which helps reinforce the bonds among the troop. In the photo, mom is holding baby while another adult female grooms him. Baby appears less than thrilled. The look on his face is priceless. Animals, even babies, have individual personalities. Sometimes they like baths, sometimes they don't. And like us, they have good days and bad days. I relish being able to show that in my work.

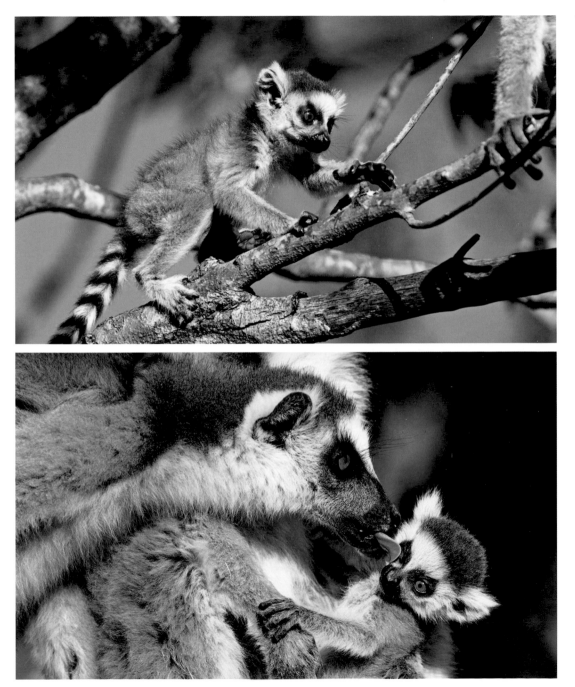

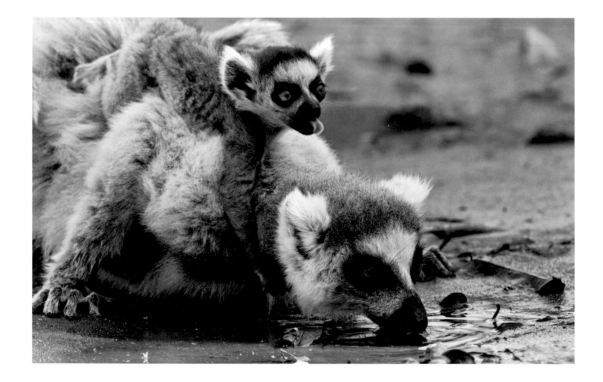

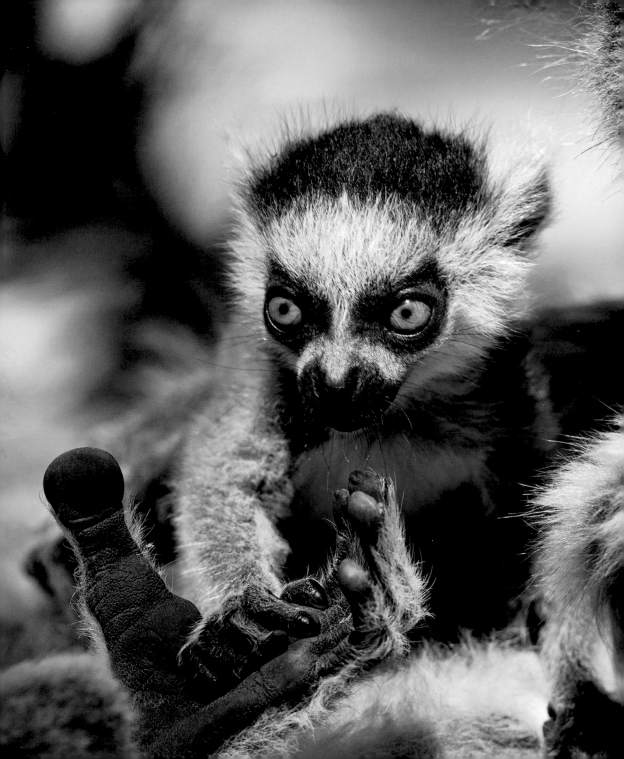

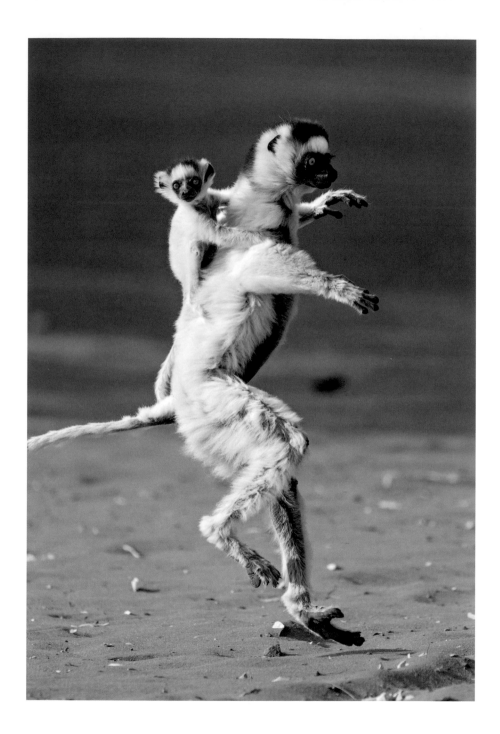

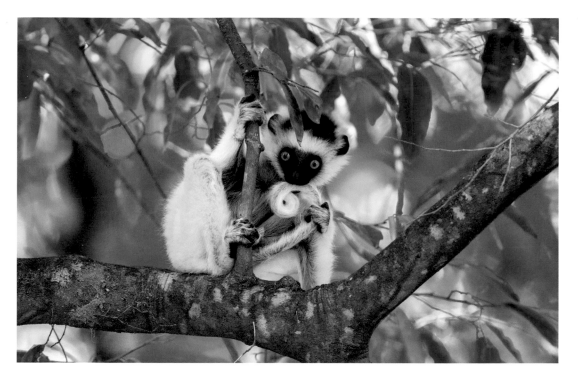

Sifaka

(Left) Verreaux's sifakas are a type of lemur, and one of the most famous of the 100+ lemur species due to their dancing ability. Mom's dance moves were fun, fast, and bouncy—a two-legged sideways hop with her 3-week-old baby on board. Verreaux's sifakas normally travel by treetop, where they can jump up to 30 feet across sections of the forest canopy. But when the gap is too wide, they climb down and go by foot. The dancing makes them fast and agile, and less likely to be caught by a predator waiting to pounce.

This picture-perfect pair is also in the sifaka family, but a different species called the Coquerel's sifaka. Sifakas were named after the "sheef-auk!" cry they make to alert other sifakas to danger.

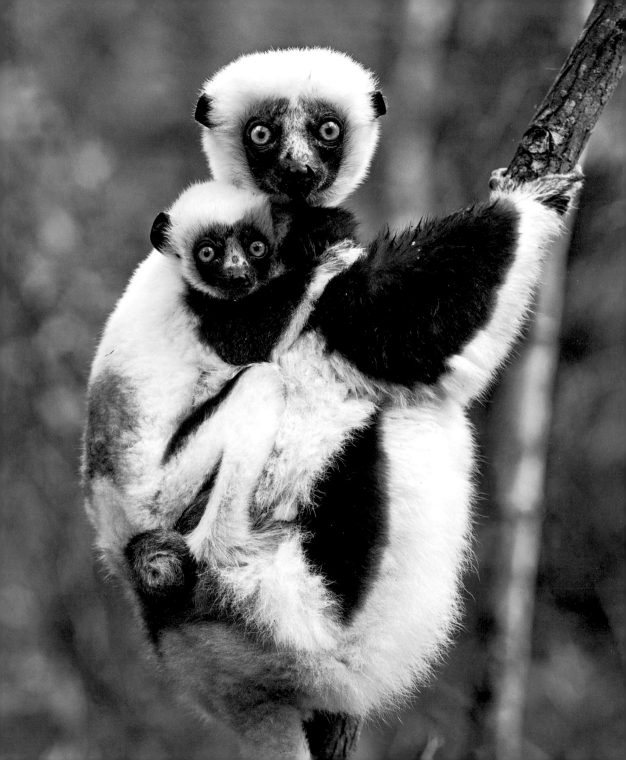

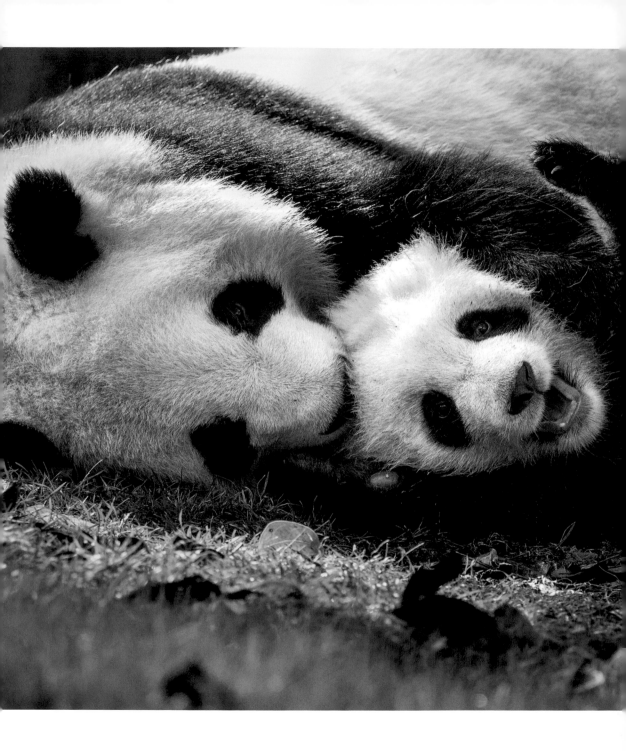

Panda

A 6-month-old giant panda cub is having a blast wrestling with mom at the Chengdu Research Base of Giant Panda Breeding in China. China has been instrumental in bringing the panda back from near extinction, and continues to be at the forefront of panda conservation. Every newborn panda is like a miracle because mom's window for reproduction is so small. She ovulates just once a year and is fertile for only two to three days. Outside of mating and raising cubs, pandas are solitary, and also quite sedentary. Getting to watch a mom and cub play was something I had dreamed about since I was a kid.

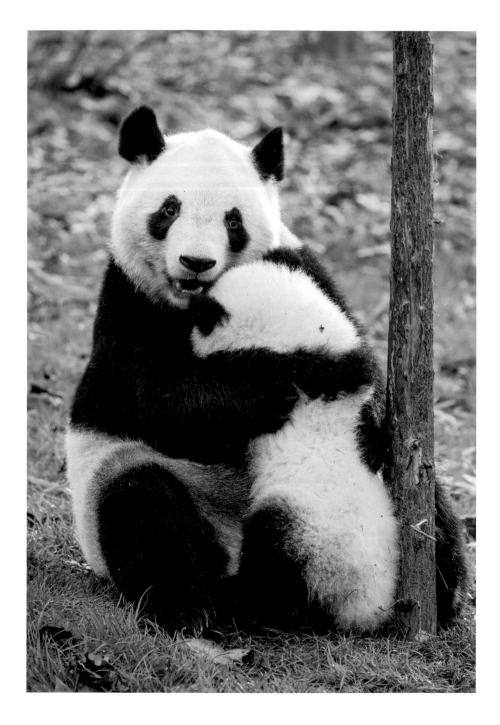

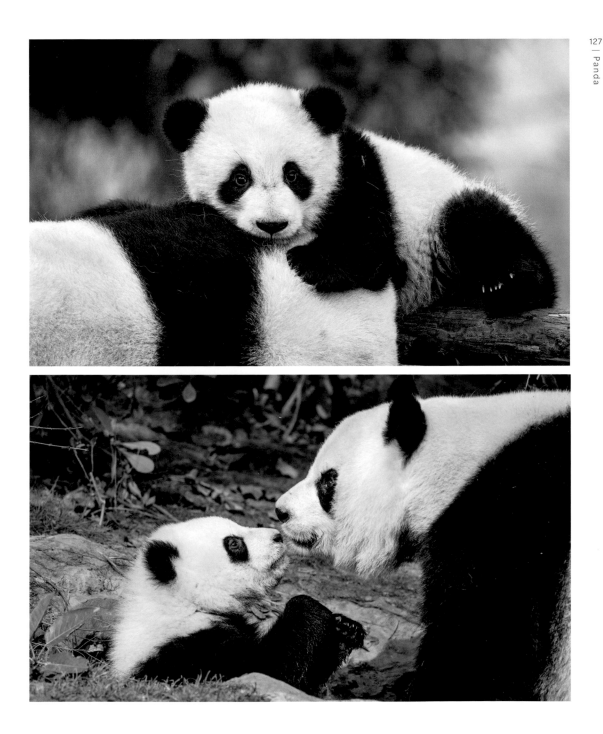

Giant pandas are born pink with sparse white hairs. At 8 months old, this one has her full adult coloring with black ears, eyes, shoulders, and legs. But she's still far from her adult size. She'll grow to be about six times as large, up to 300 pounds. I photographed her at the Bifengxia Base of China Conservation and Research Center for the Giant Panda, which breeds pandas, among other conservation programs. I'm grateful for any initiative that helps keep pandas in our world, and I am hopeful that some of the cubs will grow up to be successfully introduced to the wild.

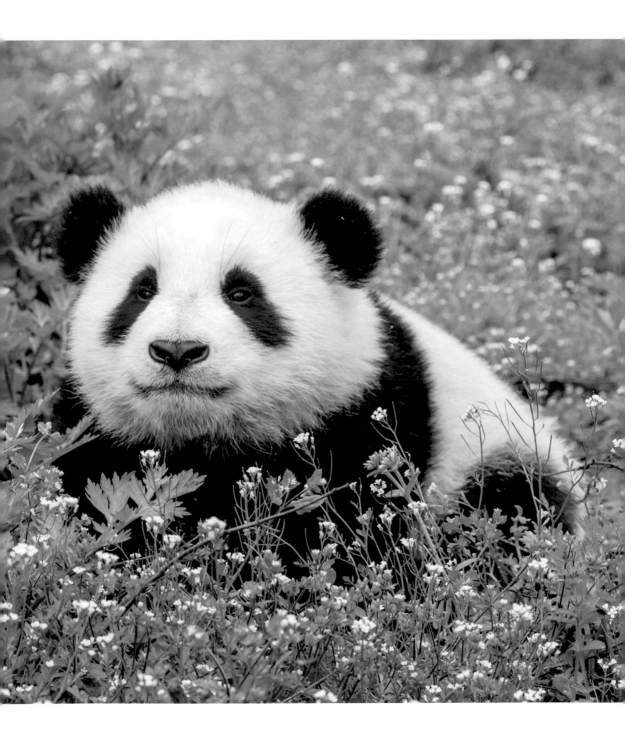

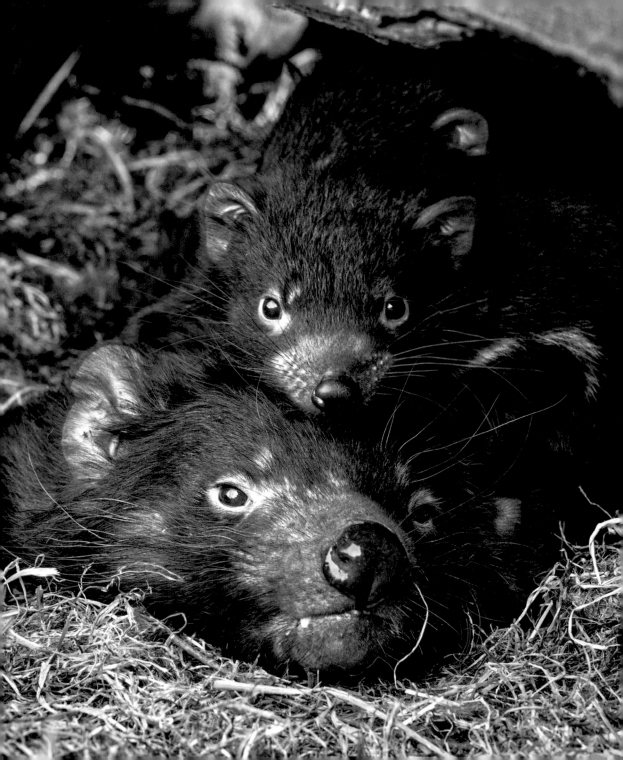

Tasmanian Devil

If you've ever heard a Tasmanian devil's blood-curdling shriek, you'll know where they got their name. They're also the world's largest carnivorous marsupial. This joey is 7 months old and part of a litter of four who were all snuggled together with mom. I found him and mom to be particularly photogenic. They live at the Trowunna Wildlife Sanctuary in Tasmania, which, in the 1990s, was a leader in re-establishing Tassie devils after their population was decimated by an infectious disease. I was really inspired by the effort, which continues today at Trowunna and throughout all of Australia, to save this fascinating species.

Mountain Lion

Photographing Nicole, a mountain lion at the Sonoma County Wildlife Rescue, was heartwarming. Nicole lives in captivity, but in this case, it's the right situation for her. Hikers found her sick and abandoned at just 8 weeks old. The rescue nursed her back to health. Without a mom to teach her life skills, though, Nicole wouldn't have survived back in the wild. She lives at the rescue as an education ambassador animal, where she is loved and adored by the staff and volunteers. Nicole is 3 months old in this photo. Her newborn blue eyes changed to golden brown a couple months later.

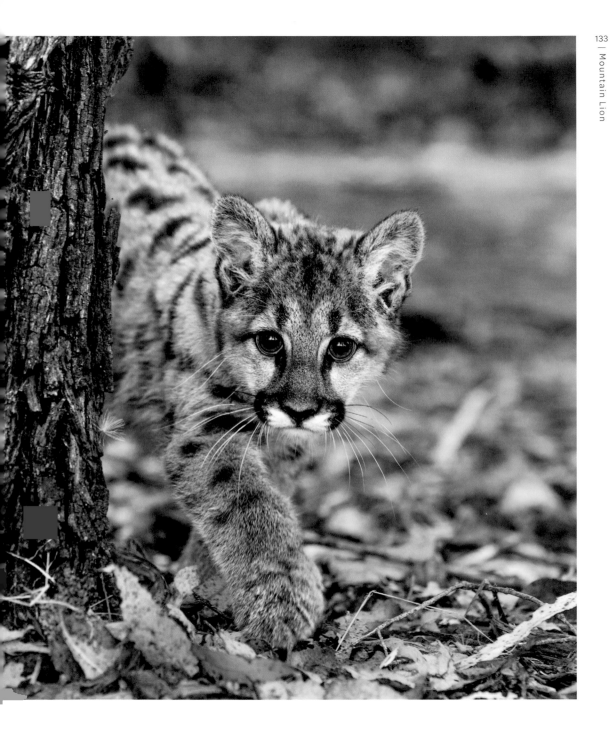

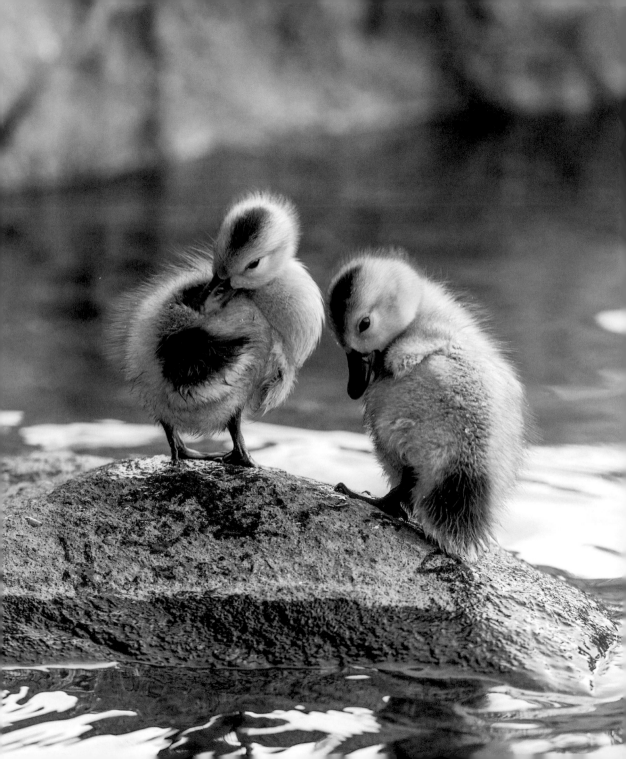

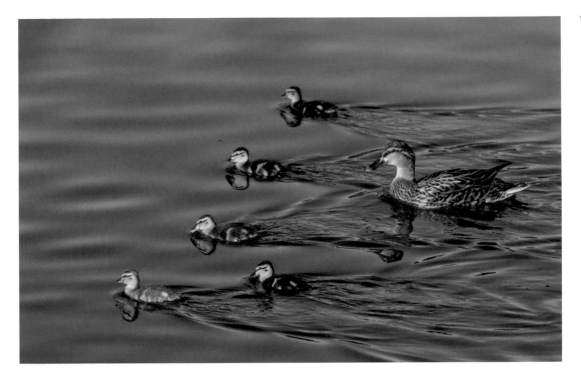

Mallard Duck

(Right) I love ducks because they are so accessible—an aquatic bird that most North Americans can easily observe close to home. And because ducklings are fuzz balls (the technical term is "born with downy plumage"). Newborns are fully capable of swimming from the moment they hatch. The swimmers in this photo are a week old. I photographed them at Howarth Park in Santa Rosa, California. They'd already heavily imprinted on mom and followed her everywhere. Having all her ducks in a row is how mom protects them, keeps them warm, and teaches them where to forage for food.

Raccoon

People are surprised to learn I did a major project starring raccoons. The opinion seems to be that wildlife found in the backyard isn't compelling enough to photograph. I disagree. Raccoons are intelligent and spirited, and even affectionate. In addition to suckling, moms snuggle and groom their babies, which are called kits. I worked with a Bay Area organization called WildCare, who rescued this trio from a nest inside the walls of a home after a pet removal service took mom. The kits are 3 months old here, and just learning how to climb trees. In another month, they will be returned to the wild.

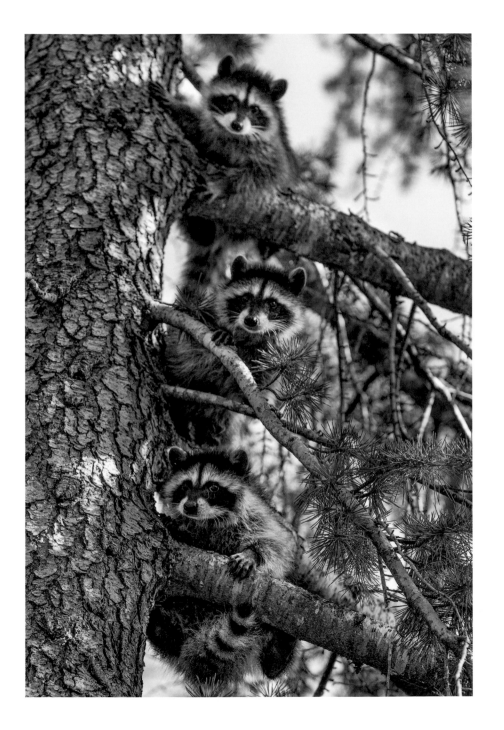

Tiger

This was one of the most epic projects of my career. Being able to work with a wild tiger den is like the holy grail of big cat photography. There are only a handful of people on this earth who have had the privilege and I'm so grateful to be one of them. This is mom with two of her four cubs, just outside the natal den— the place where she gave birth—in Bandhavgarh National Park in India. The cubs are 4 weeks old here. It takes a very relaxed tigress to allow a human so close to her den. Mom was already habituated due to conservation tourism, which made my work easier.

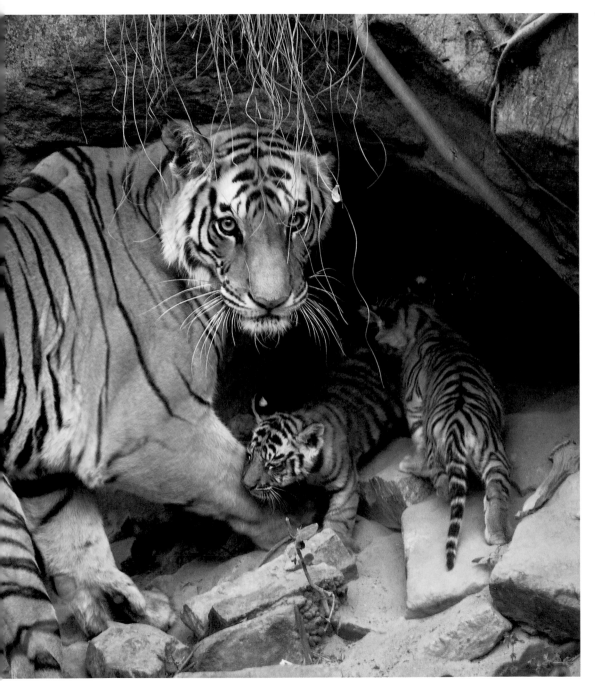

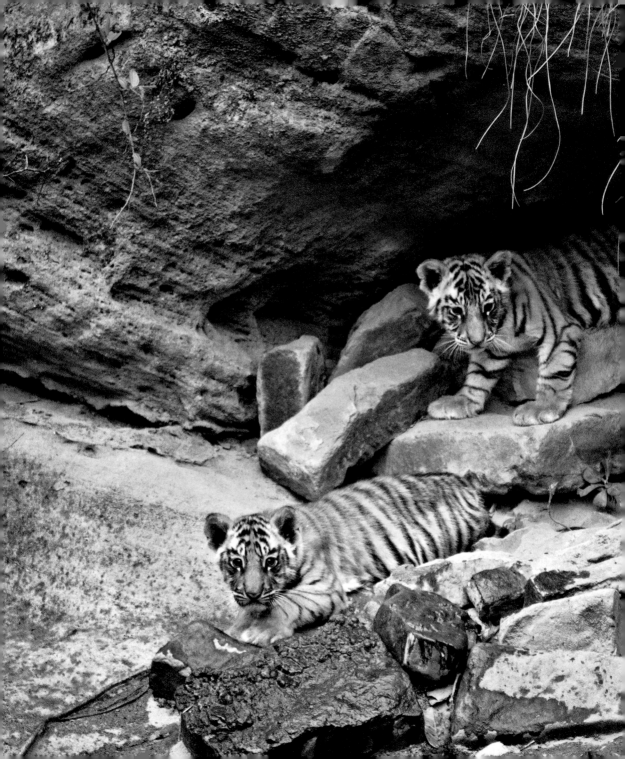

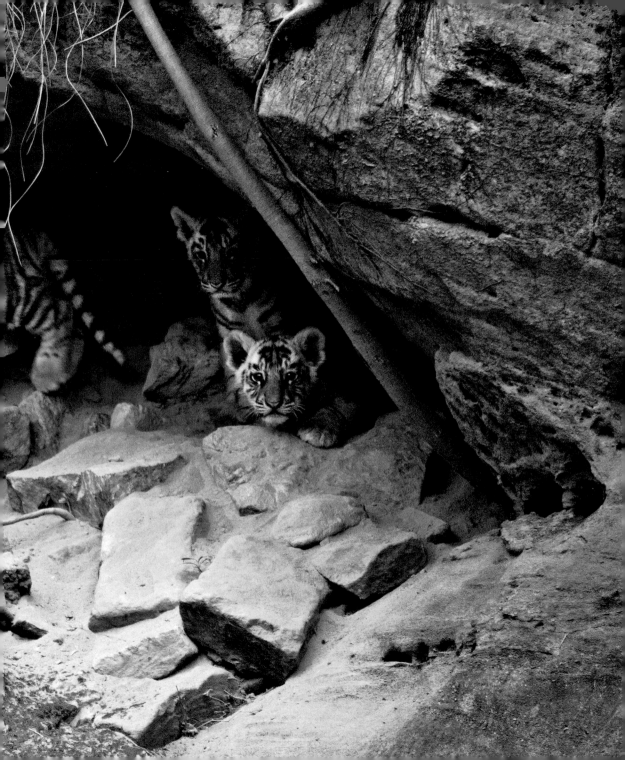

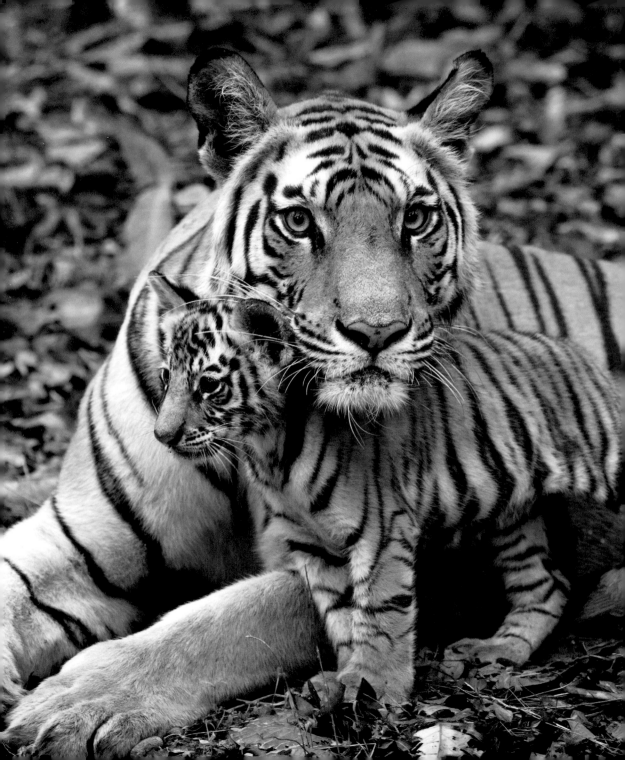

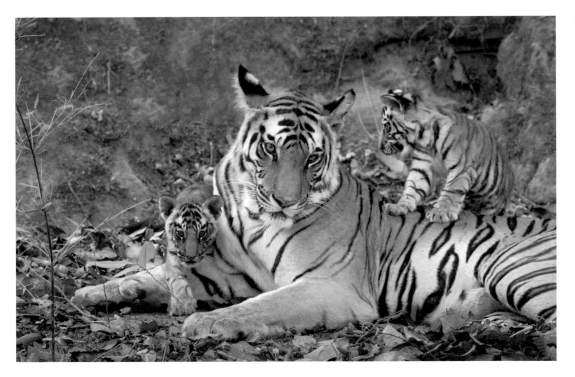

My biggest challenge in India was getting the cubs to accept my presence. Whereas mom was very relaxed around people, her cubs had never seen a human. It took about a week for them to get used to me.

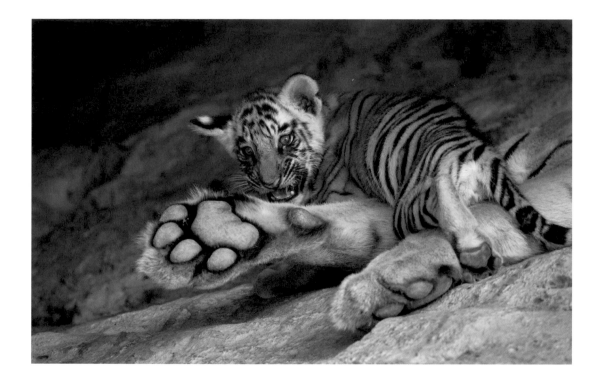

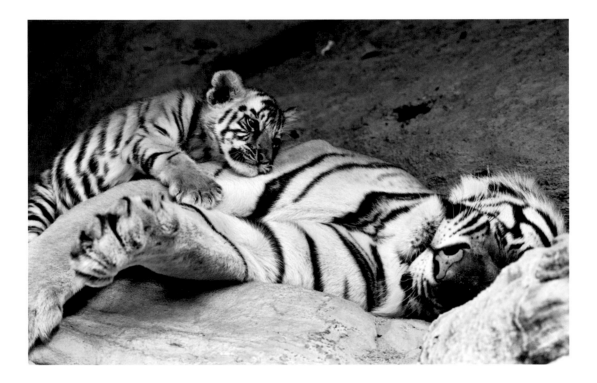

(Right) The cubs are 7 weeks old here and going on an adventure. Mom had killed a sambar deer and was bringing the cubs to it, for what was likely their first taste of meat. In a couple months, she would begin teaching them to hunt. Being solitary animals without the support of a pack, the cubs must master the skill to survive.

(Pages 148–149) Here, the cubs are 8 weeks old and piled up on mom suckling. Tigers typically give birth to three or four cubs; any more is extremely rare. The cubs will stay with mom until they are about 2 years old, at which point she'll make it clear that it's time for them to claim their independence, even if she must aggressively chase them off. My favorite element of this photo is how well you can see all of their stripes. Tigers have striped skin, not just striped fur. And their stripes are like fingerprints; no two tigers have the same pattern.

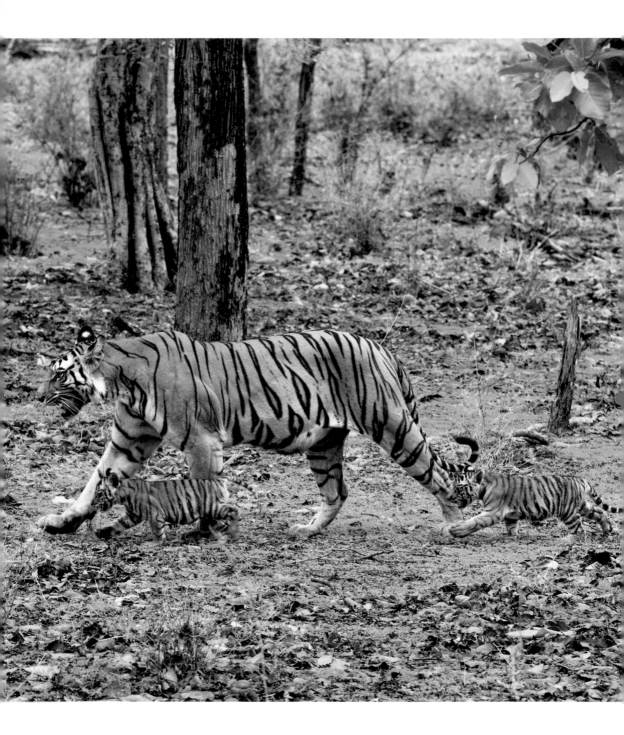

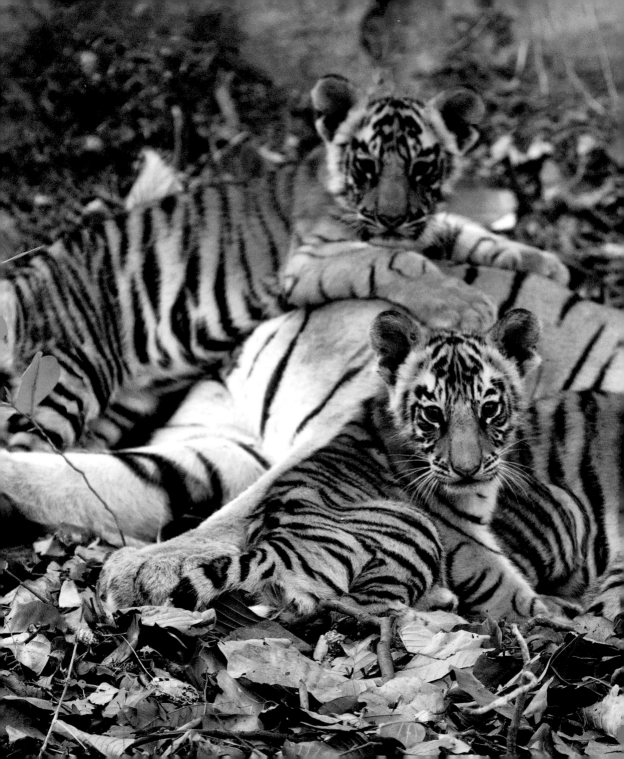

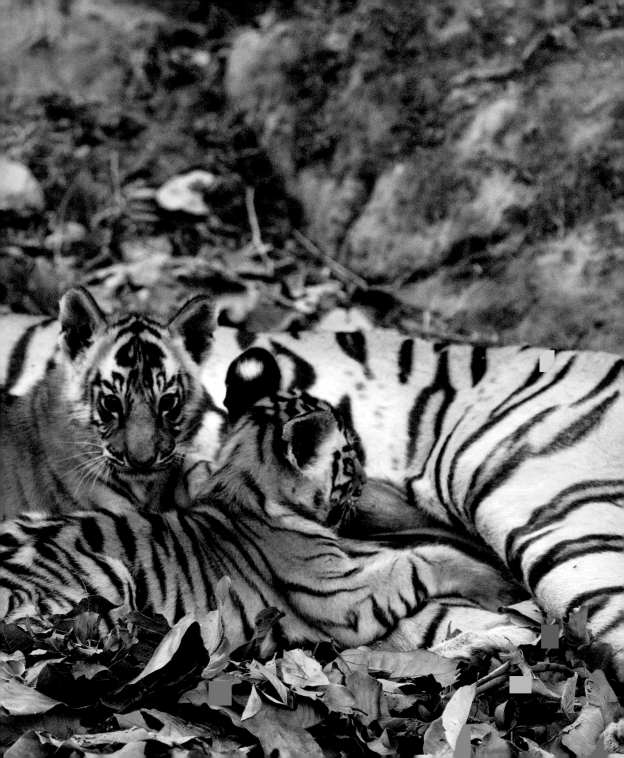

(Top) The last two photos in this chapter show tiger cubs practicing life skills. It looks fun, but it's serious business. Tigers are already endangered, with just 3,900 left in the wild, and these cubs have a lot to look out for—habitat loss, poaching for Chinese medicine, and attacks by other tigers over territory. Only 50 percent of tiger cubs make it to adulthood. This 8-month-old cub is carrying a stick exactly the same way she will need to grab the neck of a deer while hunting.

(Bottom) At nearly 2 years of age, these cubs are almost fully grown and on the cusp of independence. They are not only play-fighting, but also keeping cool in the water hole.

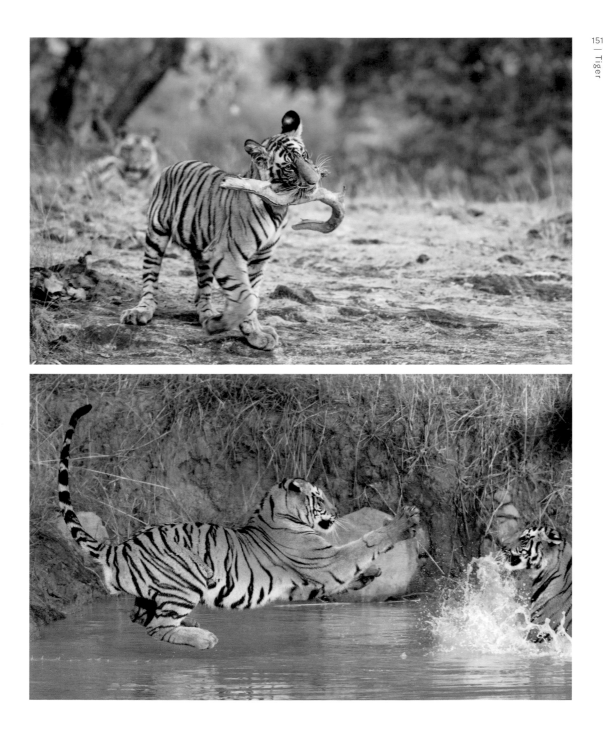

Polar &
Ocean

Polar Bear

After hibernation, polar bear moms spend about a week at the mouth of the den with the cubs to let them acclimatize to the outside world before the family departs to hunt seals. To find active dens in this narrow timeframe, I traveled to Canada's Wapusk National Park and worked with First Nations trackers who have managed decades of peaceful viewing interactions for ecotourists. The cubs in this photo are fresh out of the den, literally seeing the world for the first time. They seemed warm and content. Meanwhile, my fingers froze and I could barely hit my shutter button.

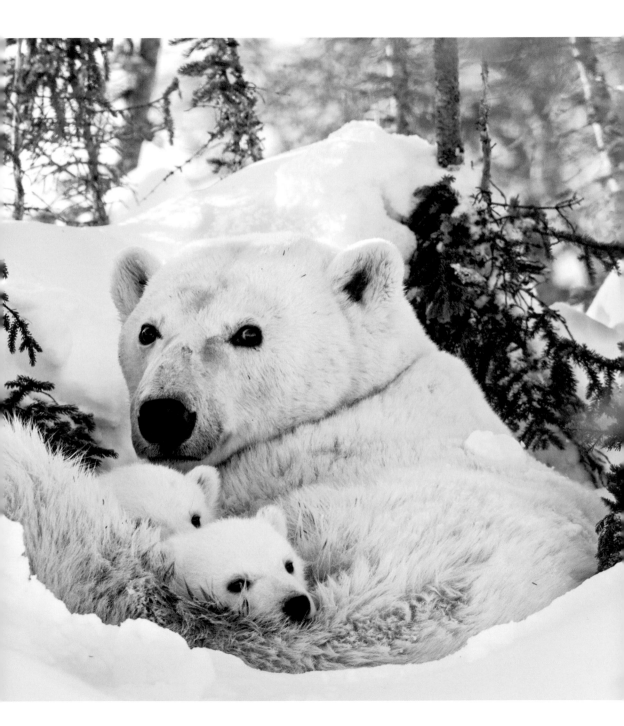

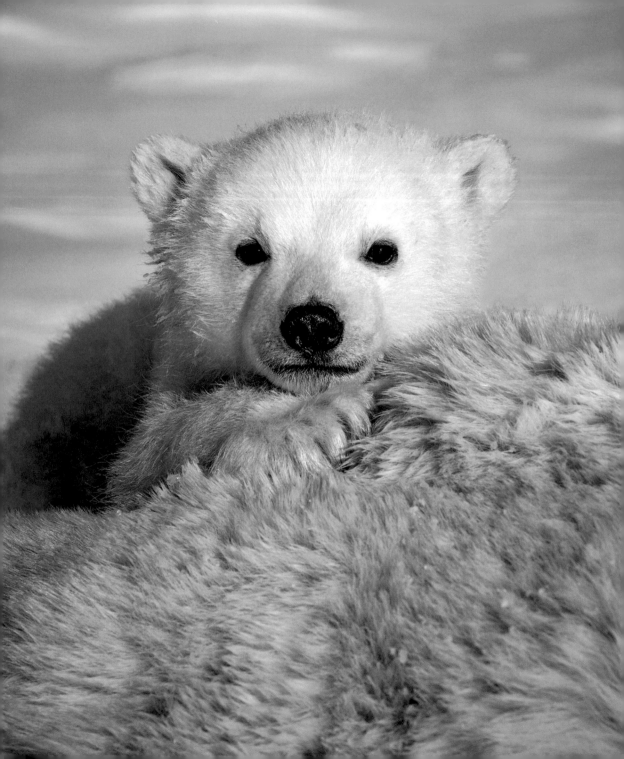

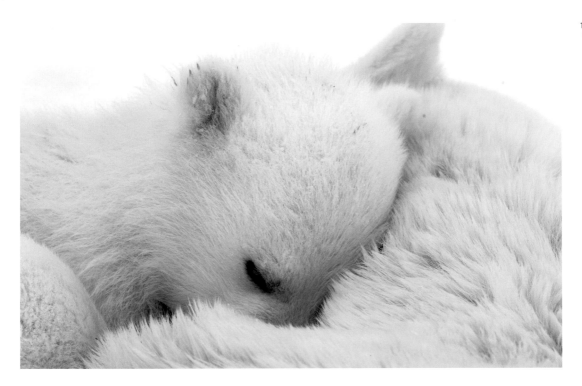

Also in Wapusk National Park, I shadowed a scientist collect-
ing data on the effect of climate change on polar bears. He
had tranquilized mom to safely weigh her and take blood, hair,
and fat samples. Her precious cub interpreted it as nap time.
Cub climbed atop mom and was soon fast asleep. When they
awoke, we'd be gone and armed with another data point link-
ing climate change—which melts the sea ice that polar bears
need to hunt seals—with the polar bear population decline.
The research enables conservation organizations like Polar
Bears International to educate people and rally support.

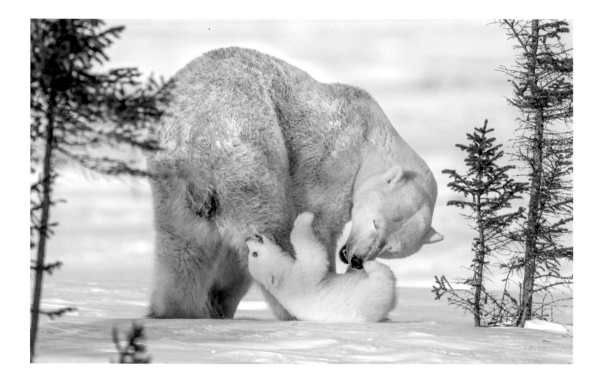

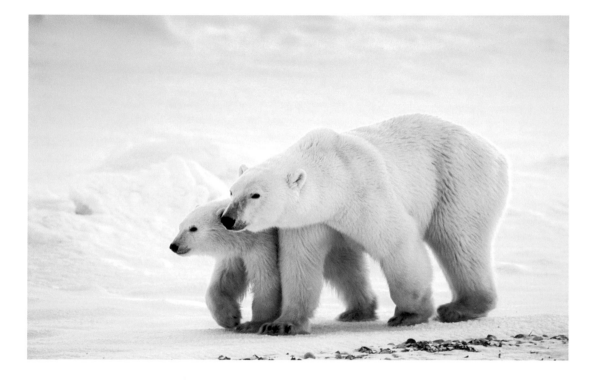

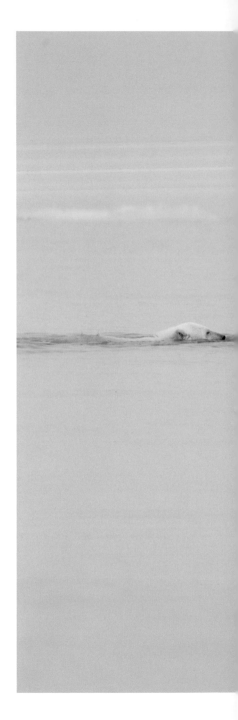

I encountered this trio in Svalbard, from aboard a Zodiac boat while leading an Arctic photo tour. The cubs are about 7 months old and swimming with mom between sections of sea ice. Imagine mom's hind legs underwater, just floating back behind her. Cub No. 1 is resting on mom's hind legs and Cub No. 2 is resting on Cub No. 1's hind legs. We could see their linkage clearly from the Zodiac; they looked like a little swimming train. Cubs are naturally strong swimmers, but they don't yet have the same endurance as mom. It was a clever way for them to take a break.

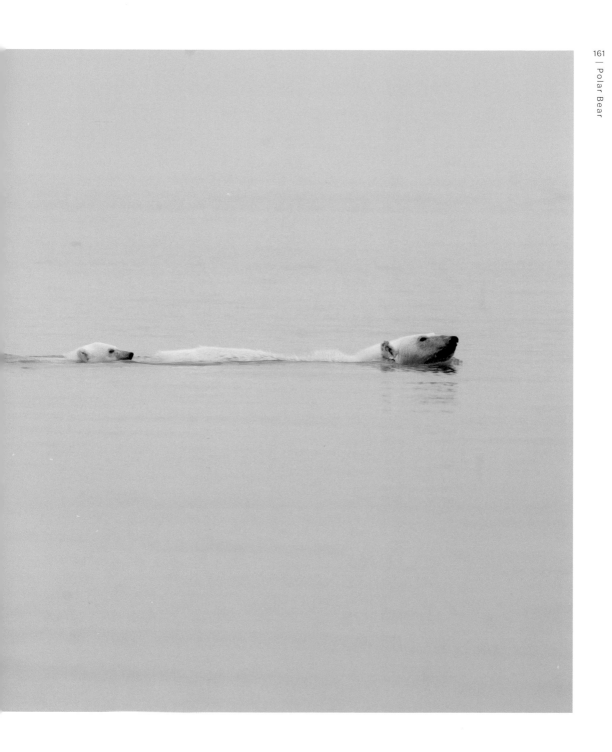

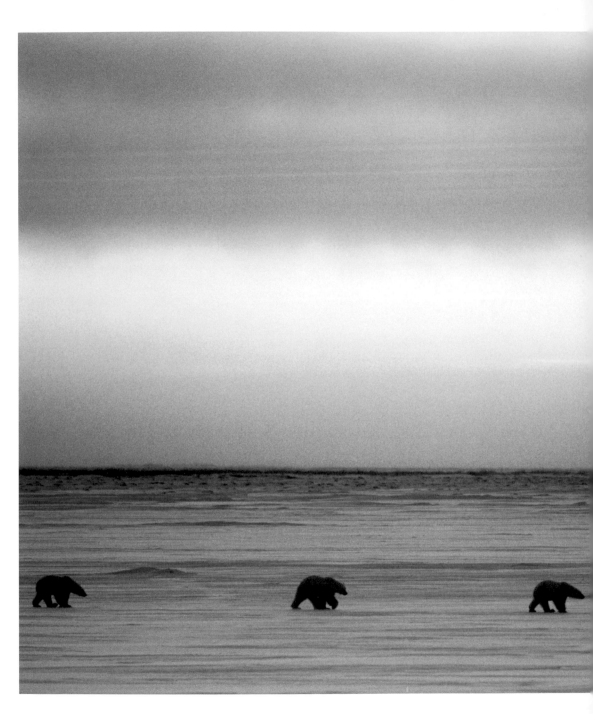

Polar bear cubs spend the first 2.5 to 3 years of their lives dependent on mom. Here, 2-year-old triplets follow mom across the tundra in Wapusk National Park toward the sea ice to hunt. She's an incredible mom to have raised healthy triplets—three mouths are a lot to feed in the era of melting sea ice. Only 43 percent of polar bear cubs survive their first year, down from 65 percent in the 1980s and 1990s. Watching this successful family strut beneath the sublime light of the Arctic sunset, I felt much hope.

Albatross

On uninhabited Steeple Jason Island in the Falkland Islands, I encountered the largest colony of black-browed albatrosses in the world. Albatrosses live exclusively at sea, except when raising chicks. This one is 1 to 2 weeks old, cozied up in its nest of mud and grass. Albatrosses have the longest wingspan of any bird species and can live more than 70 years. They evoke more lore than any other bird I know. From Samuel Taylor Coleridge's classic poem "The Rime of the Ancient Mariner" to sailors' belief that albatrosses carry the souls of dead mariners, they inspire superstition and awe.

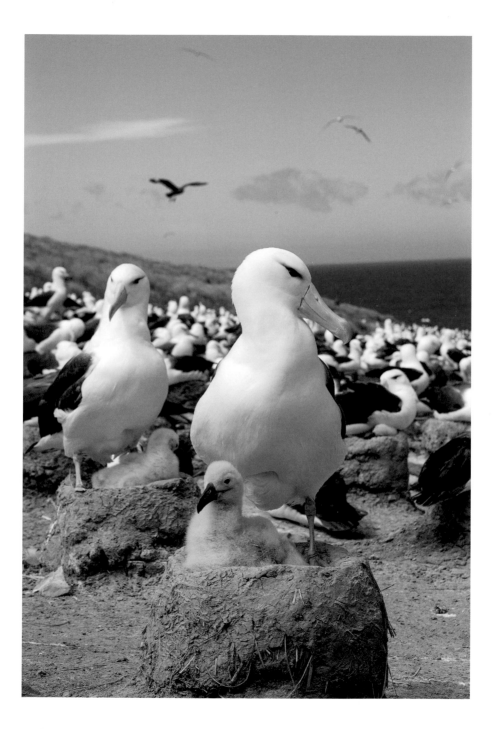

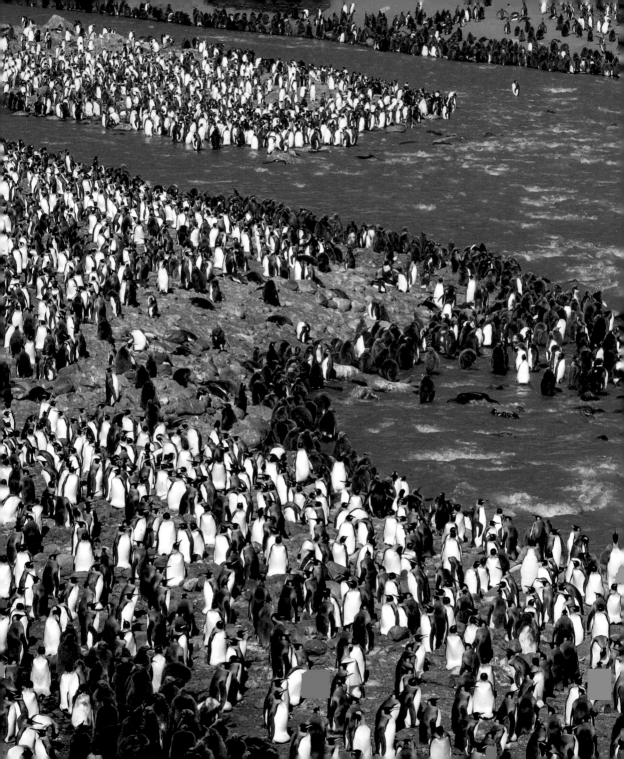

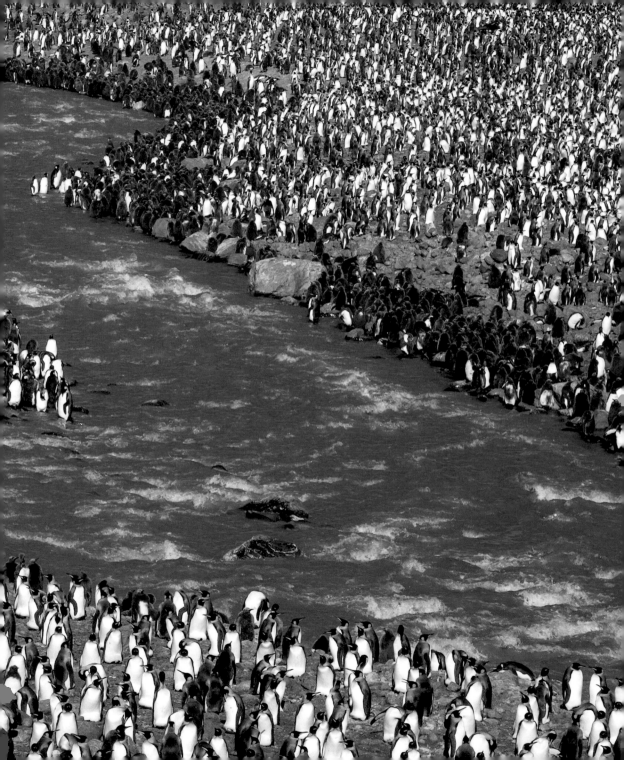

Penguin

(Pages 166–167) The king penguin colony at St. Andrews Bay on South Georgia Island is one of the few places on earth where the animals don't have an innate fear of humans, which is so innocent and endearing. But with more than 300,000 breeding pairs of king penguins, not counting their fuzzy brown chicks, it's also overwhelming. I remember being gobsmacked when I arrived—it felt like I'd landed on another planet. Penguins and chicks dawdled straight toward me, intent on pecking my camera if I'd let them. The noise was deafening (parents identify their chicks by voice). Only after I'd desensitized was I able to start composing photos.

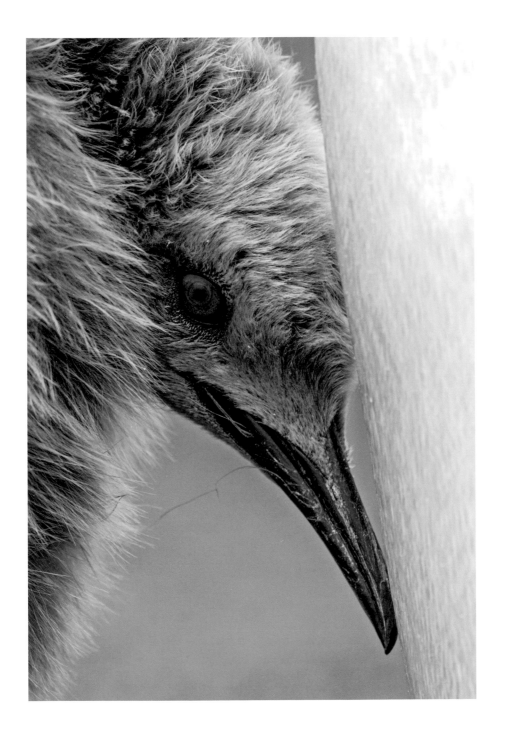

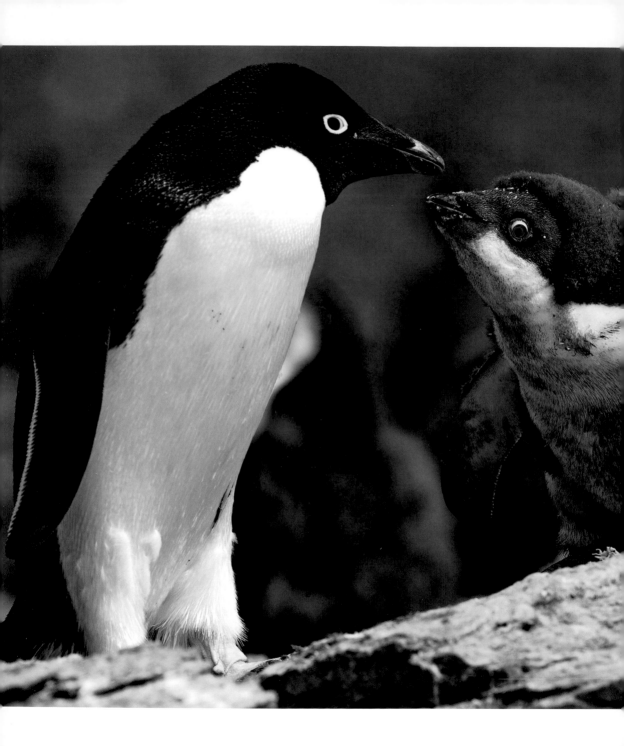

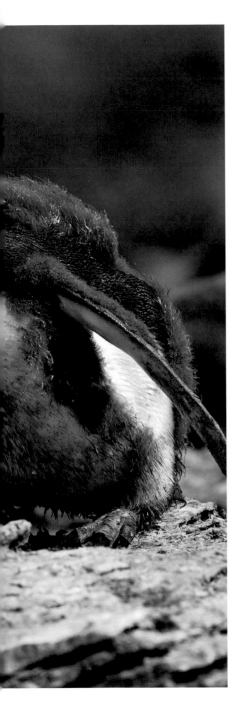

Unlike most penguins, Adélies live exclusively in Antarctica and are one of only two species of penguins who breed there. They are also the littlest species of penguin in Antarctica. I think the chicks look hilariously unkempt when they molt. They lose the downy plumage they're born with in chunks, eventually morphing into the sleek tuxedo of adulthood.

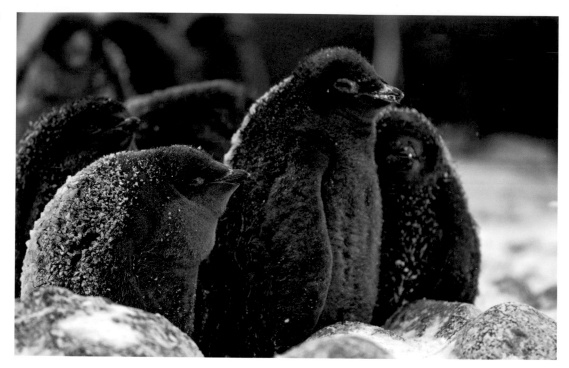

All the Adélie chicks I photographed were in the second stage of parental care—old enough to be outside the nest, but still dependent on mom and dad for food. During this time, they hang out with other youngsters in groups called creches, like teens in matching fleece.

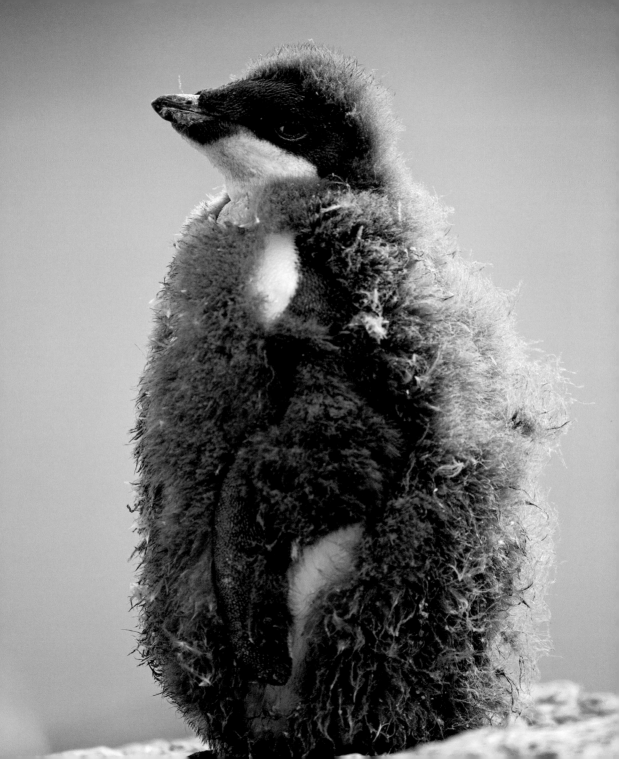

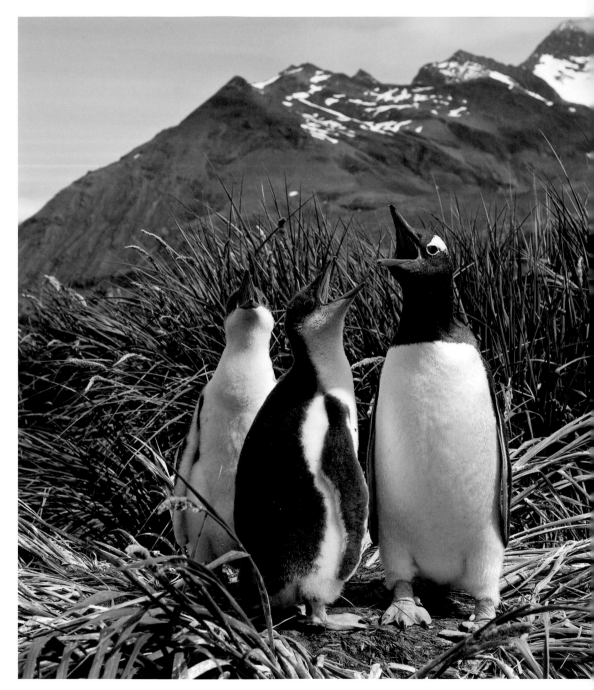

Flamboyant gentoo penguins have red-orange beaks and peach feet. I photographed them on South Georgia Island, in a small bay called Gold Harbor. Gentoos are closely related to Adélies but are considered a climate change winner because they don't like pack ice and are actually expanding their range now that it's melting.

This chick is enjoying a fish breakfast regurgitated by mom (or dad). The chick will grow up to be an amazing diver like her parents, able to reduce her heart rate from 100 beats per minute down to 20 to use oxygen more efficiently and stay under water longer.

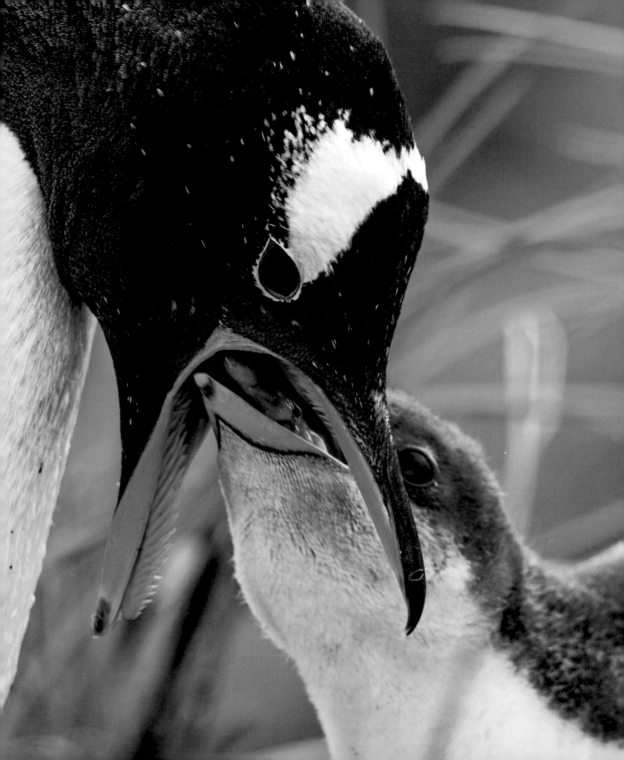

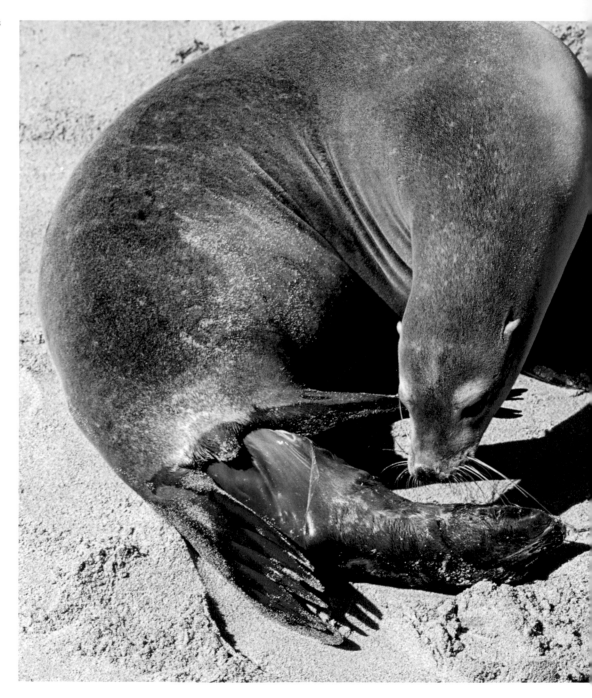

Sea Lion

Rarely do I get to photograph births in the wild. Most animals do it privately, while in hiding. Not California sea lions. I was delighted to be granted special access to a breeding colony on San Miguel Island in Channel Islands National Park, along with a team of researchers, to observe. In the photo, mom is already memorizing her pup's scent as she's birthing him. In a colony of 80,000 sea lions that all look the same, smell and sound is how they will reunite when mom goes out to sea to hunt. It's charming the way moms constantly nose their newborns.

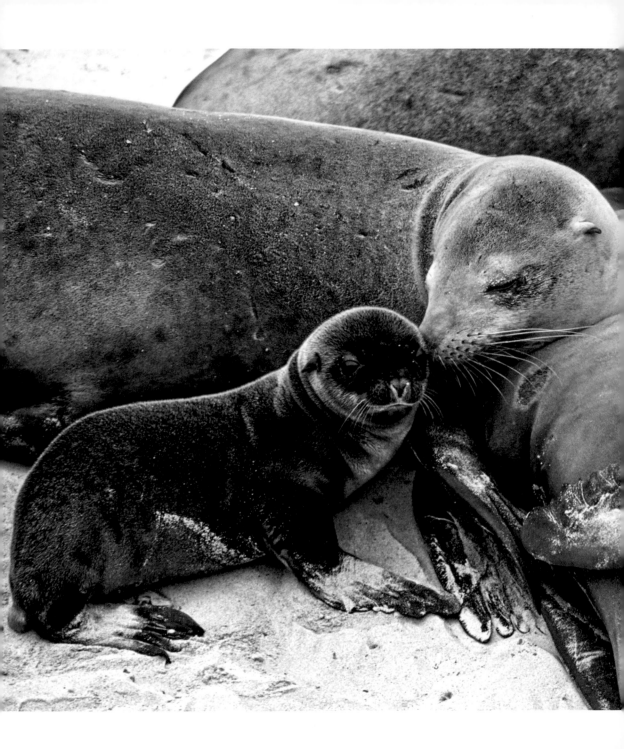

Sea Otter

When it comes to cute baby animals, it's hard to top otter pups, as demonstrated by this little guy in Monterey Bay, California. His natal coat is warm, fluffy, and buoyant. While mom dives for food, he just floats there on the surface like a cork. When mom is ready to forage elsewhere, she puts the pup on her belly and paddles him over. Pup spends the majority of his day sleeping on mom's belly wrapped in her arms, or getting groomed. To help keep pup well insulated, mom licks the water off his fur and blows air into it.

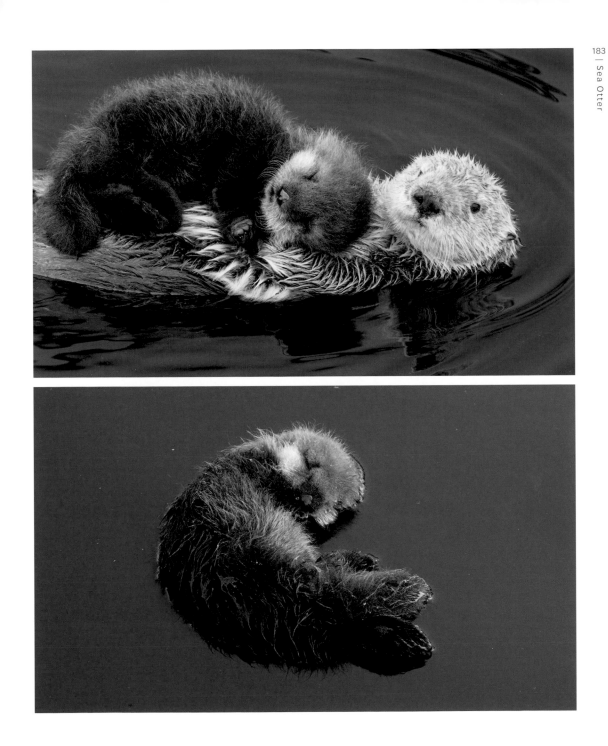

My photos are all of southern sea otters, the subspecies that lives along the central California coastline. They're also known as California sea otters, and survived near extinction from the fur trade in the early 1900s thanks to the efforts of local conservationists in Big Sur. The way the story goes, locals kept a colony of 50 surviving sea otters secret. That single colony repopulated 200 miles of California coastline. Sea otters are thankfully protected today, but still endangered due to new challenges like overfishing, oil spills, and an increase in shark attacks. They're an indicator species for the health of our marine ecosystem, which means what's good for sea otters is good for all of us.

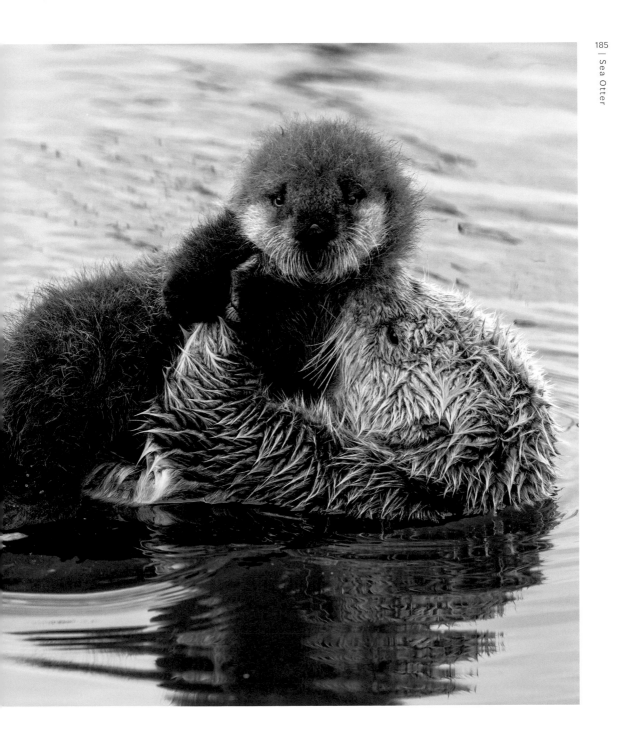

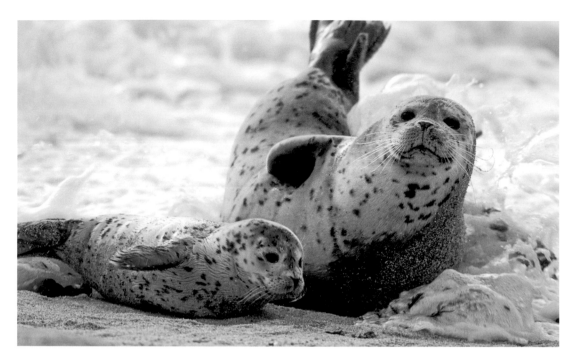

Seal

Harbor seals and their pups hold a special place in my heart. In college in my early 20s in Santa Cruz, California, they helped me become a professional wildlife photographer. I spent four seasons with them. Harbor seals are not habituated to humans, and are quite shy. I practiced stealth photography using blinds and hides, like covering myself with a camouflaging cloth on the rocks during low tide. The intimate moments between moms and pups that I witnessed—from frolicking in the sea foam, to piggybacking in the water, to nursing on the rocks—are not only among my favorite photos, but were also important learning moments in my career.

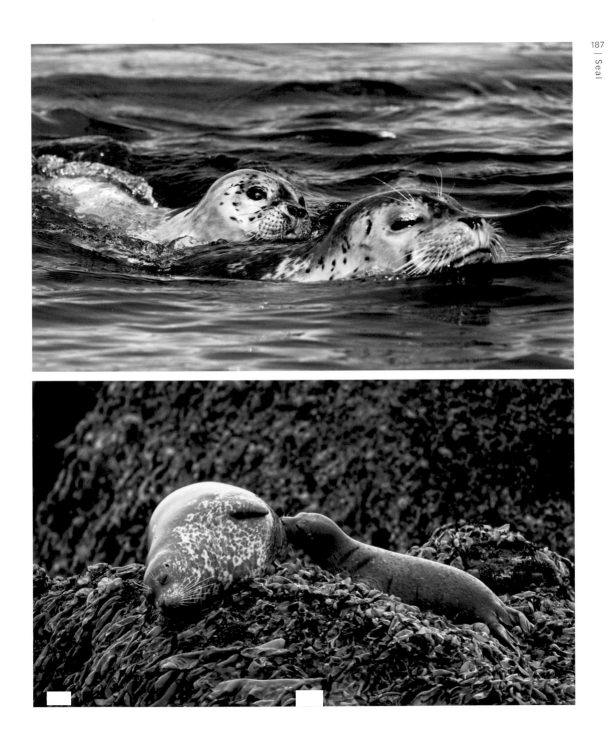

Dolphin

Long-beaked common dolphins are so friendly and energetic that they'll often follow alongside your boat, leaping and somersaulting, or dance behind in the boat's wake. It was the former during this photography tour I co-led in the aquamarine waters of Baja California. The calf is just 2 weeks old, but she's not a prodigy—all dolphins are born with the ability to swim and leap. In the pod, she'll stick to mom's side for about the first 18 months while she's nursing. Baby dolphins are called calves, female dolphins are called cows, and males are called bulls.

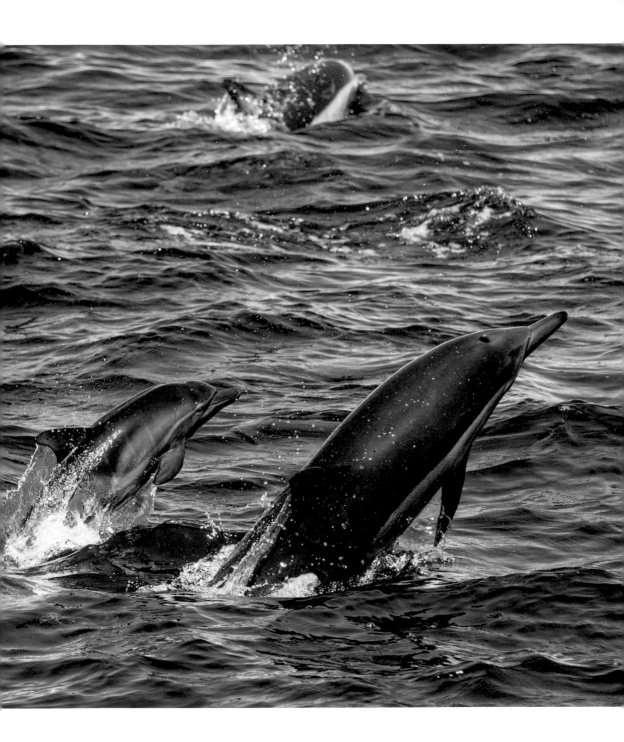

Orca

In Alaska's Prince William Sound, a 4-month-old orca calf surfaces beside mom. Calves need to come up for air more frequently than the rest of the pod. Adults can hold their breath for up to 15 minutes, but a newborn can last just 30 seconds. I had the opportunity to photograph these magnificent mammals while aboard a boat working with an orca researcher. I learned that orcas don't completely lose consciousness when they sleep. Half of their brain goes to sleep while the other half stays awake to swim and breathe. You know which side of the brain is awake because the eye on the opposite side will be open.

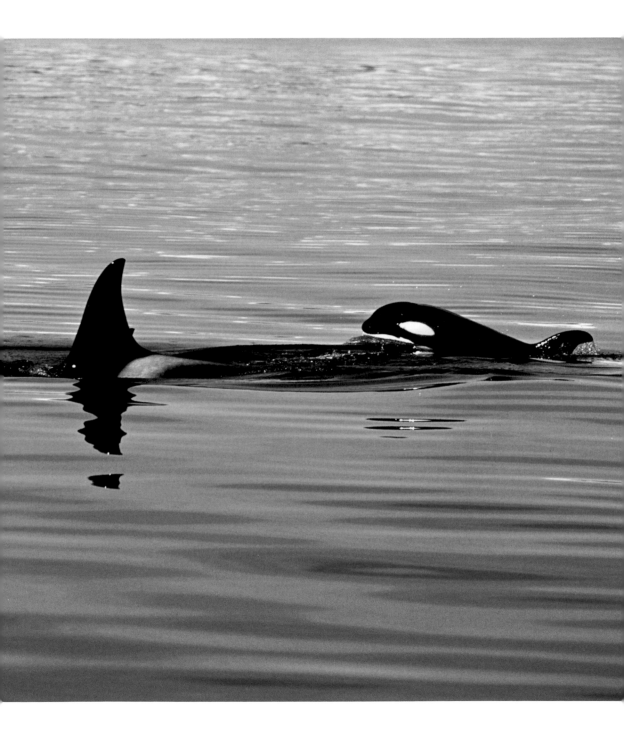

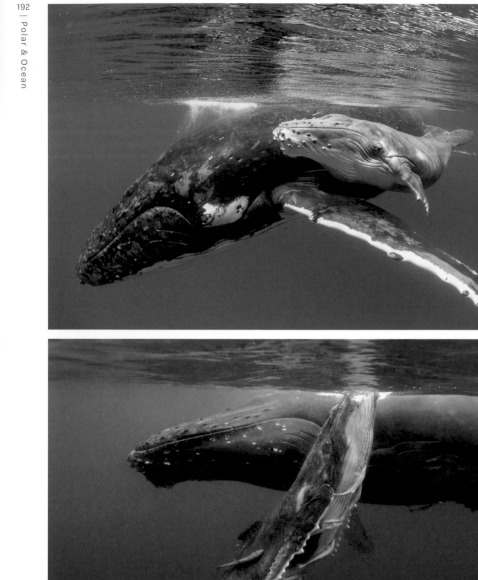

Humpback Whale

(Top) I lead humpback whale photo tours in the island nation of Tonga in the South Pacific Ocean. It is hard to put into words how it feels to swim with an intelligent 40-ton mammal and its newborn. Being in the water with something so large and strong, and yet so friendly, is truly a spiritual experience. Humans had almost hunted these gentle giants to extinction when a world-wide moratorium on whaling was finally passed in 1982. The fact that we humans did that to them and yet we are still able to have these beautiful experiences together feels like we have been forgiven. It's astounding. The calf is just 5 days old in this photo, about 10 to 15 feet long. Newborn humpbacks are born grey and smooth with no scratches yet from mom's barnacles.

(Bottom) Mom is hanging out with her calf in a sheltered cove, which is safe from danger like killer whales. A new study shows that when traveling in the open ocean between safe spots, mom and calf whisper to each other to avoid detection.

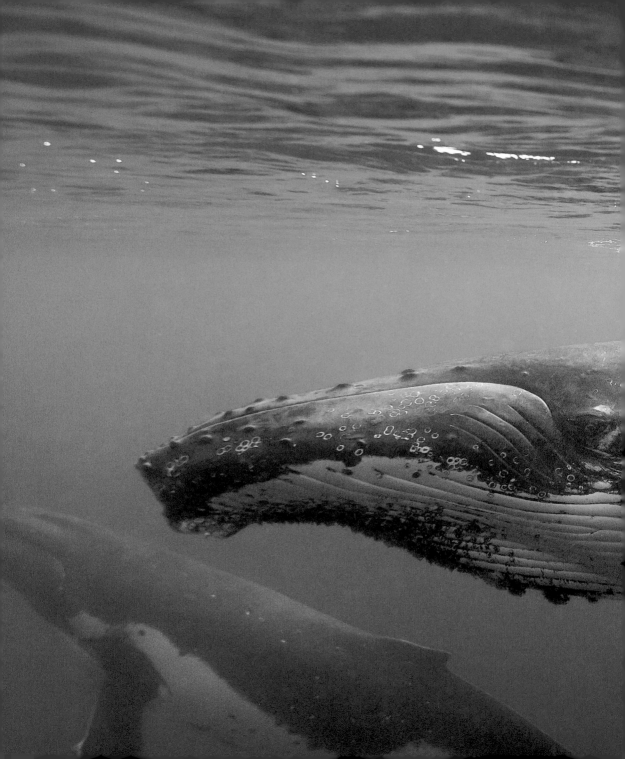

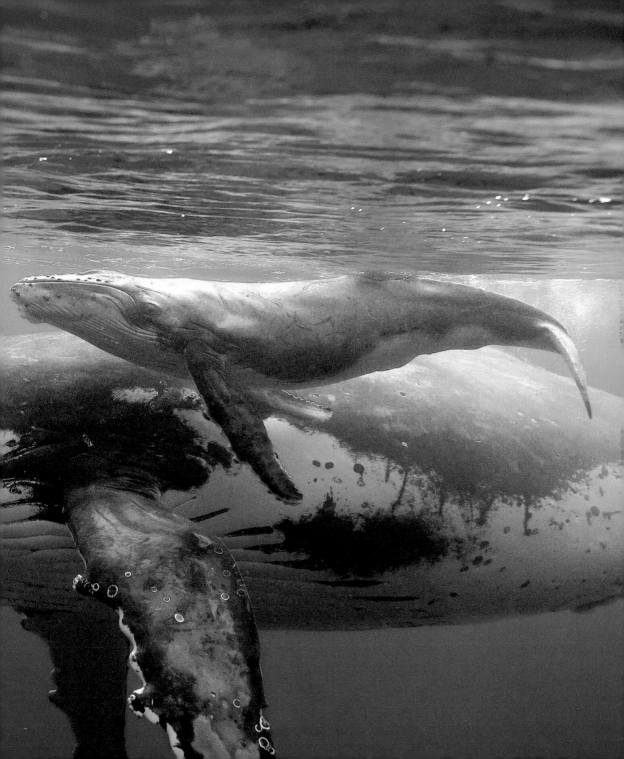

(Pages 194–195) The humpback in the background is an escort, an adult in the pod who helps mom fend off predators and pesky male humpbacks. An escort can be male or female. Sometimes it's the calf's grandmother, which is darling.

(Right) Here the calf is blowing bubbles while mom sleeps. Like orcas, humpbacks remain half-conscious while sleeping, resting one side of their brain at a time.

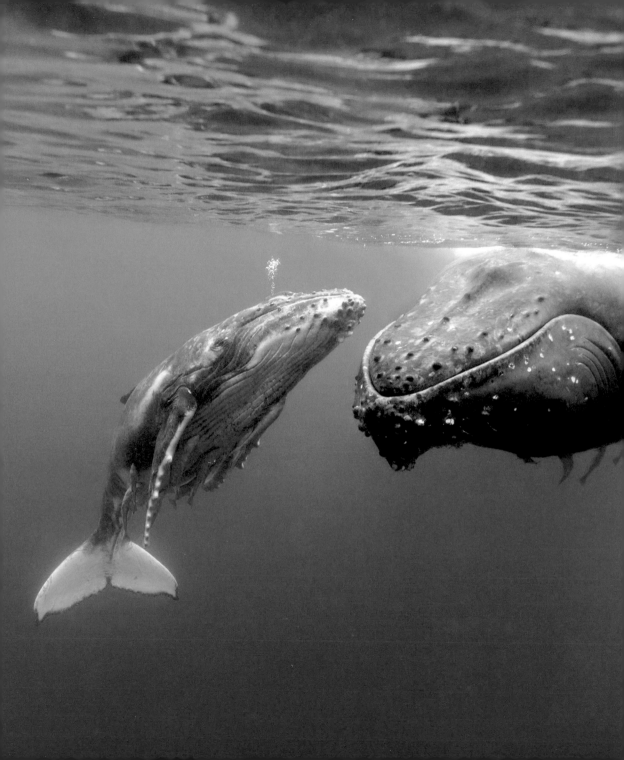

Savanna & Grassland

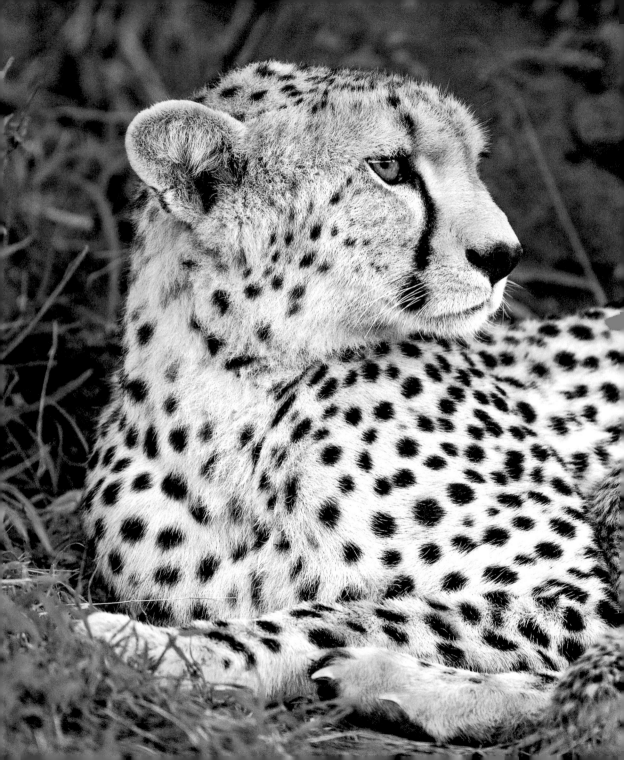

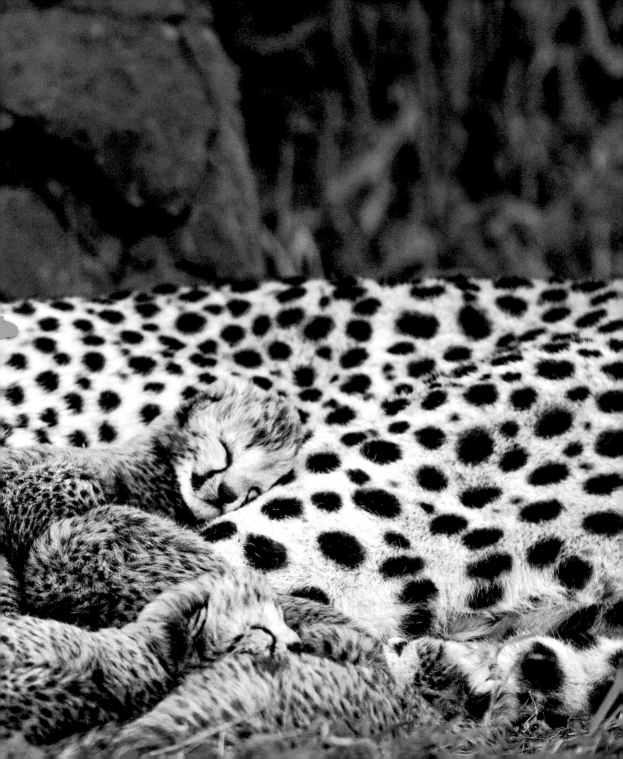

Cheetah

Cheetahs have always captivated me. My first big dream as a wildlife photographer was to work with a cheetah family, so I moved to Kenya and lived in a bush camp in the Maasai Mara National Reserve for three years. There are now only 7,000 cheetahs left in all of Africa, and seeing newborns is extremely rare because moms keep them so well hidden. These photos are incredibly special to me because the cubs were just 5 days old. I'd spent weeks tracking mom while she was pregnant in hopes of sharing this very moment.

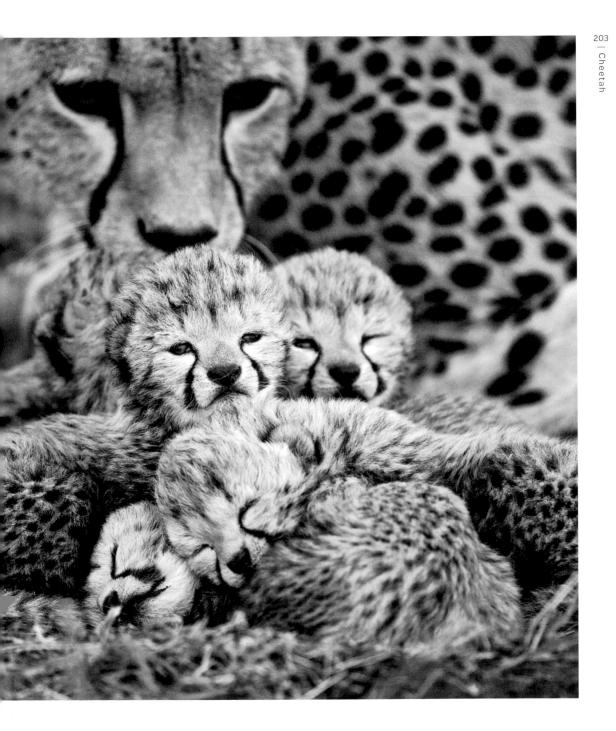

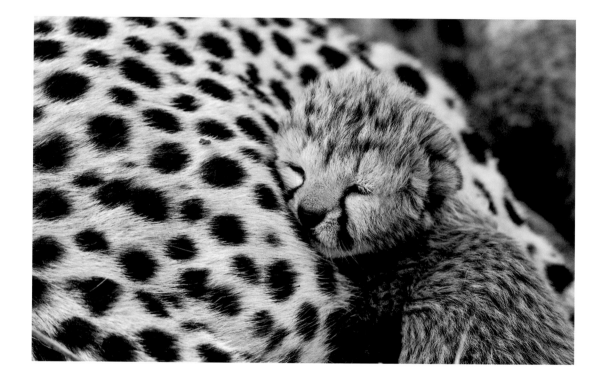

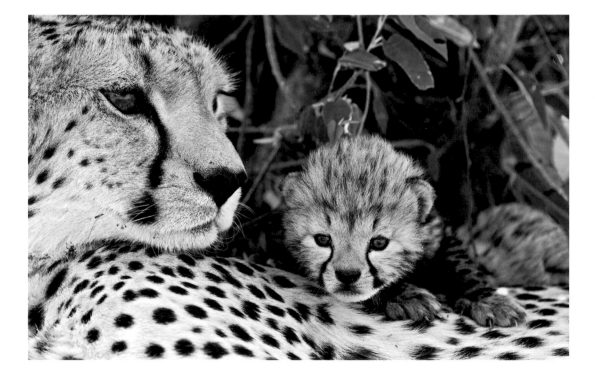

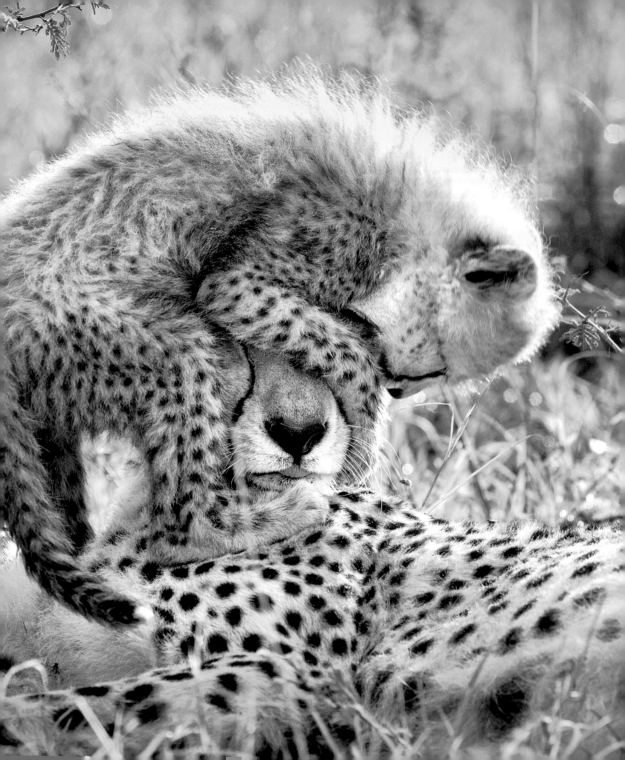

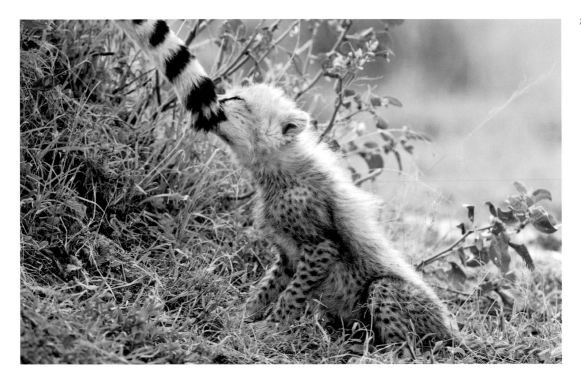

(Left) This is a different cheetah family, with a litter of three older cubs that I got to know particularly well in my first 18 months in the Maasai Mara. Cheetah cubs are among the most playful of all mammals, which means their moms are among the most tolerant. I know from the scientists I work with that play serves an important functional purpose for youngsters. By pouncing on mom's head, this 6-week-old cub is improving her hunting skills and coordination, and building strength. But I think play is also emotional—I've seen so much joy in baby animal play.

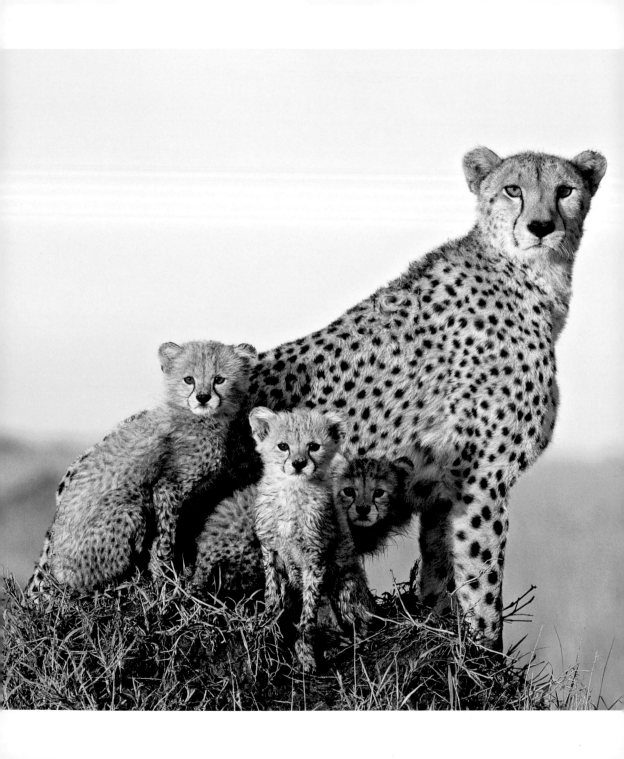

The cubs are 8 weeks old in this photo and follow mom everywhere. She's standing on a termite mound scanning the open savanna for prey, and also looking for danger in the form of lions, hyenas, and baboons. The cubs are at their most vulnerable here—away from the nest but not yet fast enough to outrun predators. Sadly, cheetah cubs have one of the highest mortality rates in the animal kingdom. Ninety-five percent don't live past 3 months because they make easy meals for predators. These cubs were fortunately quick studies: fully alert, in perfect imitation of mom.

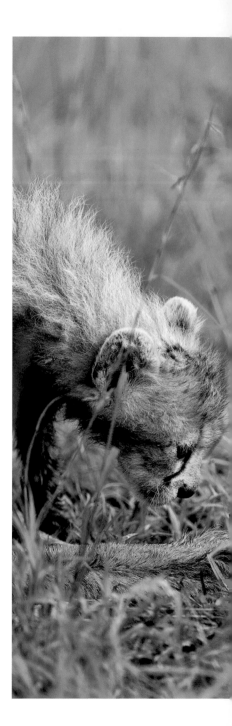

One of the best parts of following a cheetah family every day from sunup to sundown is getting to see all the firsts. Here, the cubs are 7 weeks old and tasting meat for the first time. After mom made her kill, a Thomson's gazelle, she brought the cubs out for a nibble. The cubs were strongly drawn to the meat, but quite clumsy with it. Fun fact: The fuzzy hair on the cubs' backs is called the mantle. Scientists think it's so predators will mistake them for honey badgers, which are so vicious that predators steer clear.

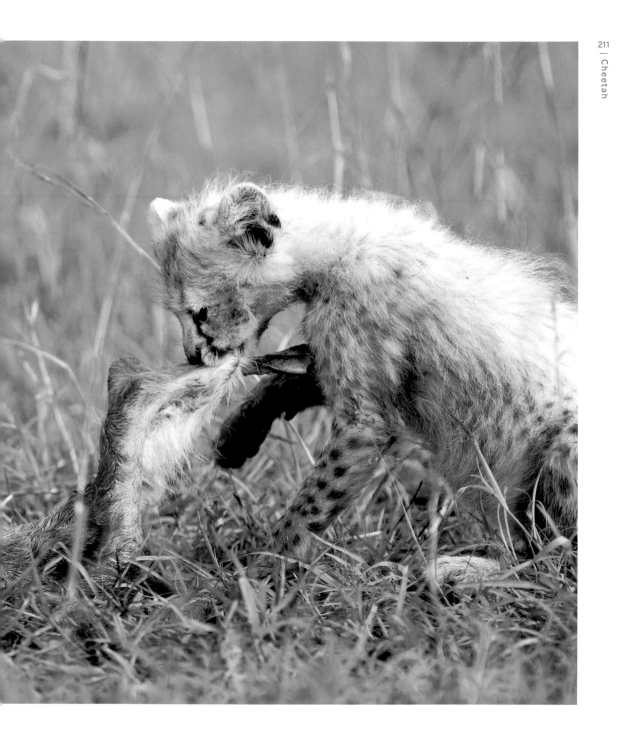

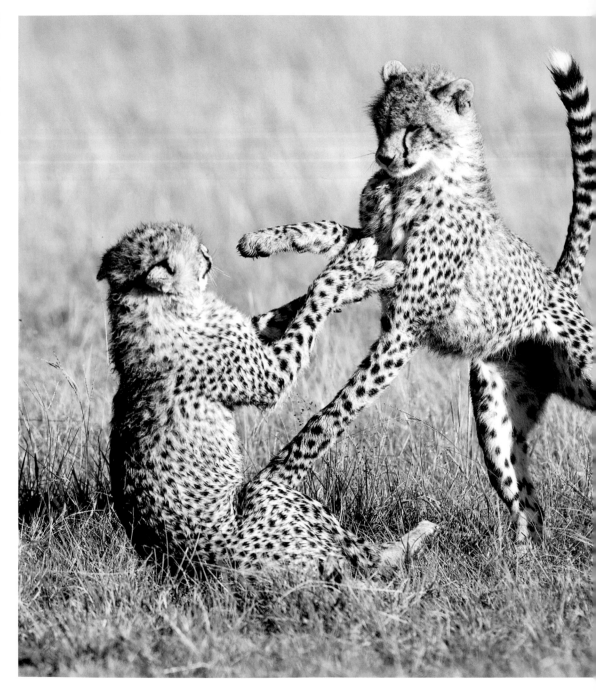

At 9 months old, these siblings are play-wrestling their way to becoming the fastest, most agile land animals on earth. Cheetahs have been recorded running at speeds of up to 68 miles per hour—and it's their swiftness more than their strength that helps them catch prey and avoid predators. In the Maasai Mara, their top prey are Thomson's gazelles, which are not only strong runners, but also try to outmaneuver cheetahs by weaving. When these cubs grow up, they'll use their tails like rudders during the chase—for balance on quick turns—exactly like Cub No. 1 is doing in this photo. It's extraordinary to watch.

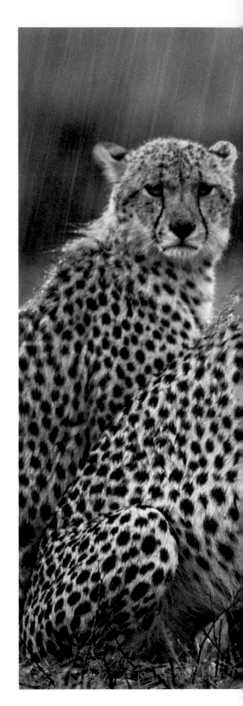

I photographed this beautiful, healthy family in the Ndutu region of the Ngorongoro Conservation Area in Tanzania. Mom, whose face is turned, has a reputation in the region for being a parenting superstar. I once saw her jump on the back of a hyena to protect a cub. Her cubs are 18 months old and fully grown. They are just days away from independence, when mom will sneak away while the cubs are napping, leaving them to claim their adult lives. Young females go off on their own, eventually raising cubs. Young males stick together, forming a sibling coalition to increase their hunting success and to better defend against predators.

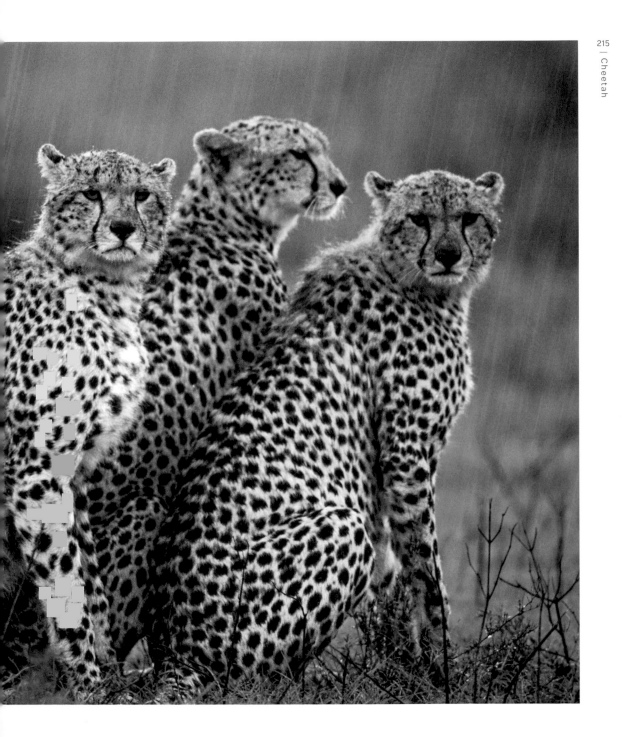

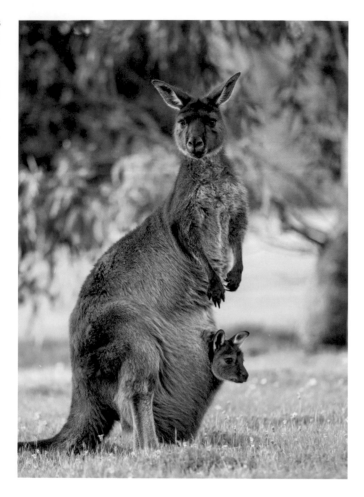

Kangaroo

Kangaroos are the most famous of the macropods, a family of marsupials that include wallabies and pademelons. Most marsupials carry their babies, called joeys, in a pouch. I encountered these Western grey kangaroos in Australia on Kangaroo Island, which is known for its abundance of wildlife, especially its namesake.

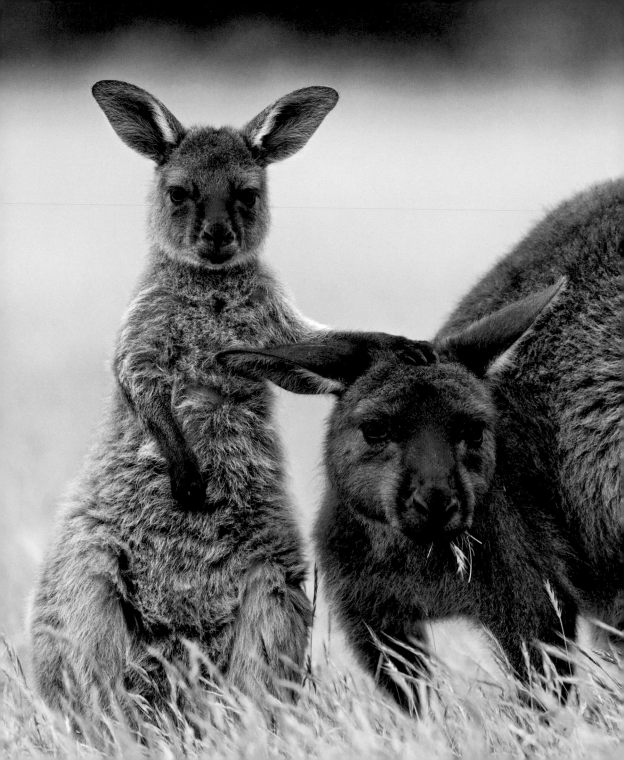

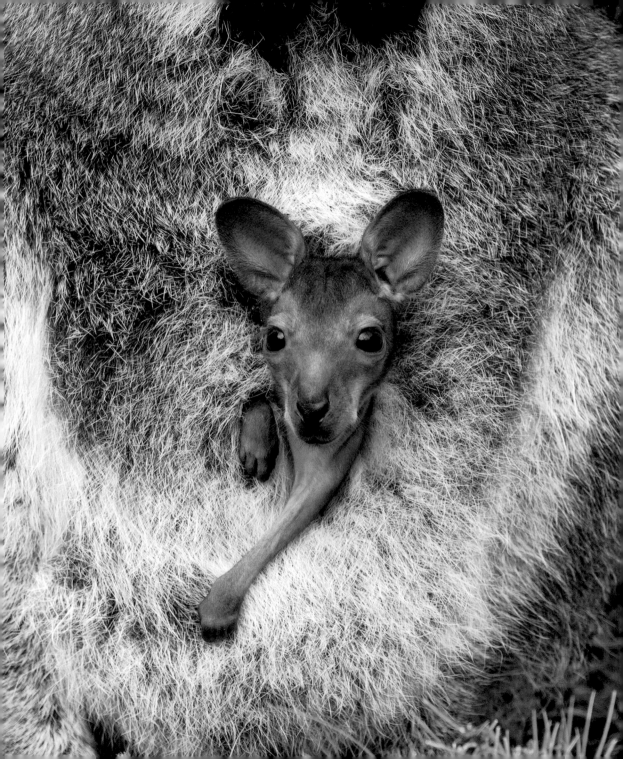

Wallaby

In Cradle Mountain National Park in Tasmania, a Bennett's wallaby joey is keen to explore beyond mom, but she's not having it. She's flexing the strong sphincter muscle at the opening of her pouch to keep joey indoors for now. At birth, joeys are the size of a grape; pink, hairless, and blind. They live exclusively inside mom's pouch for the first 4 months, then slowly begin to spend longer periods of time outside. By 10 months, they completely outgrow the pouch.

Pademelon

Also in Cradle Mountain National Park, a Tasmanian pademelon joey plays with mom. Pademelons are among the smallest macropods, almost mouselike in appearance.

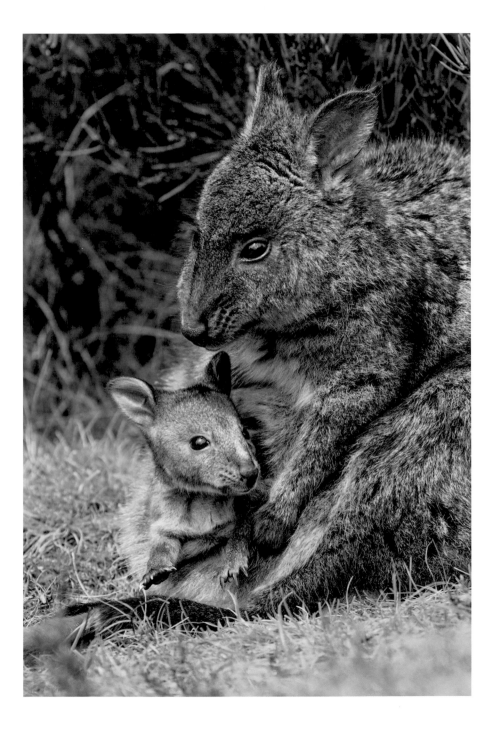

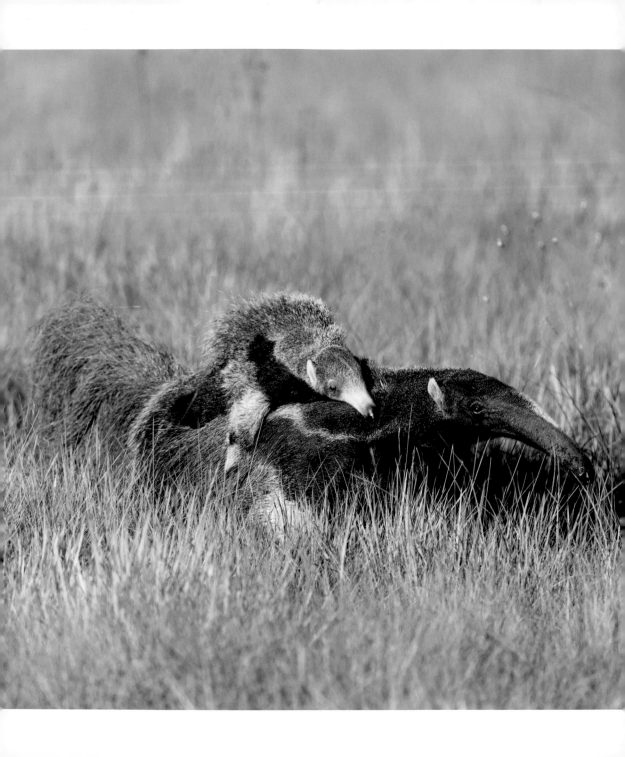

Giant Anteater

To spot a shy giant anteater—whose sense of smell is 40 times better than mine—in Brazil's Serra da Canastra National Park, I hired a tracker who understood how to use the wind to avoid detection. I was delighted to get to see this awesome mammal and her 6-month-old pup up close. Mom is nearly 7 feet long and she's fierce enough to fight off a jaguar with her 4-inch claws. Her snout does more than sniff. She inserts it into termite mounds and ant nests, flicking her sticky tongue 150 times a minute to lap up as many insects as possible.

Baboon

A group of female baboons are hanging out together with their babies in Kenya's Maasai Mara National Reserve. Baboons are very social, living in large troops of dozens of individuals. They're also very intelligent and communicative, utilizing about 10 different vocalizations along with body language like lip smacking, eye narrowing, head shaking, and eyebrow raising. Their body postures and actions can appear very human. The little ones in this photo are 4 and 5 months old. It's the stage where they're starting to spend some time separated from mom while foraging, but always within arm's reach—kind of like toddlers.

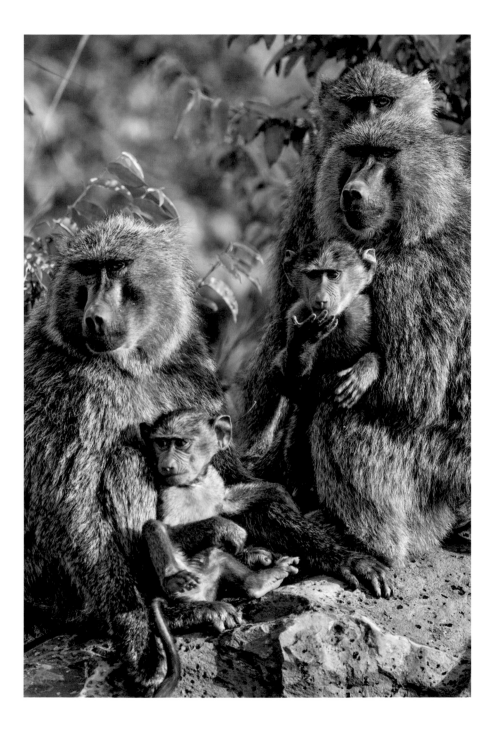

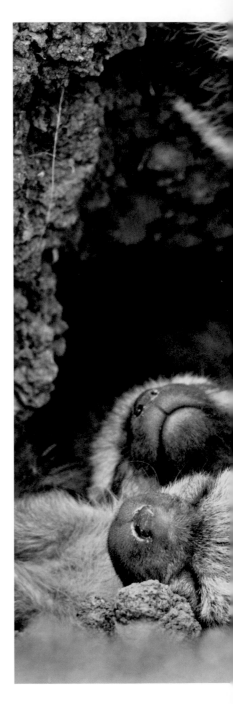

Bat-Eared Fox

Living in the Maasai Mara for three years, I was able to get acquainted with some of the lesser-known species of the savanna. Among my favorites is the bat-eared fox. They are incredibly cute, with comically large ears, and a sweet shyness about them. After following a breeding pair for about a week and discovering their den, I observed some fascinating behavior: The fathers are just as involved as the mothers in raising their young. Pictured here is dad, snuggling his 2-week-old pups. I've since learned that highly-engaged fatherhood is typical among canine species, including jackals and coyotes.

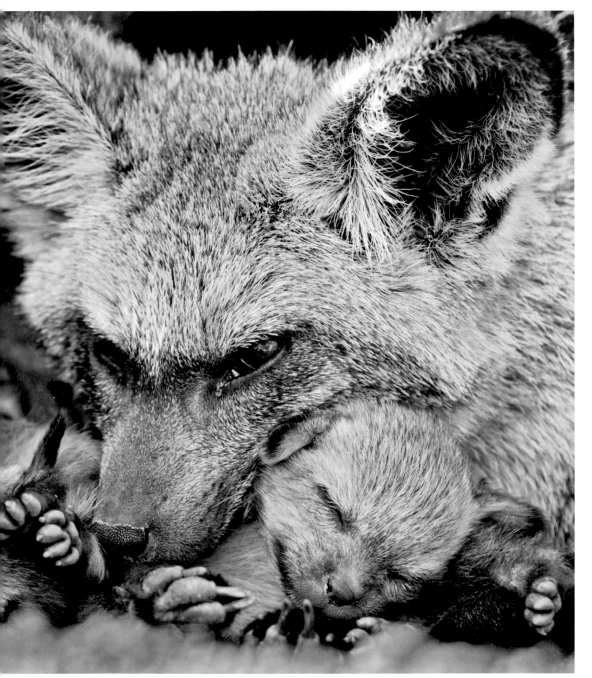

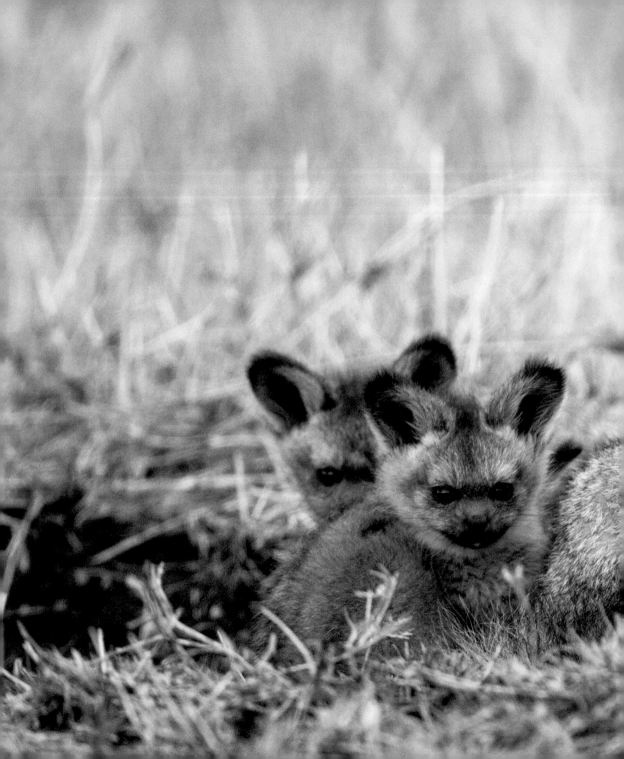

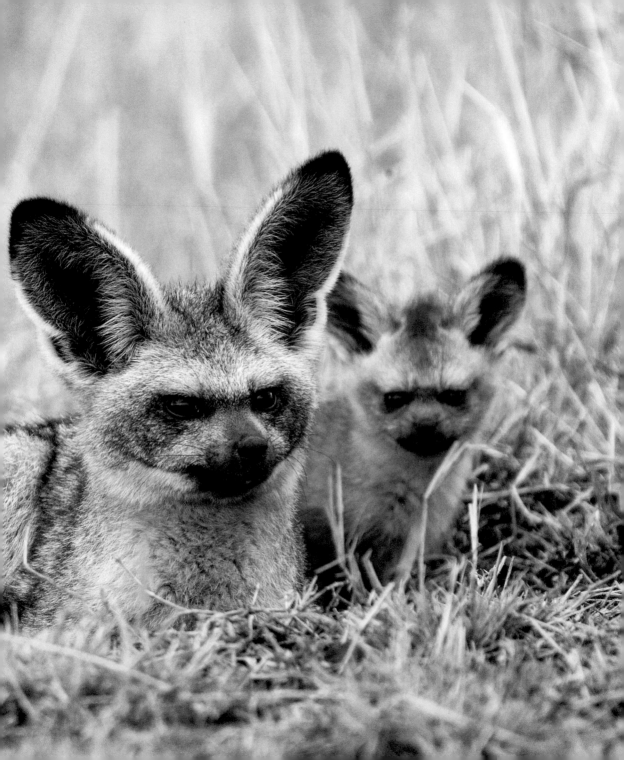

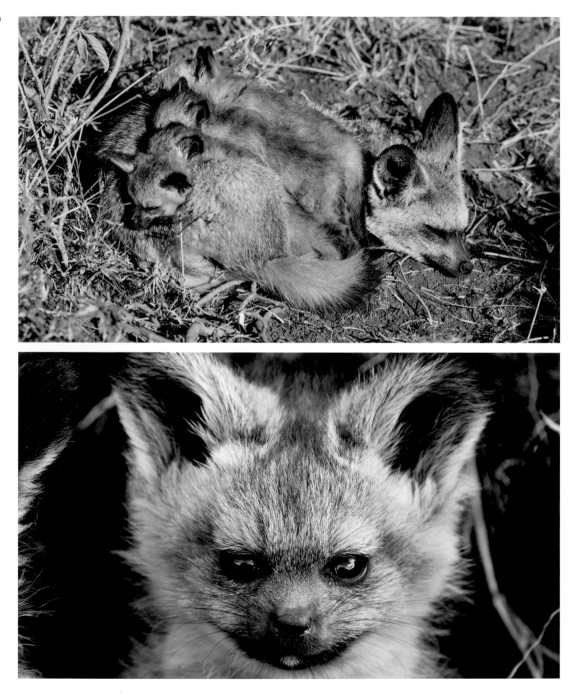

(Top) I ended up spending a month with this endearing bat-eared fox family. Here, the pups are 5 weeks old and snuggled up for a nap with mom. Their position, lying mostly on top of mom, is typical. With bat-eared foxes, the more physical contact the better. They are highly social and when the pups get old enough, the entire family will forage together, sleep together, play together, and groom together. Even when the pups are fully grown at 6 months, they will continue to live with their parents until they find a mate and start a family group of their own.

Elephant

Mother elephants use their trunks to communicate with their calves, offering reassurance or, in the case of this 1-month-old in the Maasai Mara National Reserve, simply moving baby along. African elephants live in matriarchal societies, and the bond between mom and calf is one of the strongest in the animal kingdom. This little one belongs to a small herd of about a dozen elephants—older brothers, big sisters, cousins, aunts, mom, and grandma. The entire herd will work together to raise and protect this beloved baby. The photo continues to be my most popular print, a favorite for nurseries.

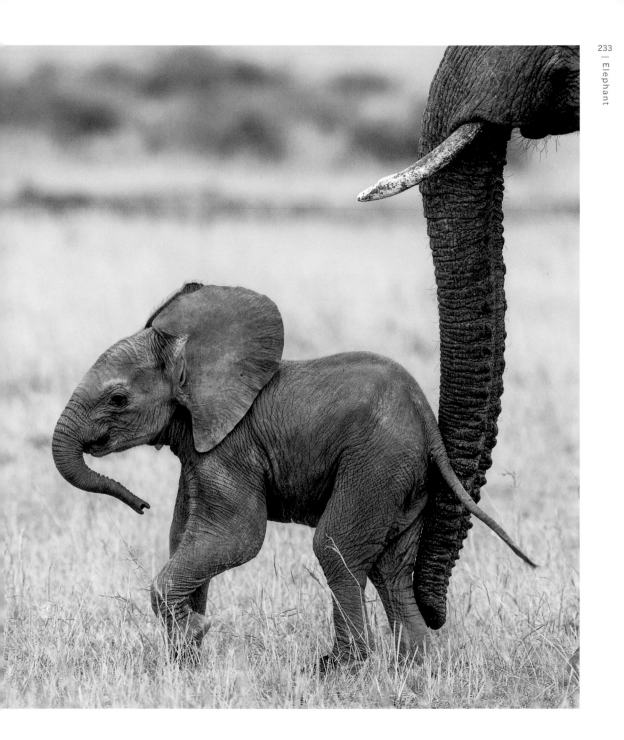

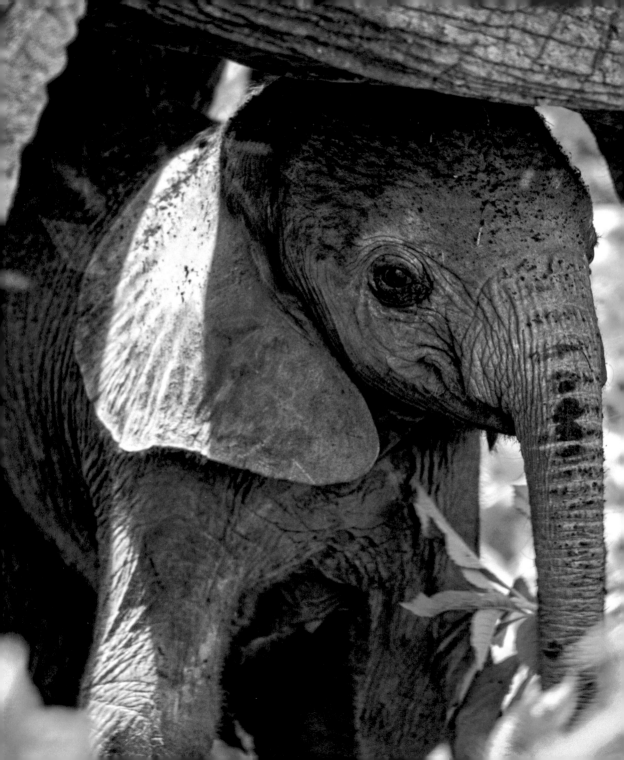

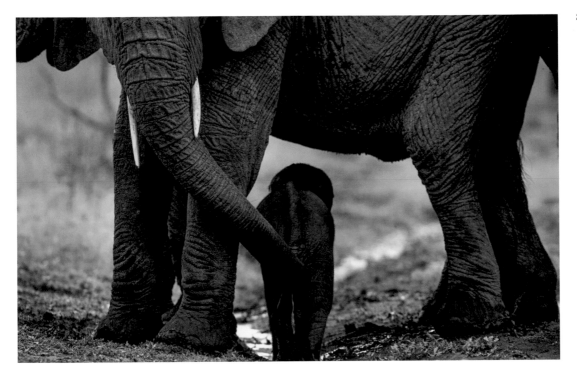

At the tender age of 2 days, this newborn elephant in the Ngorongoro Conservation Area in Tanzania will spend all of his time underneath mom, where he's the most protected. He'll even nurse standing under there. During my time with this herd, I noticed other family members approaching mom and connecting with the new baby by touching him with their trunks, all within the confines of mom's "crib." It was precious. I was deeply saddened to learn that since 2009, Africa's elephant population has decreased 20 to 30 percent due to poaching for ivory. Supporting the Wildlife Conservation Network's Elephant Crisis Fund is one way to help end this abhorrent practice.

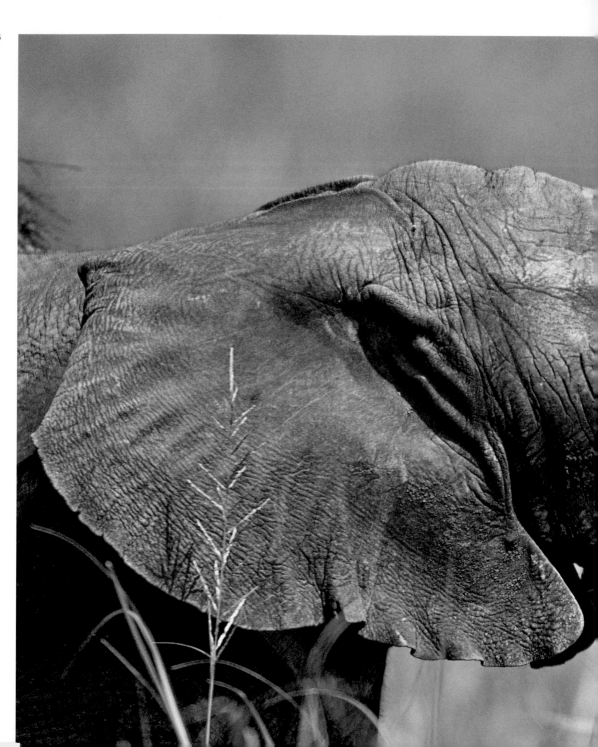

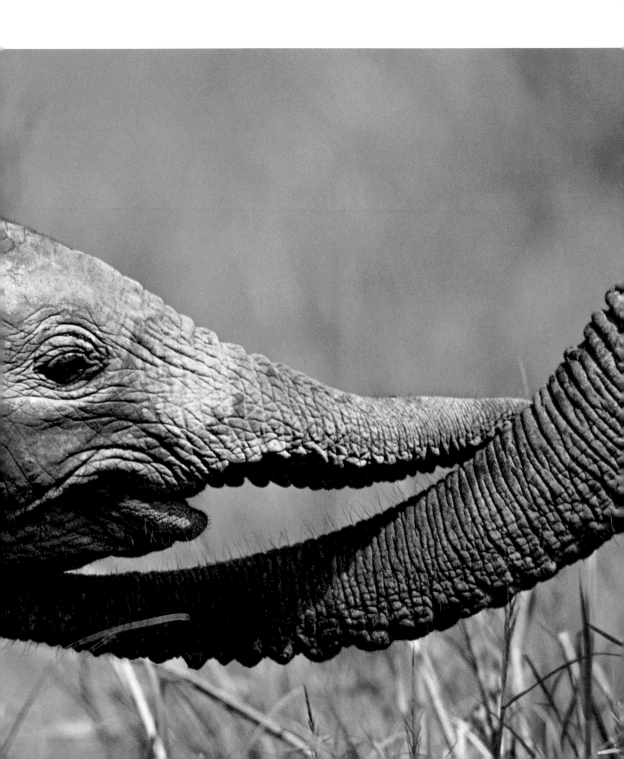

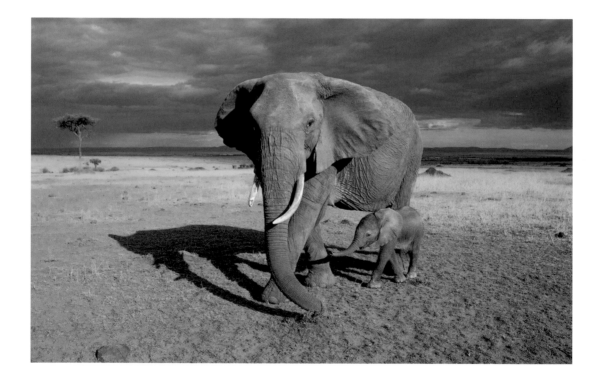

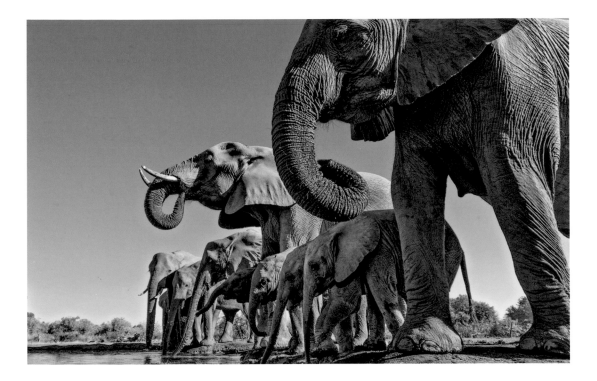

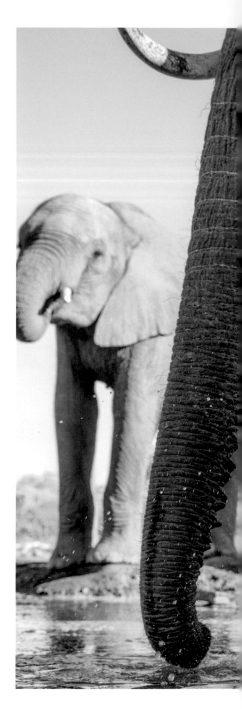

Elephants are magnificently engineered to take in mass quantities of water. An adult's trunk holds 2.5 gallons, and they can drink 50 gallons in a single day. To get these intimate photos at a watering hole in the Mashatu Game Reserve in Botswana, I shot from a hide—in this case, an underground shipping container. What a perspective! The babies had recently mastered the use of their trunks, and were elegantly sucking up water and pouring it into their mouths. Prior to about 6 months of age, they wouldn't have had the coordination. They would have knelt and gulped the water with their mouths.

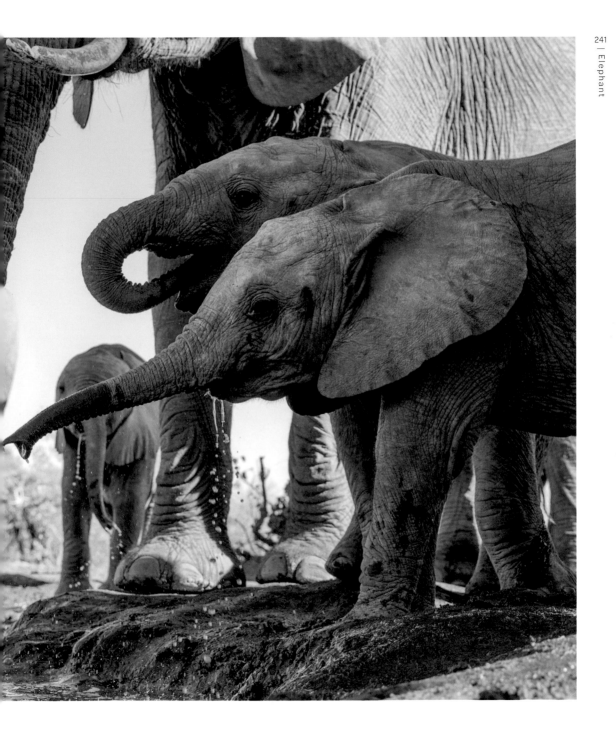

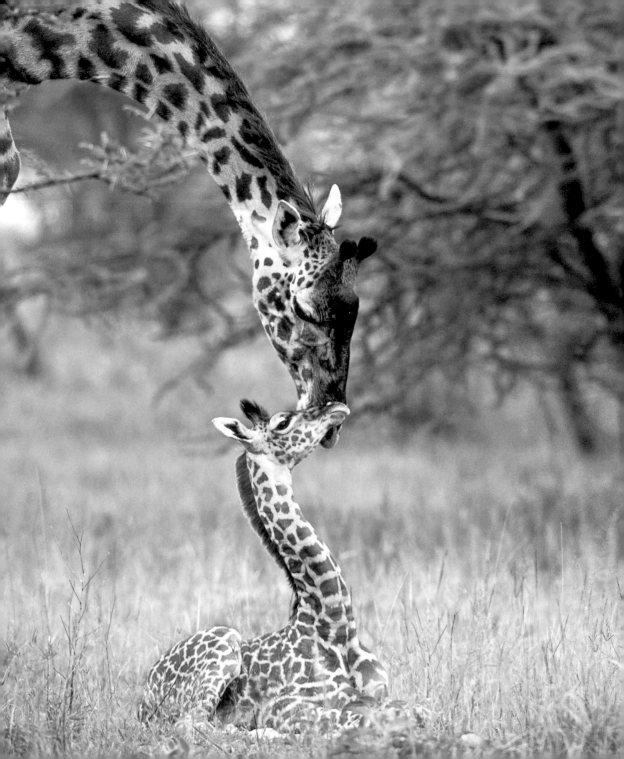

Giraffe

This newborn Masai giraffe in Tanzania's Ngorongoro Conservation Area is just 2 to 3 days old and still developing his walking skills. Mom, like all giraffes, separated herself from the herd to give birth and will bond with her newborn for a few days while the calf works out his wobbles.

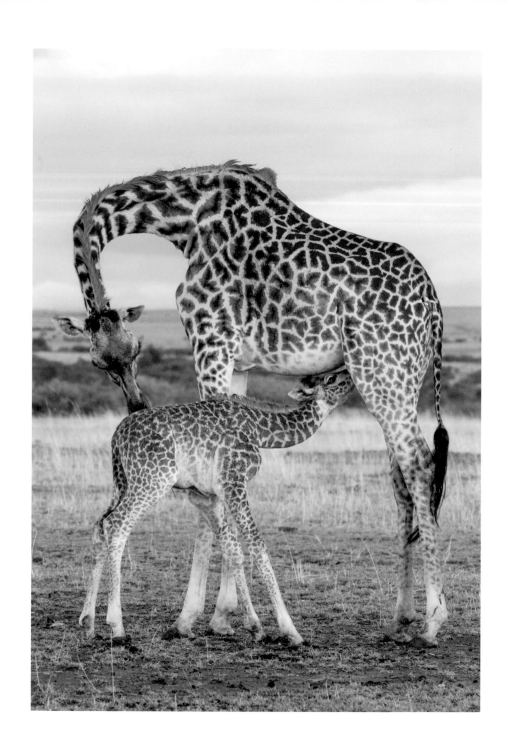

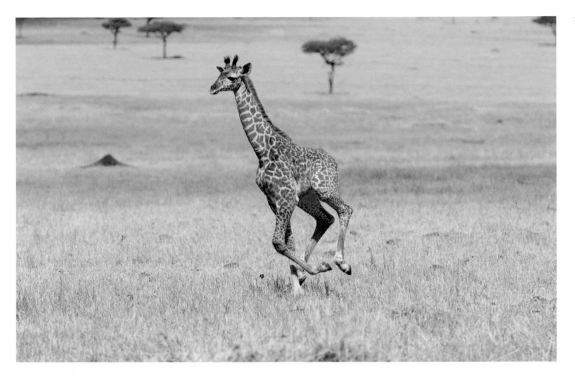

I was delighted to witness these beautiful, fleeting moments—
and the calf's rapid development—before they rejoined the
herd. Seeing giraffes in the savanna is such a classic symbol of
Africa that most people don't know giraffes are at risk. Since
the 1980s, giraffe populations have dropped by 30 percent,
and in some countries by as much as 95 percent.

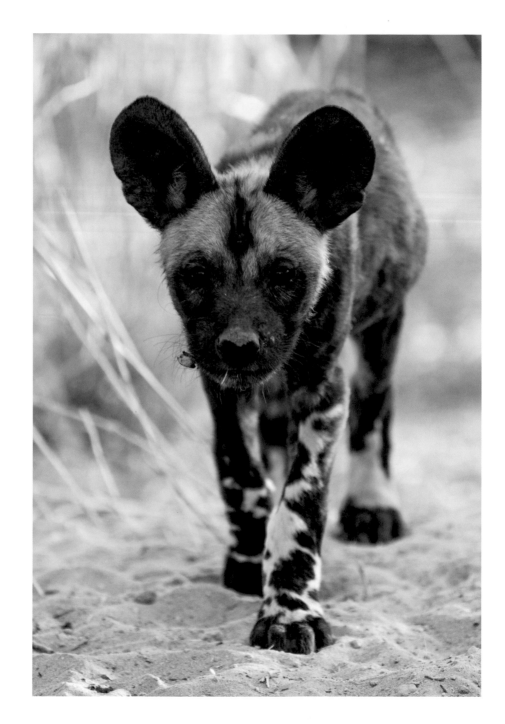

Wild Dog

I was amazed to discover that African wild dogs need up to 800 miles of land to hunt and roam. As a photographer, it made following a family nearly impossible—their territory was just too big. Conservationists have the same challenge. There's no way to stop wild dog packs from roaming outside of protected areas. It's part of the reason they're the second most endangered carnivore in Africa.

Wild dogs live in packs and are incredibly social, which means pup play is pretty much nonstop. They're constantly snuggling each other, jumping on each other, or exploring together in a small group. It's quite fun to photograph. These little ones are 5 weeks old, in the Linyanti region of Botswana.

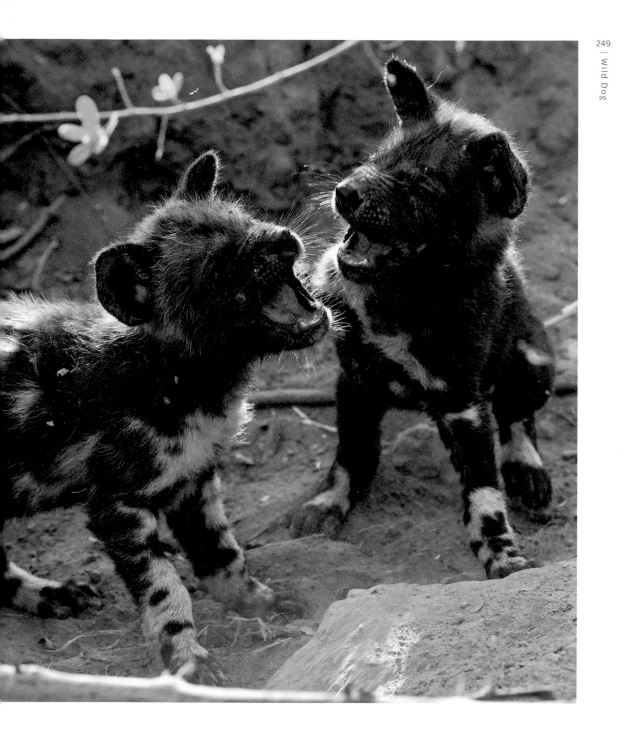

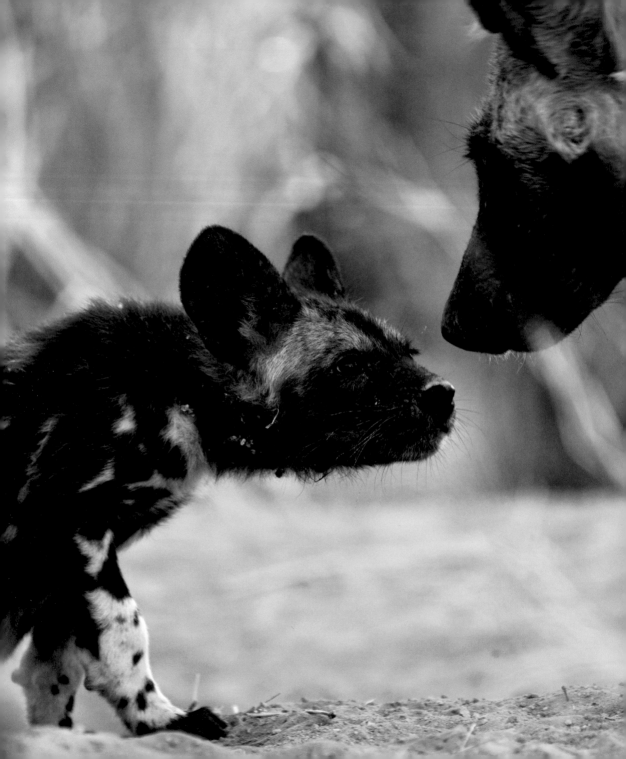

As adults, wild dogs' social nature will continue to affect every aspect of their lives. They will hunt in teams and collectively care for the pack's young. They will babysit pups too young to join the hunt. After a successful hunt, they will regurgitate meat to share.

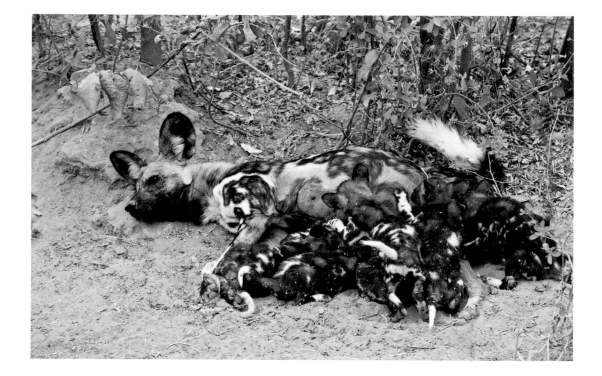

(Left) It's not a coincidence that mom looks like she's smiling in this photo. Suckling is a tender moment regardless of species. At 5 weeks old, the pups are eating a combination of mom's milk and regurgitated meat from the pack.

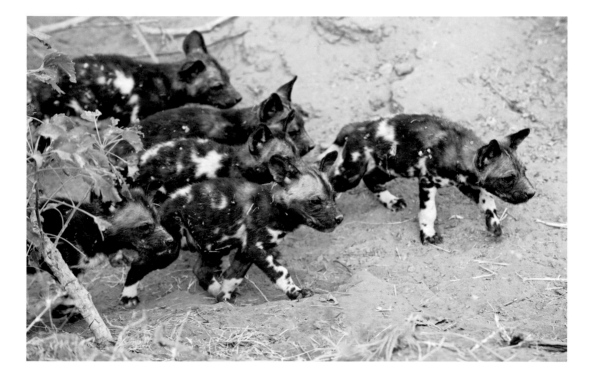

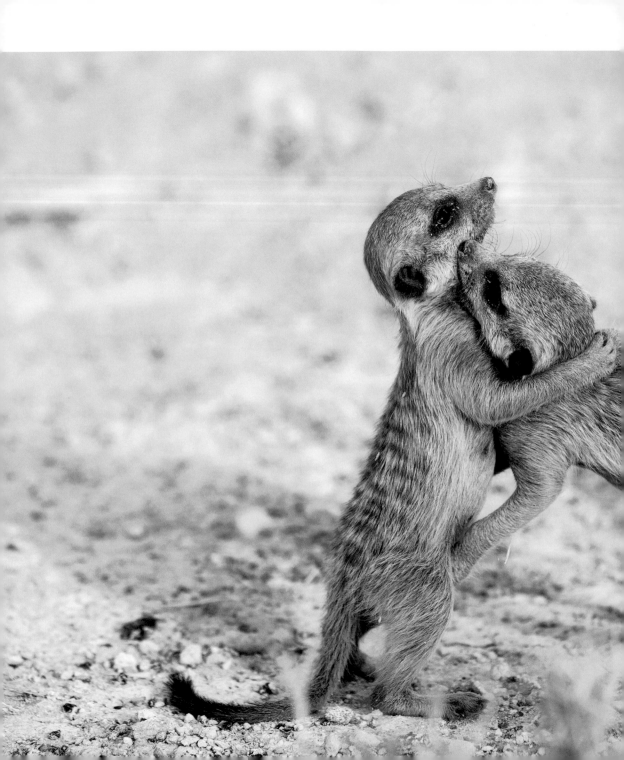

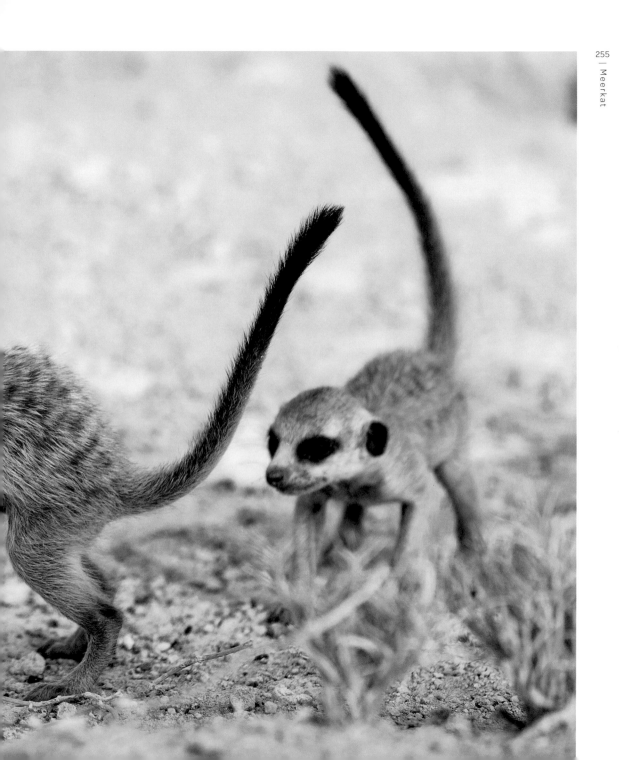

Meerkat

(Pages 254–255) Don't let their dainty adorableness fool you: Meerkats are one of the most aggressive animals on earth. In a territorial dispute with another mob, they will fight to the death. These 6-week-olds are play-fighting, a favorite activity for little ones. Pups also practice posturing and bluffing because it's better for the mob to win by intimidation than to risk a deadly physical encounter.

(Right) Meerkat mobs live together in a burrow, an intricate underground tunnel system. Only the alpha female and male have babies, and their pups stay underground for at least the first three weeks of life. I came to love sunrise on the salt pan because it's when meerkats start peeking—checking that the coast is clear before they come out to forage. It's quite photogenic. The pup in this photo is 6 weeks old, which is old enough to go outside, but she doesn't do much foraging yet. Instead, cubs this age beg from the adults, who are surprisingly good-natured about sharing their scorpions.

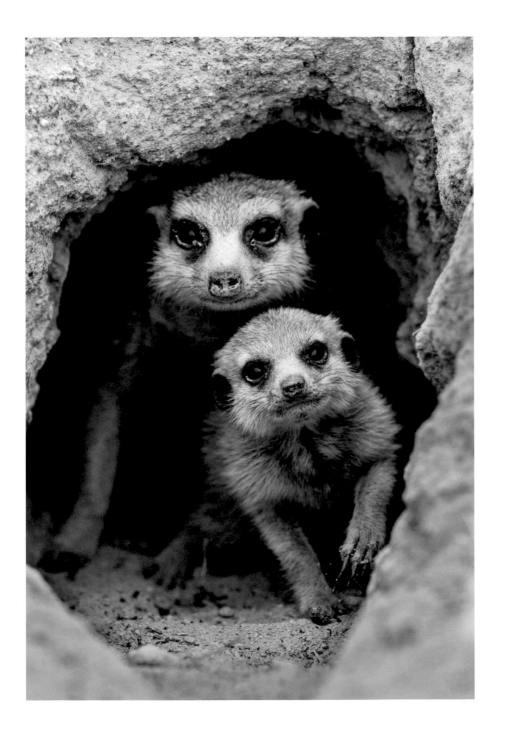

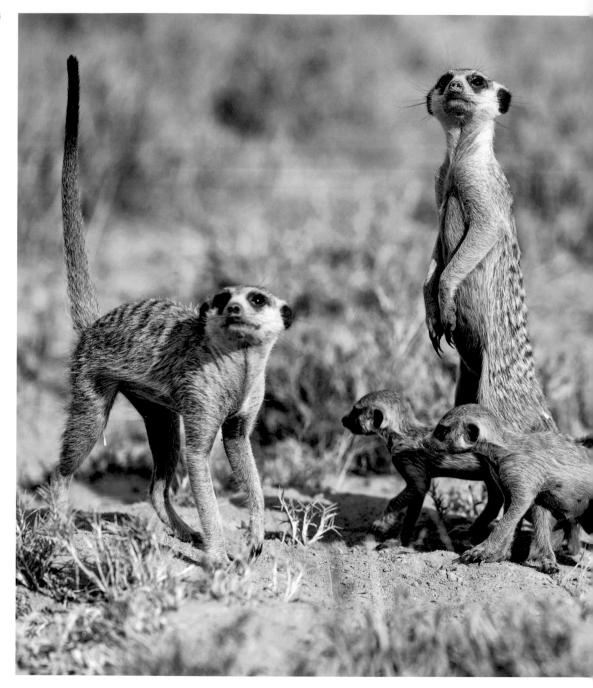

A pair of 6-week-old meerkat pups forage in Makgadikgadi Pans National Park in Botswana while two adults keep watch. The adults are scanning the sky for eagles, their main predator along with jackals. Meerkats can spot an eagle on the wing from 1,000 feet away. This hypervigilance is their best protection in the open flatlands of the salt pans. At least one adult is always on guard, keeping watch over the entire family group, or mob. One animal they're not afraid of? Ecotourists. Meerkat sentries scrambled up my back while I was photographing to use me as their lookout post!

Pups are able to stand shortly after birth, and as adults will reach 12 inches tall on their hind legs. Standing makes it easier to spot predators. Meerkats do it so often that moms can even nurse that way.

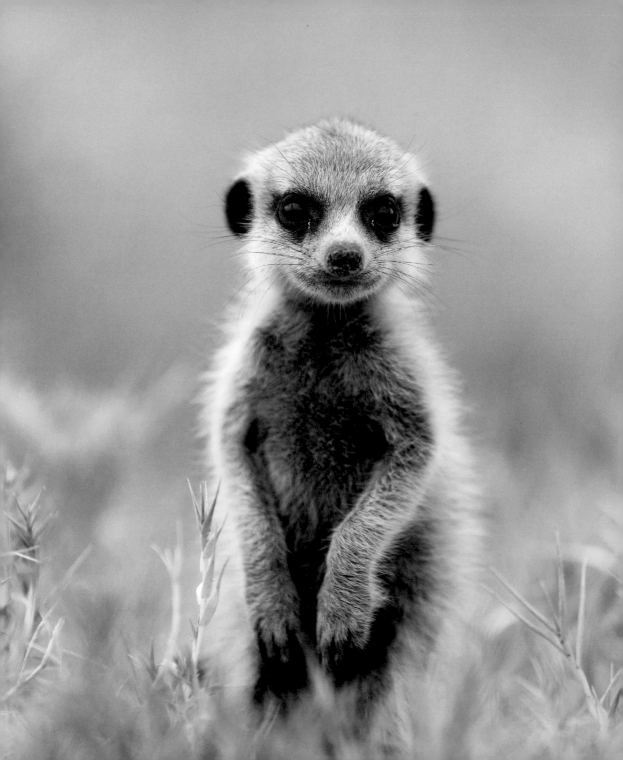

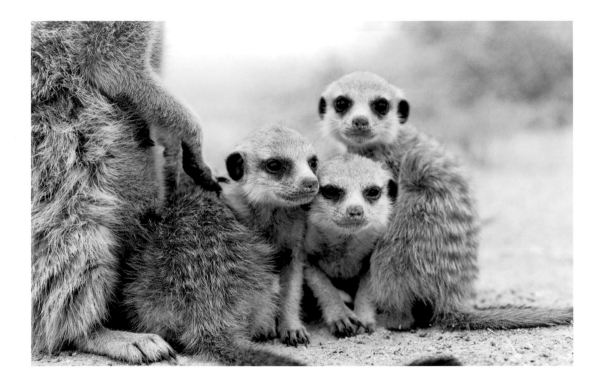

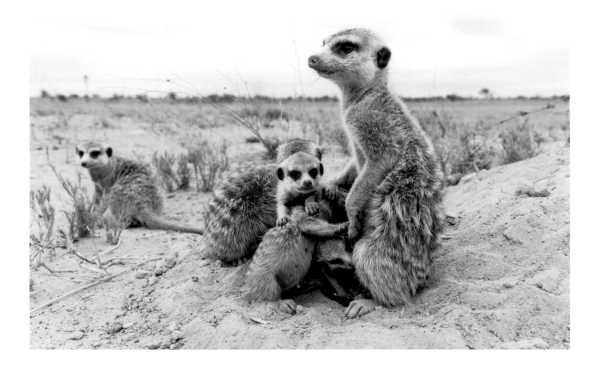

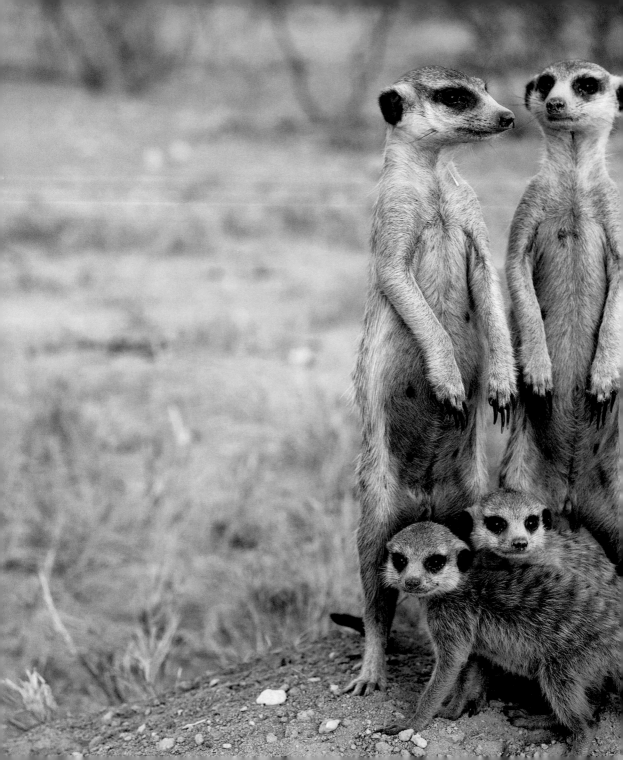

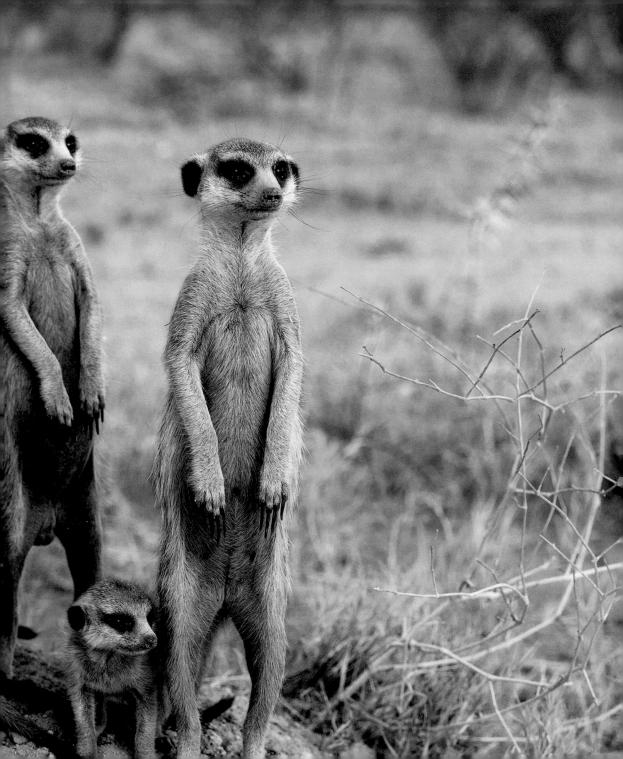

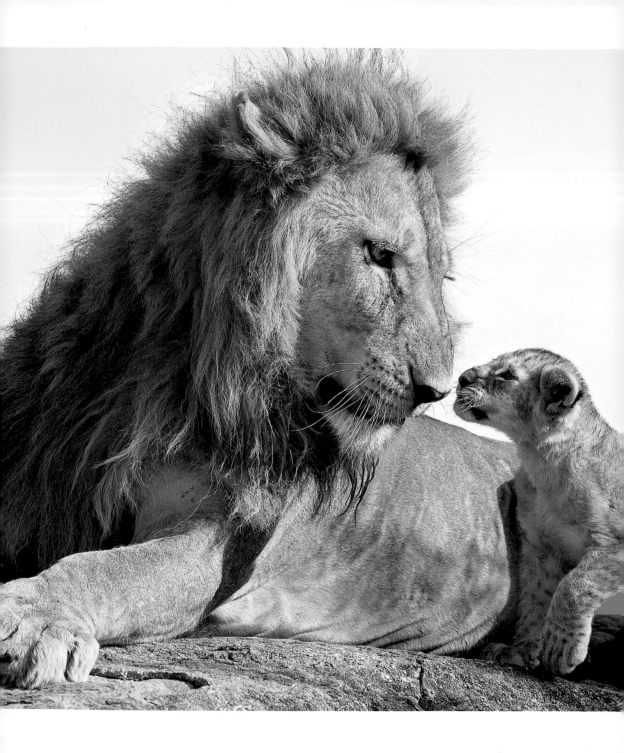

Lion

In the golden morning light of Kenya's Maasai Mara National Reserve, a lion cub meets her dad for the first time. I'd been following this pride for three months, even before mom gave birth, and knew the cubs were almost ready to leave the den. I was ecstatic to be there for this once-in-a-lifetime moment. Mom led her three cubs across a grassy area to a rock where dad was waiting. The cub in the photo regarded him for a few minutes, almost shyly, before climbing up. Her raised paw shows she was hesitant. She needn't have worried—dad gave her a big sniff of approval.

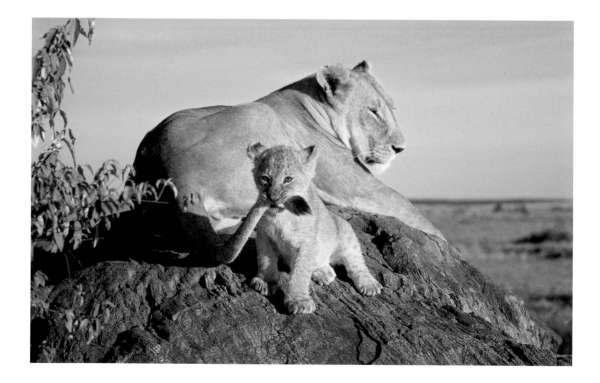

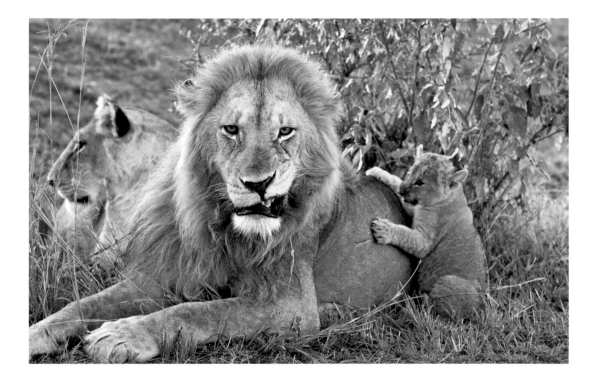

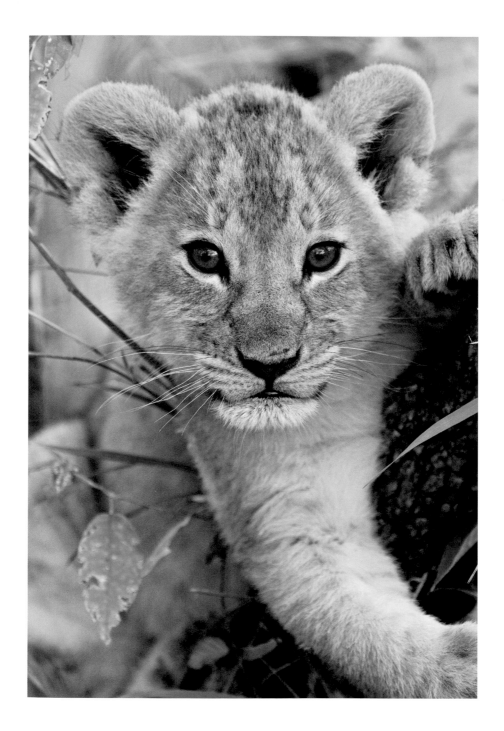

(Left) Even at 5 weeks old, this male lion cub looks regal. He will become one of the most magnificent cats on earth, with a full mane and 420 pounds of muscle mass. Ideally, he'll rule a pride of his own, but the sad reality is that he faces a far greater adversary than competing male lions. Humans have reduced lions' distribution to just 8 percent of their historic range, and with human-lion conflict on the rise, farmers have taken to poisoning lions to protect livestock. The Wildlife Conservation Network was one of the first to sound the alarm about this, and I'm proud to support their efforts.

(Page 272) Watching a lioness pick up a newborn cub in her mouth was a common sight for me during my time in the Maasai Mara. What struck me about this moment was the humorously indignant cub. Cubs don't feel any pain when mom picks them up with her mouth—it's actually quite gentle—so his protest was a temper tantrum. He clearly wanted to continue doing whatever he'd been doing before mom arrived. The scene reminded me of how I learned to sense when lion cubs were ready to leave the den: They became too unruly for mom to keep them inside.

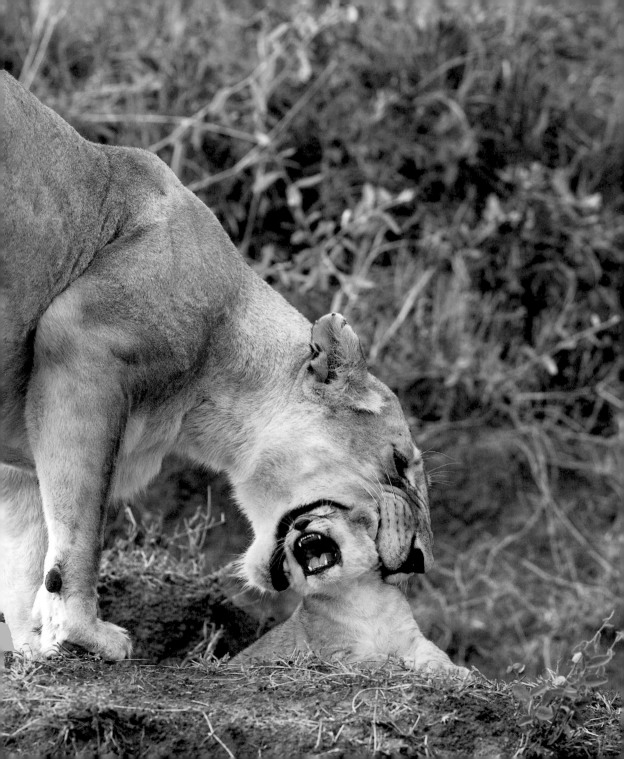

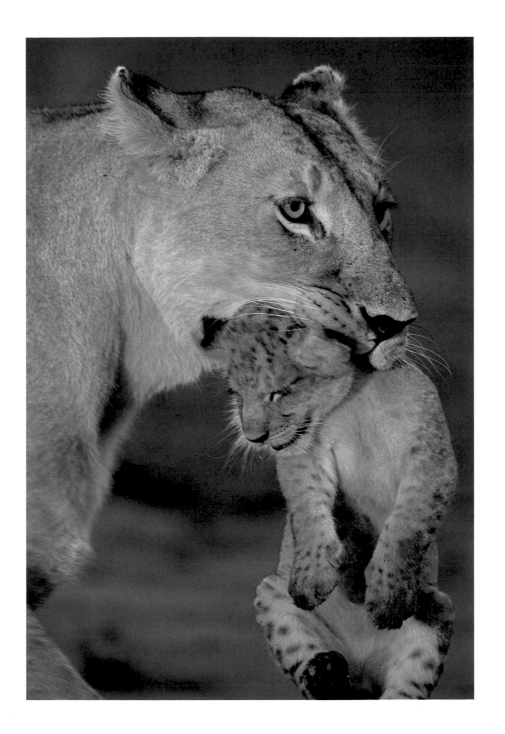

At 6 weeks old, these cubs are still exclusively suckling. They won't start eating meat until about 3 months, when mom will begin taking them to kills. By 6 months, the cubs will be fully weaned and eating only meat. At about a year old, they'll start hunting with the pride and fully assume their place as the most formidable predator in Africa. Lions are absolute powerhouses. These cubs will be capable of killing antelopes and zebras, and, when teamed up with others in the pride, will even take down buffalo, elephants, and hippos.

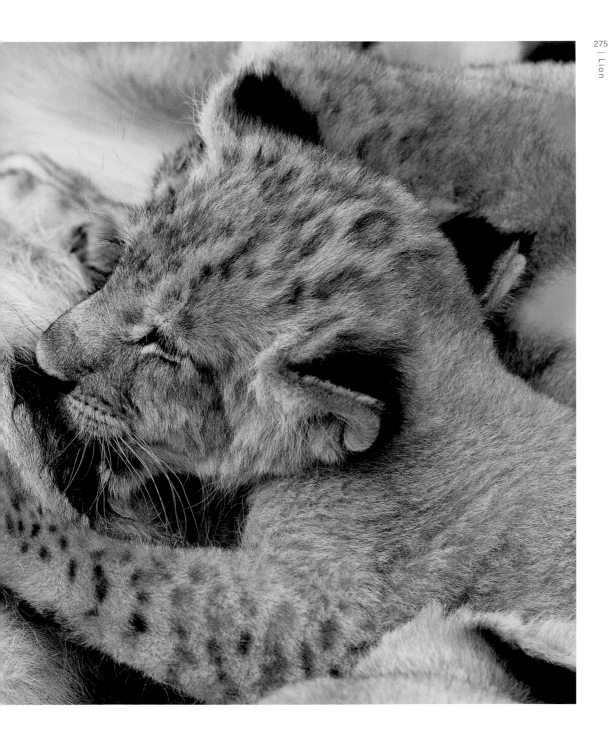

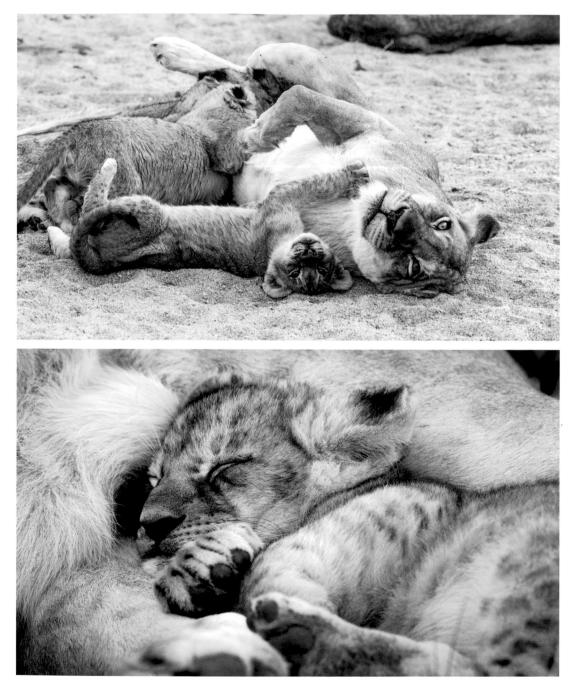

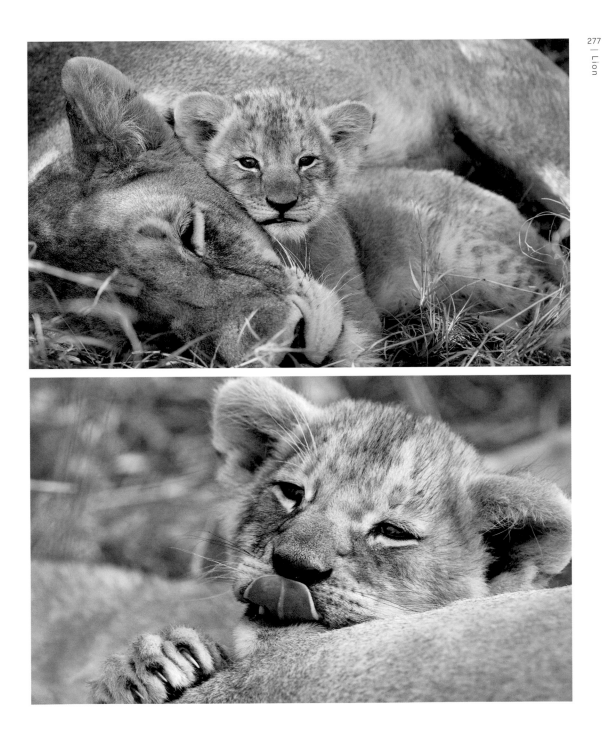

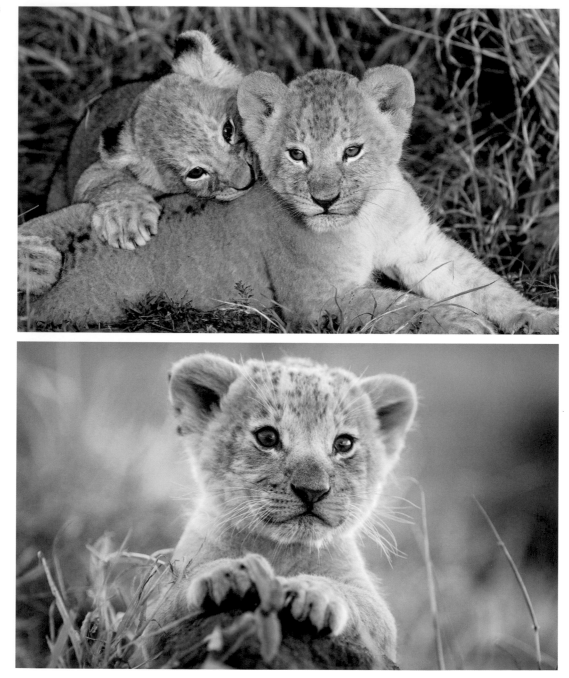

(Top) Lions are unique in the animal kingdom in that they're the only truly social cat; all other species in the feline family—from domestic cats to tigers—are predominantly solitary. As such, lion cubs are charmingly affectionate with each other. Females will usually stay with the pride their entire lives. Males will go onto start a pride of their own. This pair is from a litter of three, and are brothers. They will stay together as adults because they're even more powerful that way. The dominant one will lead a new pride, and the other will be his right-hand man.

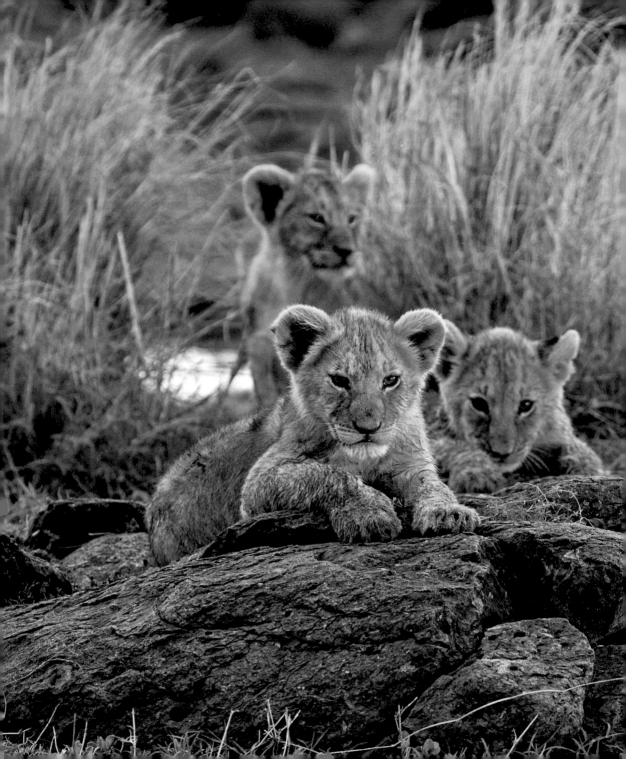

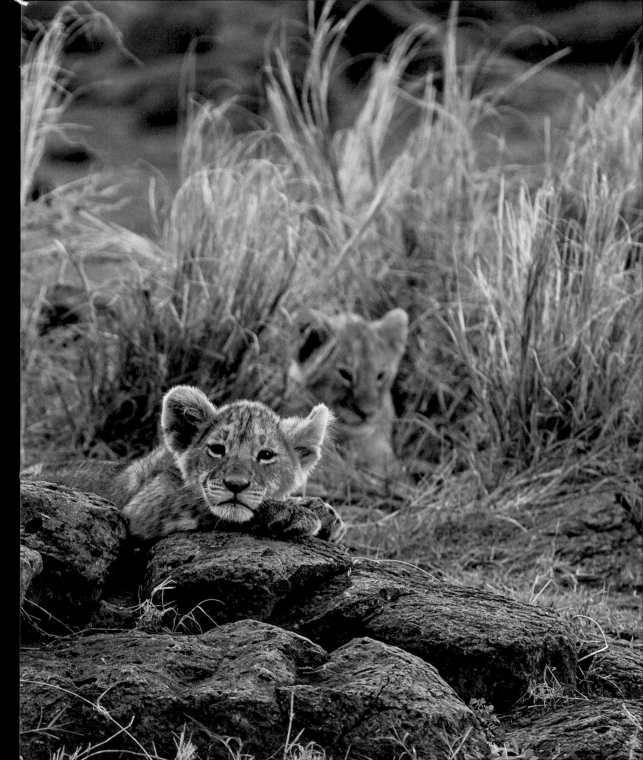

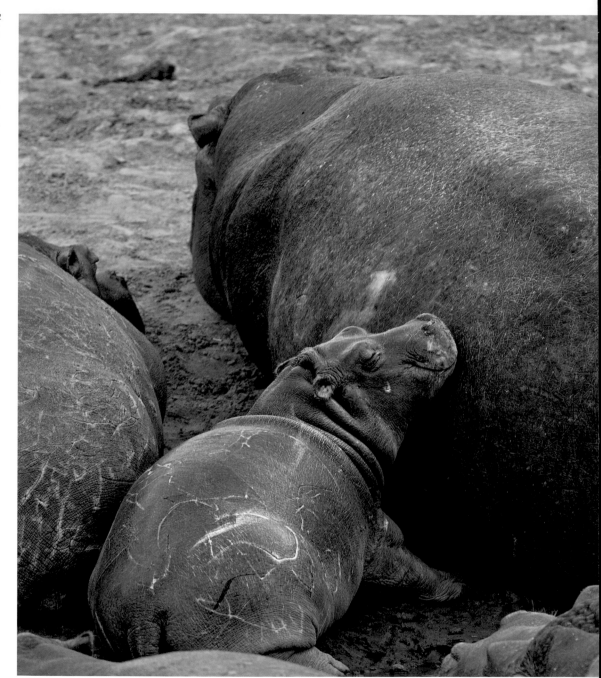

Hippopotamus

(Pages 284-285) A hippopotamus mom snugs her newborn calf between her body and the riverbank to keep him from getting swept up in the current. In another week, mom will take the calf to rejoin the herd. For now, it's just the two of them. The calf will rest with mom in protected waters, nurse underwater, and follow mom out while she grazes. Hippo vocalizations are my favorite—an unexpectedly loud cacophony of honking and snorting, usually at night when they're the most active. The noise will always be one of the quintessential sounds of the African bush to me.

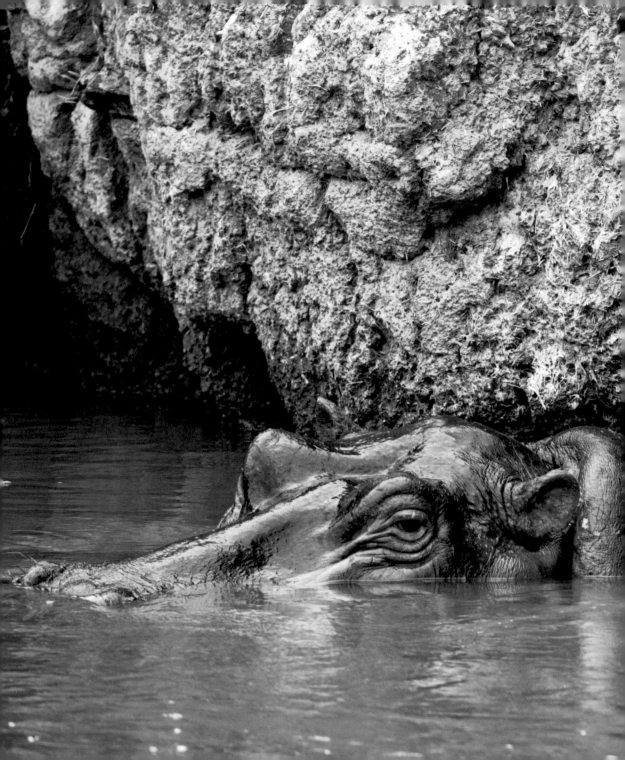

Hyena

During my time living in the Maasai Mara, I became so fascinated with spotted hyenas that I spent three months observing and photographing a communal den comprised of three families, all with new litters.

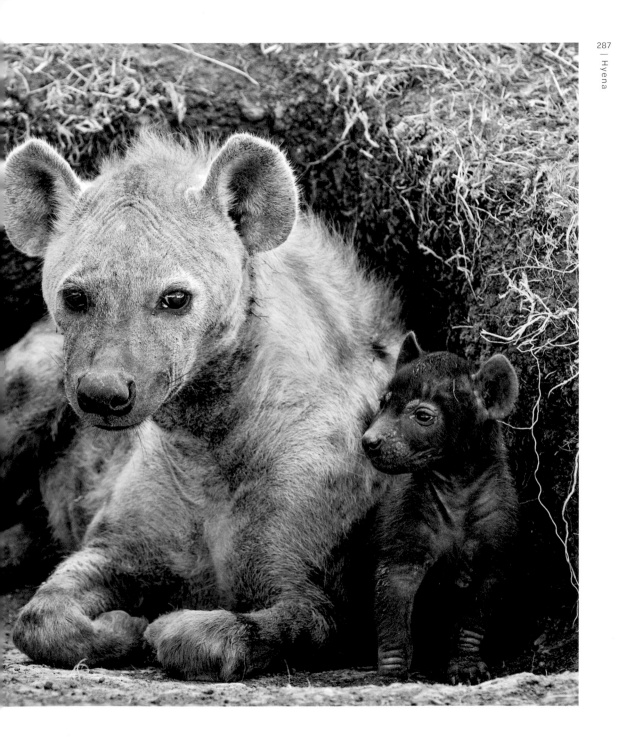

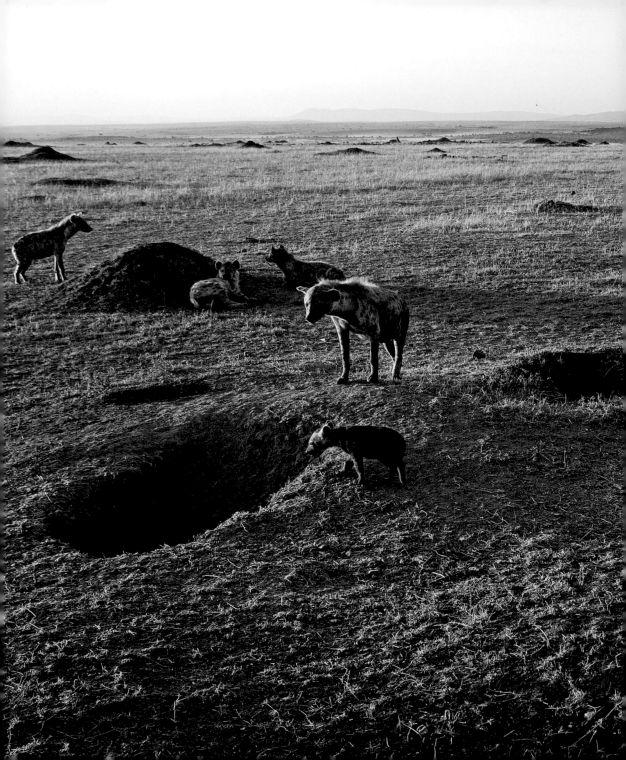

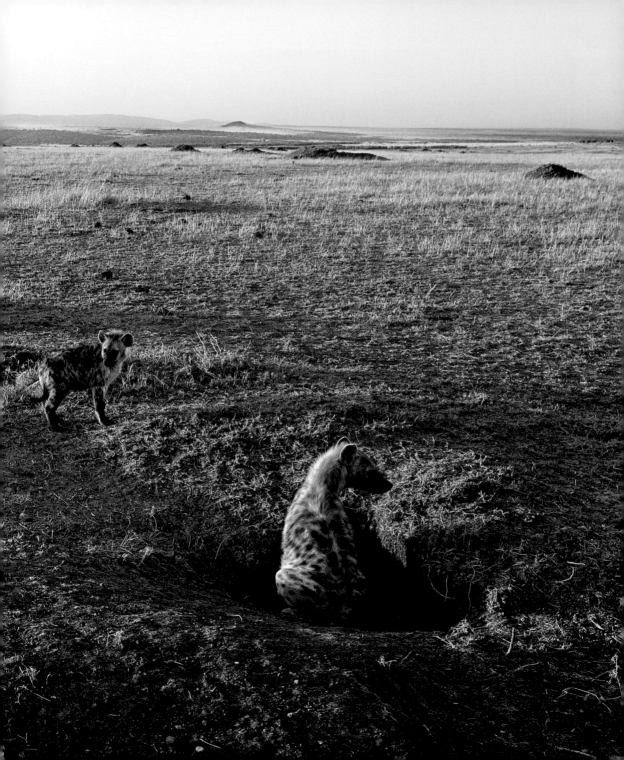

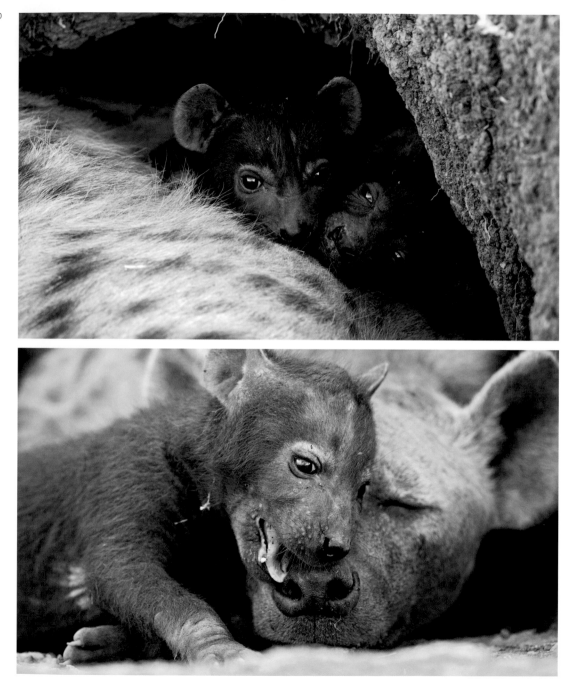

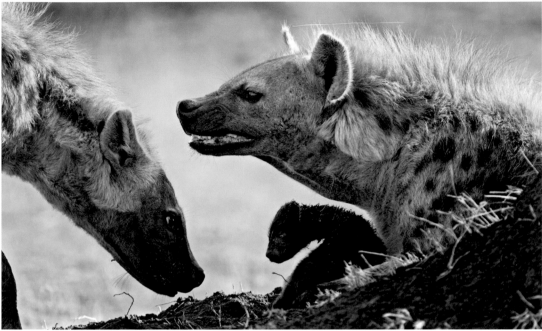

(Pages 288-289) The communal den is the epicenter of hyena social activity. Besides the three families that lived here, other spotted hyenas in the clan swung by on a regular basis to greet the families. Clans can be anywhere from five to 100 individuals and the females are dominant. The lowest ranking female outranks the highest ranking male. I took this photo at sunrise, a relaxed time when the families start to wind down after their nocturnal activities.

(Top left) Spotted hyena cubs are born black and incredibly cute. Most interesting, they're born with their eyes open and their teeth already cut because the first thing they do is fight with their sibling, typically just one, to establish rank. Within 48 hours of being born, these two had already established their pecking order. It's unique, both the biology and the behavior, even among carnivores.

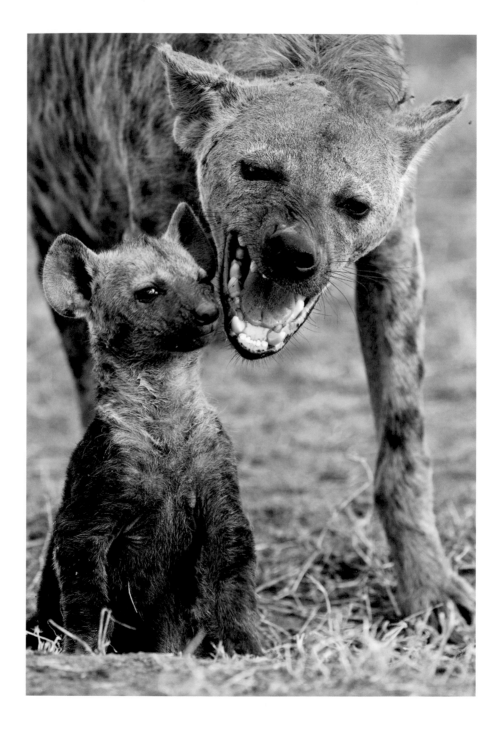

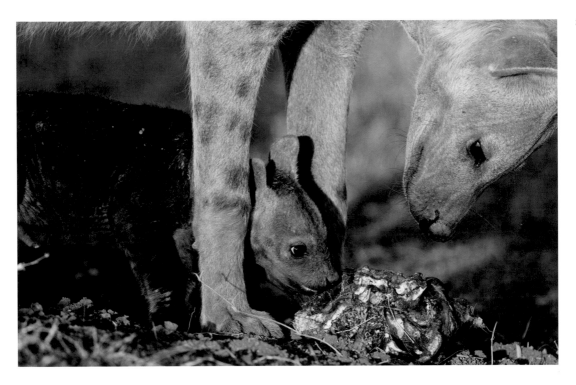

(Right) Hyenas are very accomplished hunters. Though they certainly do scavenge, in some parts of Africa it's actually more common for a lion to scavenge a hyena's kill than vice-versa. People are also surprised to learn how much hyena moms dote on their cubs. Here, mom had brought a wildebeest bone back to the communal den after a hunt and cub is taking a nibble. It would soon become his favorite toy. Moms are also fiercely protective of their cubs, even among the clan. They go out on their own to give birth, in a private natal den, and then wait for a couple weeks before bringing the cubs to the communal den.

(Pages 294-295) This 4-month-old cub is taking a stretch. Note her spots have come in.

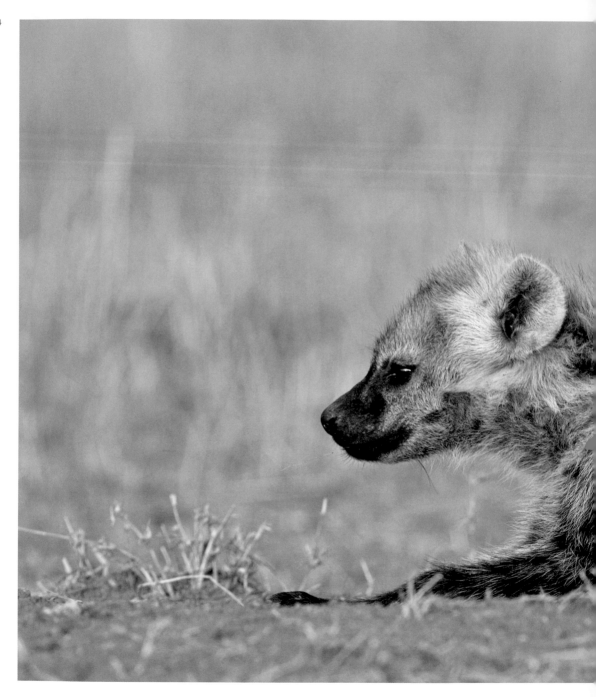

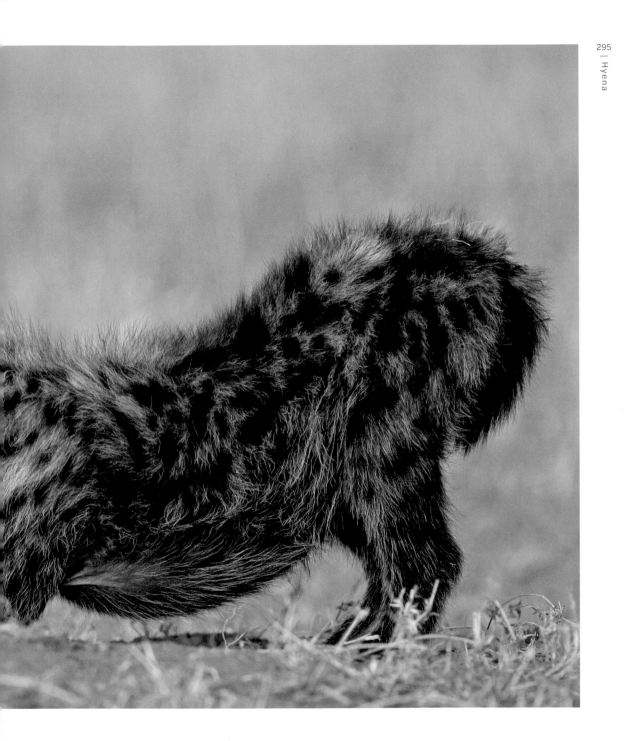

While heading out to shoot meerkats in Botswana, I came upon a brown hyena den. It was incredible luck. Brown hyena sightings are rare—they're not only nocturnal, but also shy and elusive. I immediately changed plans in hopes of photographing one. As the sun started to set, mom surfaced with her cub. I thought they'd run at the sight of me, but instead they sat down at the mouth of the den and rested. I got to spend a full hour with them in the magic light of the desert dusk before they left to hunt.

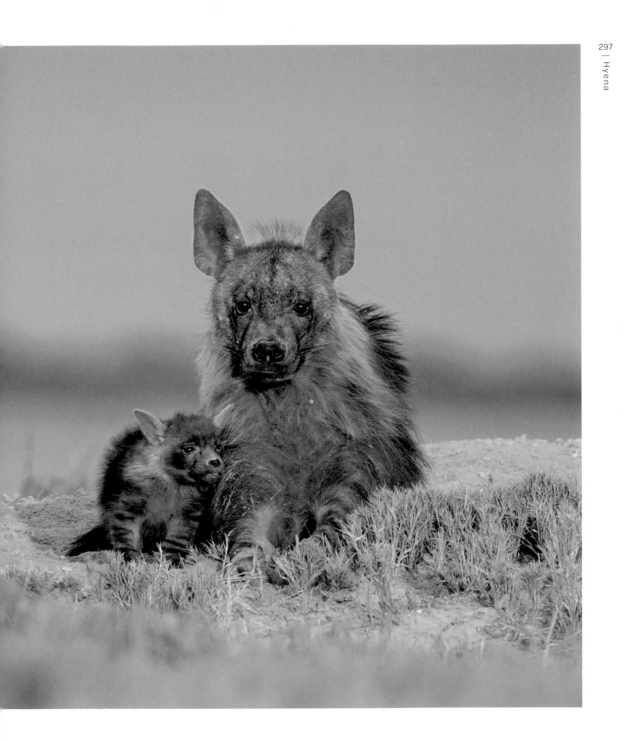

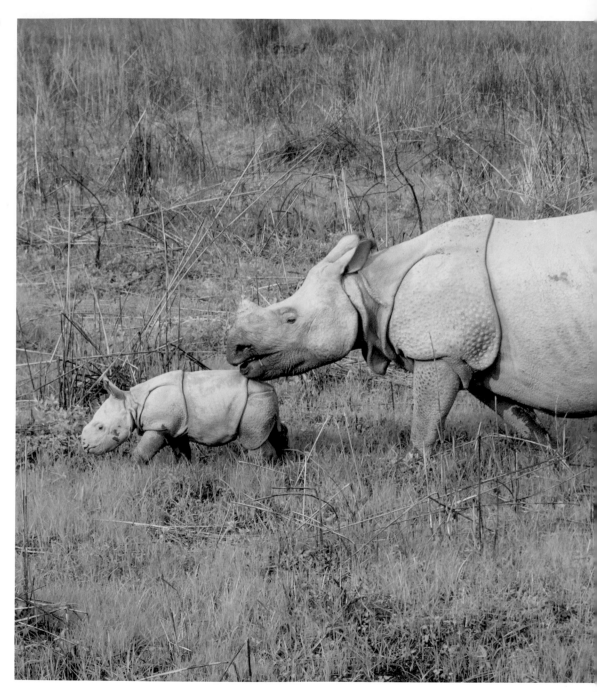

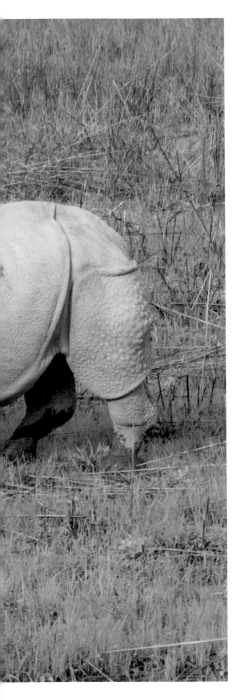

Rhino

This greater one-horned rhinoceros calf is a miniature version of mom, and at the tender age of 1 week, sticks to her side. They are fortunate to live in Kaziranga National Park, where rhinos have rebounded from near-extinction thanks to strict protections implemented by India and Nepal.

In Africa and parts of Asia, rhino populations continue to plummet from poaching. Rhinos are prized in Chinese medicine for their horns, which fetch a large sum. Rhino poaching operations have gotten so sophisticated that poachers come by helicopter and use night-vision technology. Like drug traffickers, they are armed and dangerous. Protecting rhinos has literally become a war.

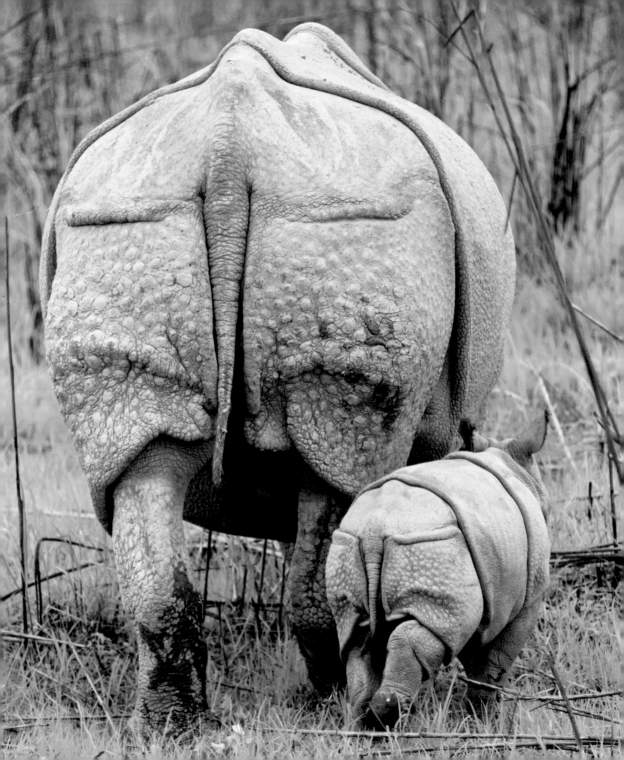

Serval

During my time living in the Maasai Mara National Reserve,
rangers brought me this 2-week-old serval, a wild cat native to
Africa, and asked if I could raise him and return him to the wild.
Ecotourists had found Moto—which means "fire" in Swahili—
abandoned at the side of the road. I fed him a blend of milk,
eggs, and fish oil, and carried him around in the pouch of my
shirt until he got stronger. As Moto matured, I began feeding
him rats. Eventually, he'd leave at night to hunt, and return to
snooze on top of my tent during the day. One morning, Moto
didn't return. I worried he'd been killed by a leopard. A week
later, I spotted him near camp. Moto wasn't dead, he'd just
gone back to the wild. He was 8 months old. It was one of the
best experiences of my life.

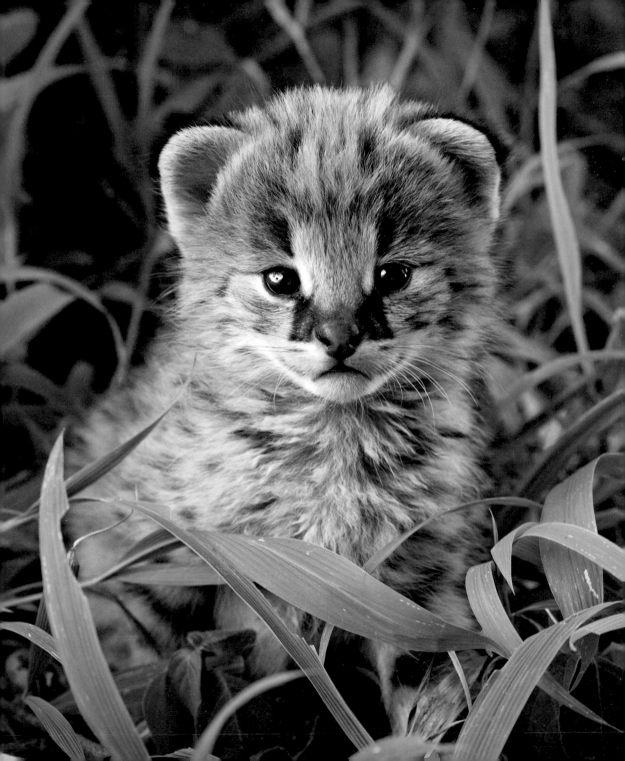

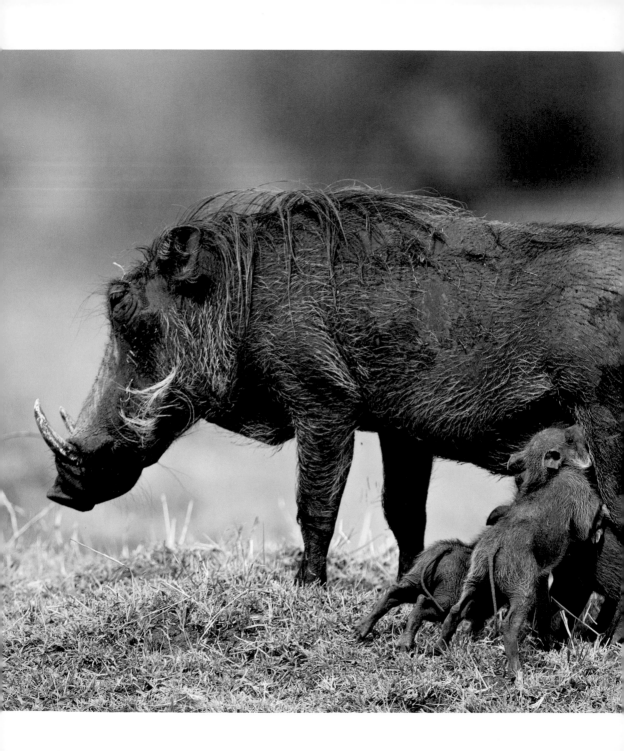

Warthog

I love warthogs. There is something so endearing about them—
perhaps because they're so strange looking. Babies, known as
piglets, are highly entertaining. They travel everywhere with
mom, scurrying after her and imitating her. Moms with piglets
often hang out with other moms with piglets, preferably loung-
ing in the mud together to cool down and ward off insects.
They're all highly communicative, using grunts, chirps, growls,
snorts, and squeals to get their points across, regardless of
age. In my three years in Kenya, I learned that they're also an
indicator species for drought. When warthogs aren't doing well,
it's too dry.

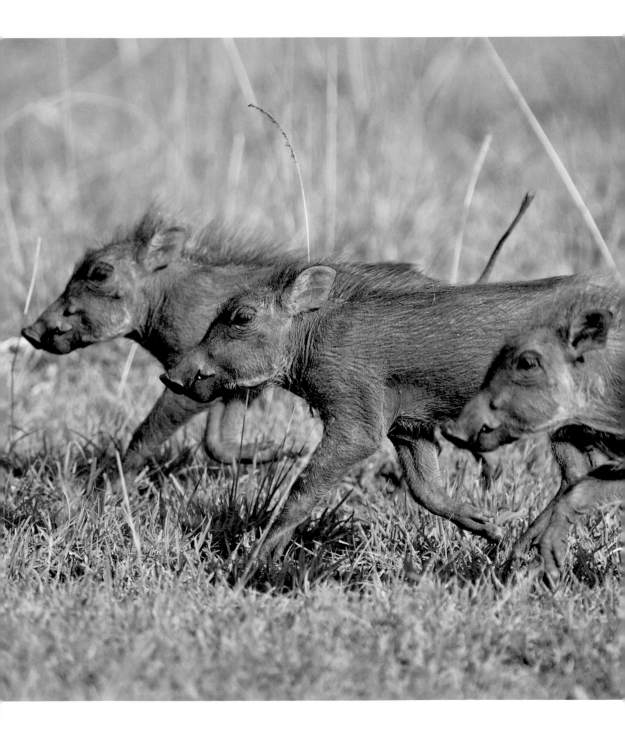

Antelope

(Top) A wildebeest calf romps with mom in the Maasai Mara. Wildebeests, with their shaggy heads and jaunty horns, are the most recognizable antelope species in the savanna. They are also the most precocial of all the hoofed mammals: Calves can stand as quickly as three minutes after birth and within two hours are running with the herd. It is a survival technique against predators.

(Bottom) Other antelopes, like the Topi calves shown here, stay grouped together for safety in numbers.

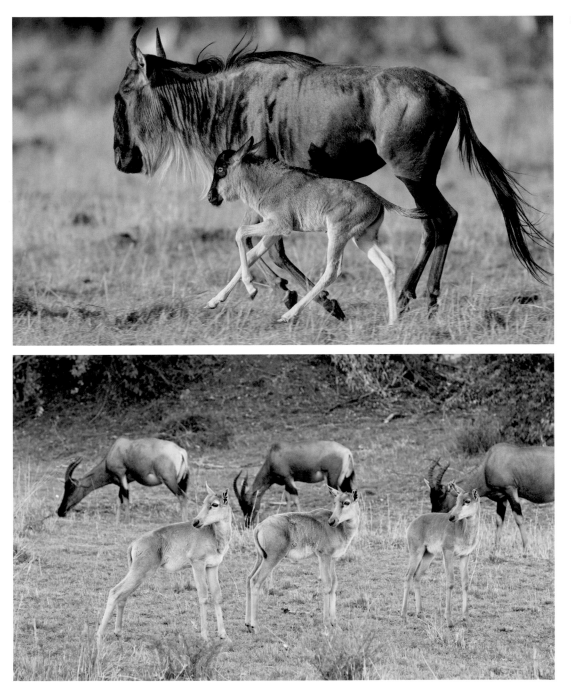

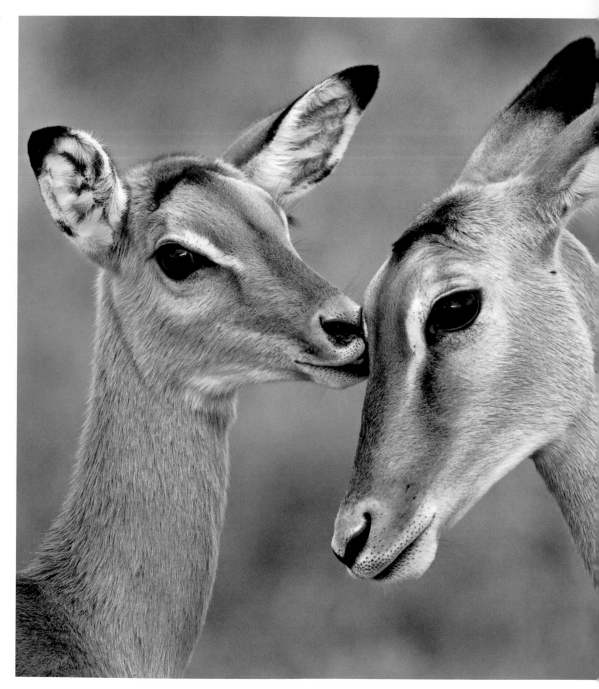

Impalas hide their scentless newborns in tall grass until the calves reach a certain age. Here, an older impala calf grooms mom in Serengeti National Park in Tanzania.

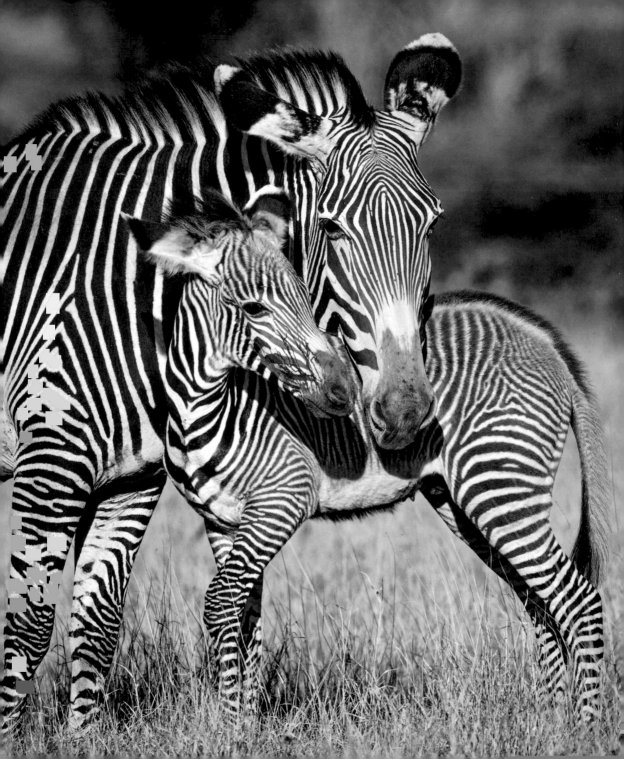

Zebra

For this precious photo of a Grevy's zebra foal nuzzling with mom in the Lewa Wildlife Conservancy in northern Kenya, I partnered with Grevy's Zebra Trust. Grevy's zebras are one of the most endangered large mammals in Africa, having experienced an 80 percent decrease in population since the 1970s. The trust works with locals to promote coexistence, like allowing these graceful creatures to drink at community water holes. Fun fact: For centuries, scientists have hypothesized on why zebras are striped. The prevailing study said it was to confuse predators. Then a groundbreaking study in 2019 proved it was to deter biting flies.

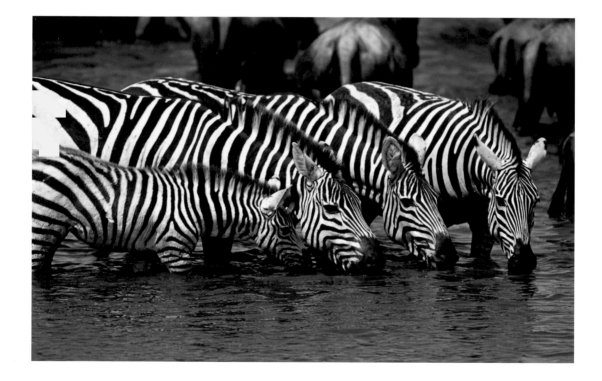

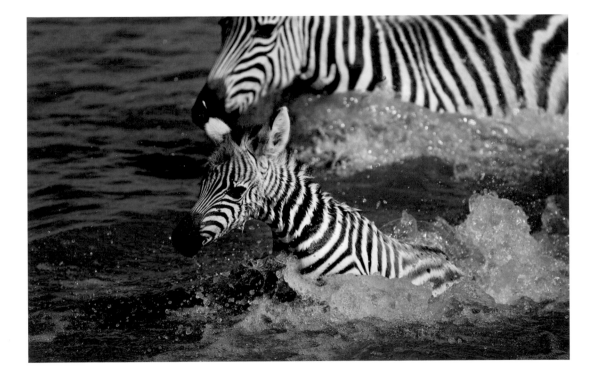

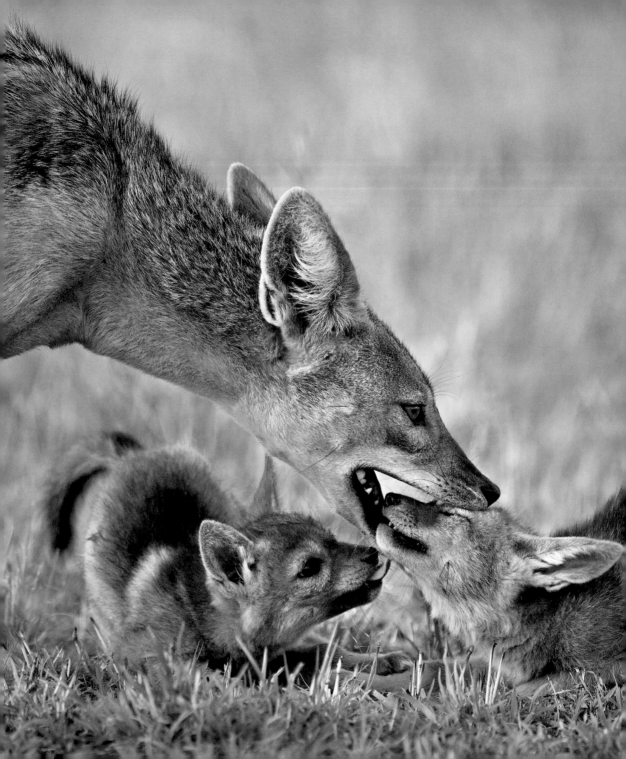

Jackal

I spent five months with this black-backed jackal family and came to know their behavior well. It wasn't easy in the beginning. It took me 17 days to habituate the parents to my presence. Each day, I came a little bit closer. I consider it one of my greatest exercises in patience, with an equally large reward—there's something really beautiful about gaining an animal's trust.

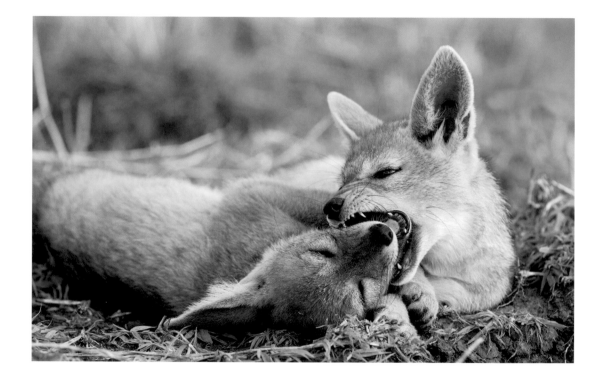

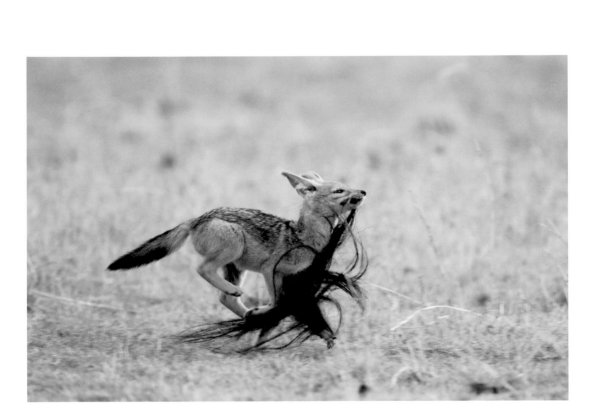

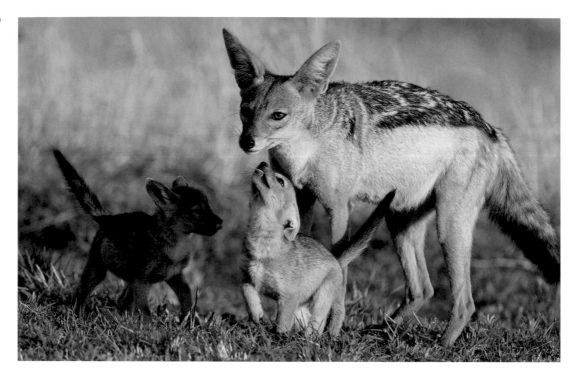

(Left) A pair of 4-week-old black-backed jackal pups in the Maasai Mara demonstrate how they say "Feed me, please" to dad. A cub licking a parent's mouth is a request for a meal of regurgitated meat.

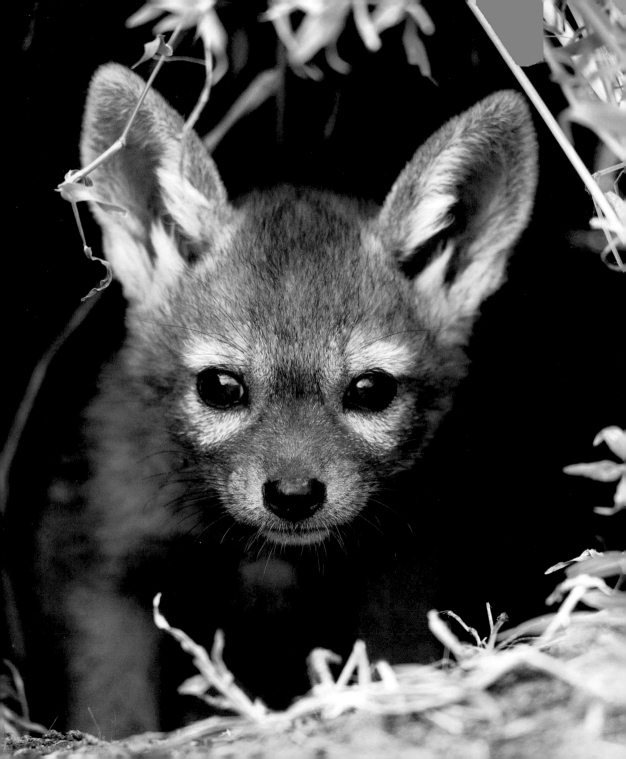

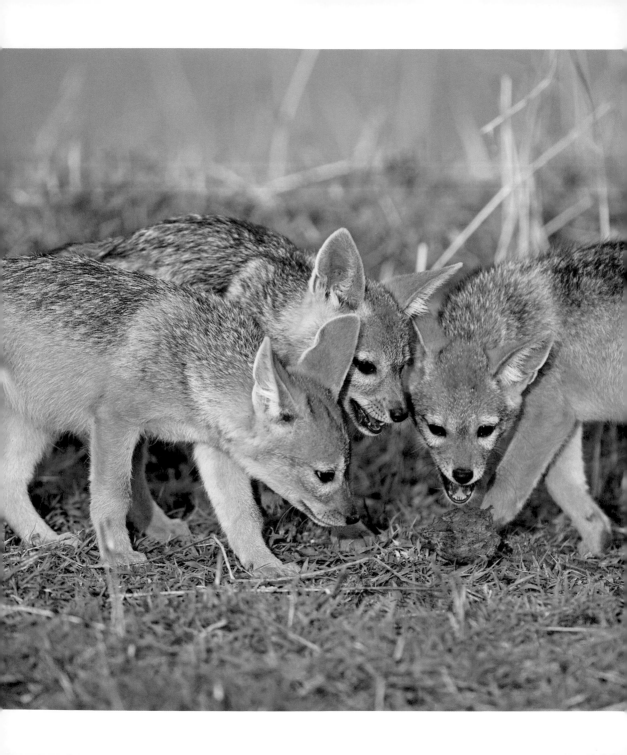

This photo always makes me smile. The pups are 6 weeks old and playing with a dung ball, a common object in the savanna. Specifically, it's elephant dung, which just so happens to be perfectly round. The parents were off hunting and the pups were keeping themselves entertained; batting and chasing the ball, and trying to take it away from one another just like a litter of domestic puppies would. I knew their "game" was really practice for catching rodents, but still I marveled at how much they reminded me of pet dogs while growing up in California.

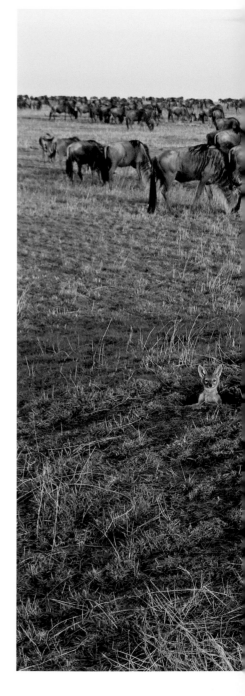

Most of my photos of animals in dens are close-ups, but it's also fun to back up and show the bigger picture. I think one of the most interesting things about dens is their ability to be invisible, to just disappear into the landscape. In this photo, mom and dad had gone hunting and left the kids at home. When a herd of wildebeests arrived to graze, the pups got curious and popped up to get a better look. They were completely surrounded by wildebeests and utterly fascinated. The wildebeests, who didn't perceive the pups as a threat, weren't nearly as interested.

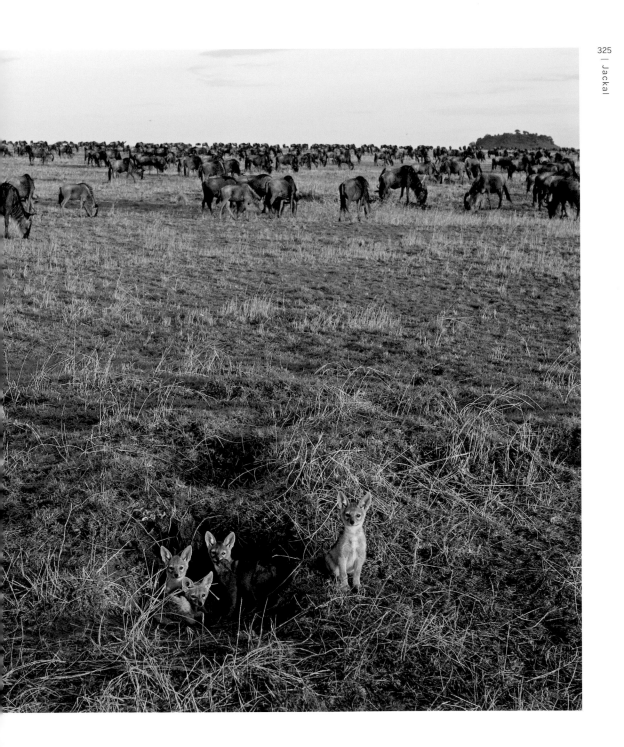

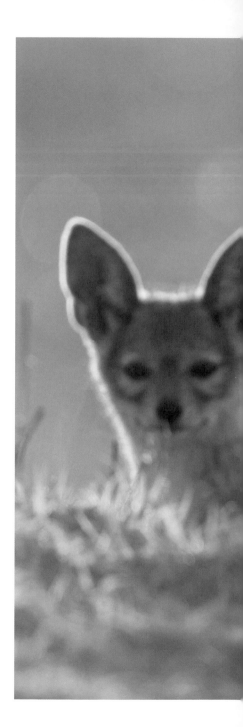

When these jackal pups reach a year of age, they'll go off to find their mate for life and start a family of their own. Something really special about jackal families is that grown pups don't always leave. Sometimes they stick around and help mom and dad raise the next season's litter. Scientists aren't sure why some jackal families have helpers and some don't, but studies have shown that families with helpers have a higher success rate of raising pups to adulthood. Plus, the helpers go onto become better parents because they have a year of babysitting experience.

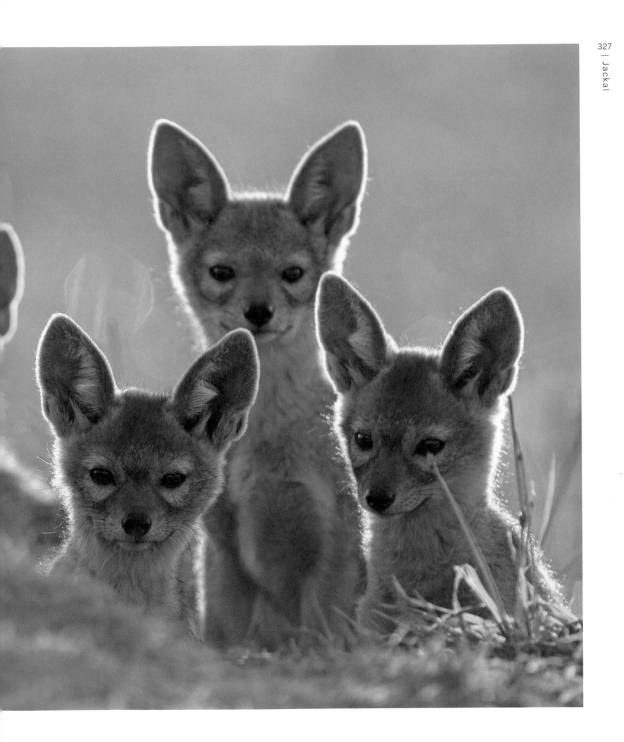

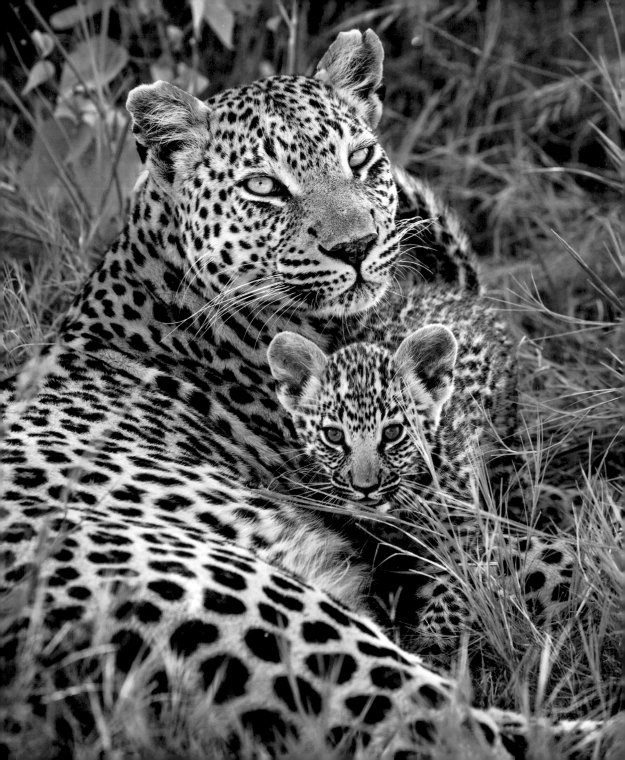

Leopard

Leopards are the most elusive of the big cats and notoriously secretive with their young. They've been known to trick safari vehicles by leading them away from den sites. It took me three years just to find the right location for a photography project. The Jao Reserve in Botswana is a small, private concession, and so well-protected that it contains leopards, like this mom, who are free from negative associations with humans and vehicles. As such, mom offered me extraordinary glimpses into her den. I had the honor of documenting hers and her two cubs' lives over the course of 18 months.

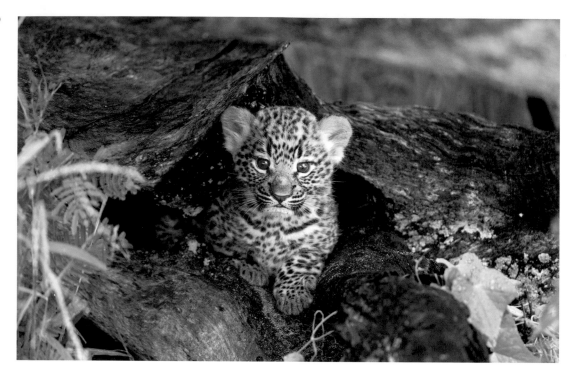

(Right) All leopard cubs are born with blue eyes, until they're about 8 weeks old. Here, one of the cubs rubs up under mom's chin in what I've come to know as the big cat nuzzle. It's very common behavior, but among leopards you'll only ever see it between a mom and her cubs because they're otherwise solitary. I noticed these cubs often did it after playing or suckling, and that after nuzzling mom they tended to fall asleep next to her. Nuzzling mom also encourages grooming, which keeps cubs free from parasites and insects, and masks their scent to predators.

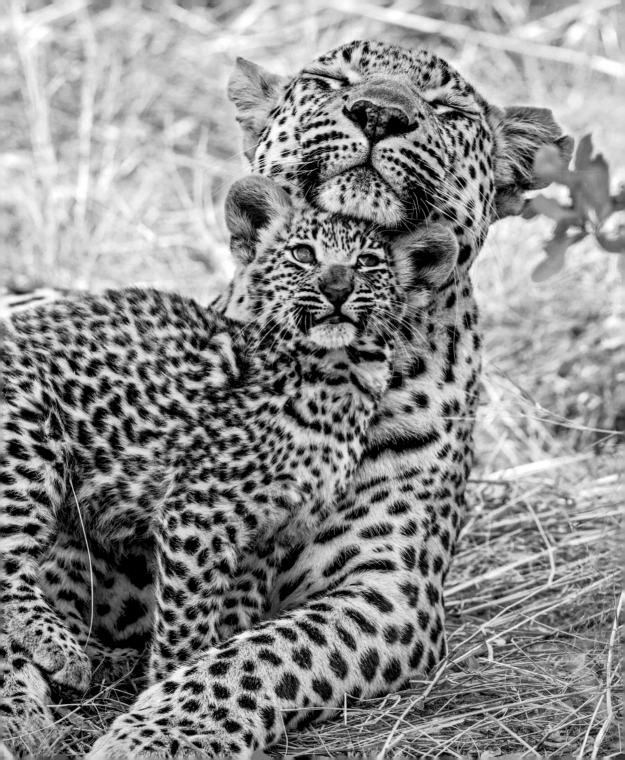

When leopard moms have to leave their litter to hunt, they'll stash the cubs in holes, most typically in logs. In this photo, mom had returned from hunting and softly, secretively called her cubs out from hiding. They came running to this sheltered, secluded spot where she proceeded to suckle and groom them. I could never have taken such intimate leopard family photos without Kambango, a tracker and guide. Kambango has been working around mom since she was 2 months old, and knew her habits like the back of his hand. Wildlife photography is sometimes a team effort.

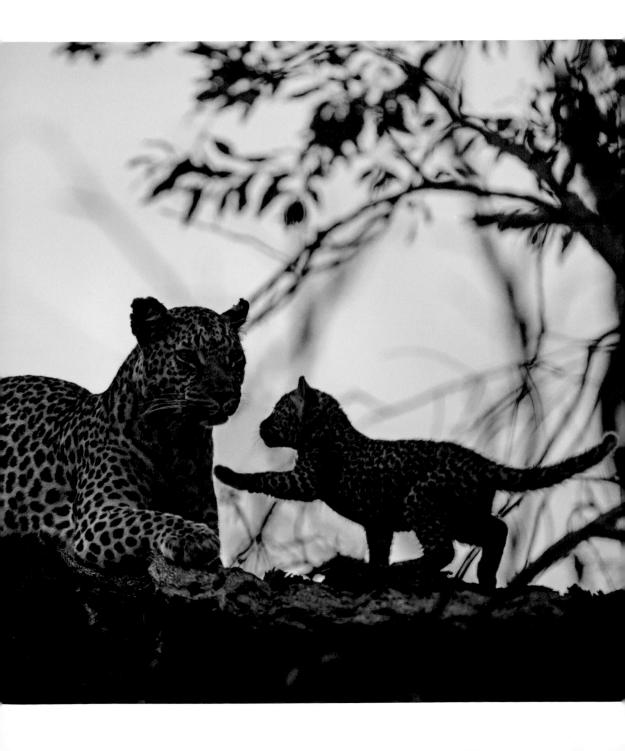

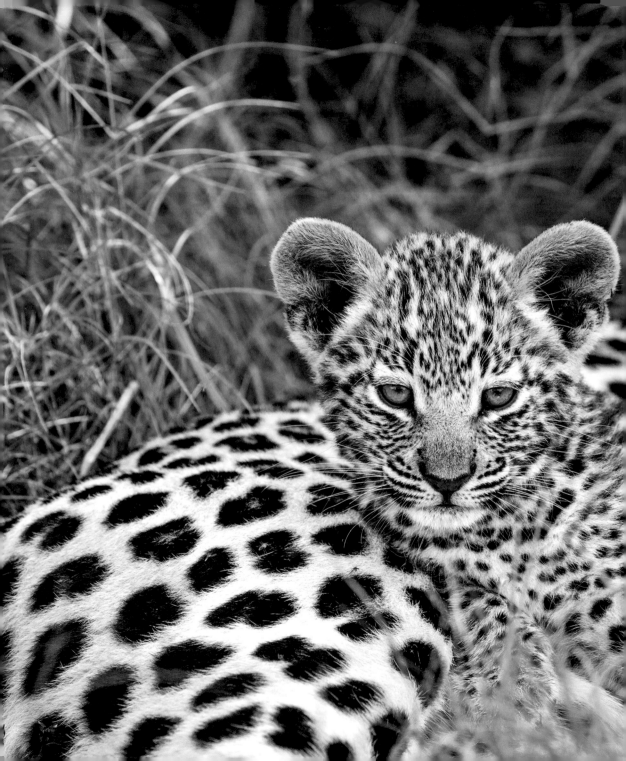

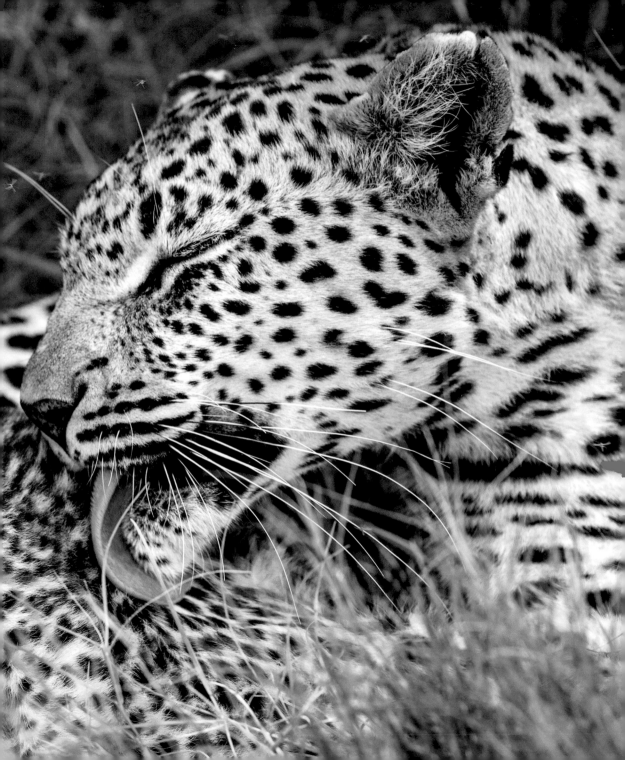

(Bottom) The number of times I would see these cubs pounce on mom's head in a single day was astounding. Of all the big cats I've worked with, leopard cubs are the most aggressive in their play. It was really funny to watch because mom would try to be all discreet and quiet and then the cubs would start playing; spitting and growling and causing a complete ruckus. The den site could go from silent and secretive to loud and boisterous in an instant. The cubs are 5 weeks old in this photo.

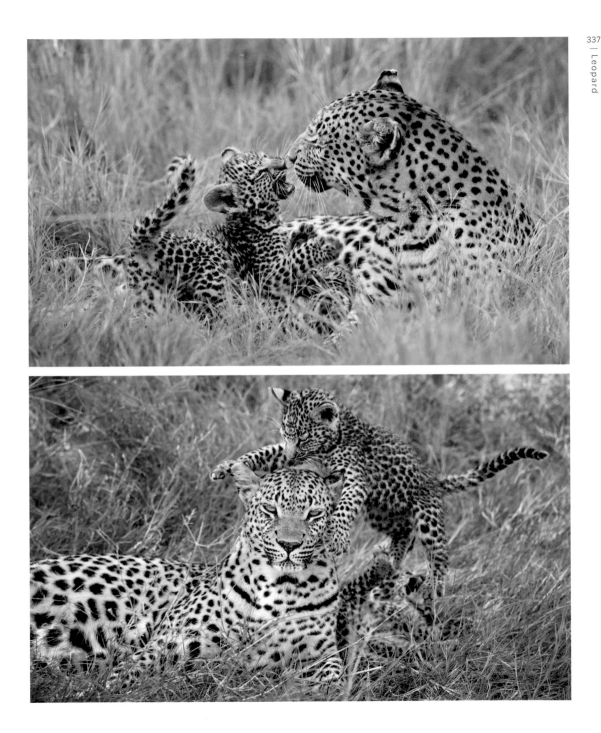

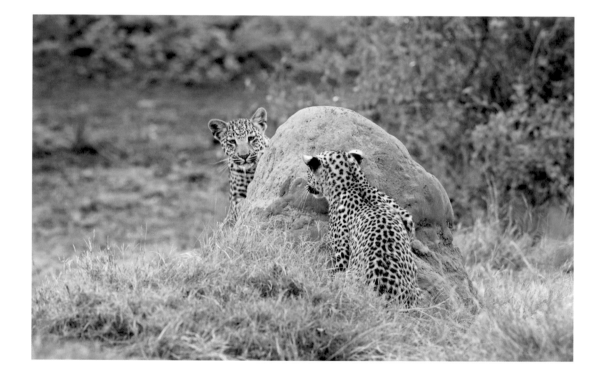

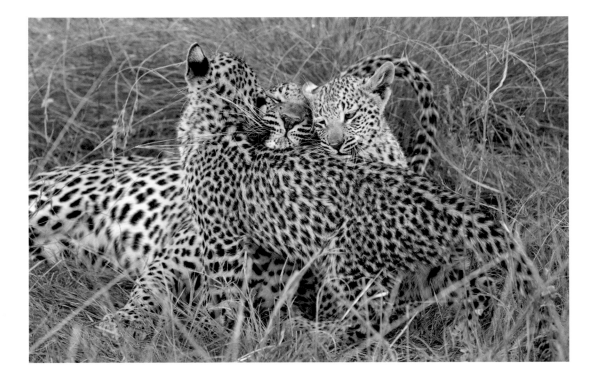

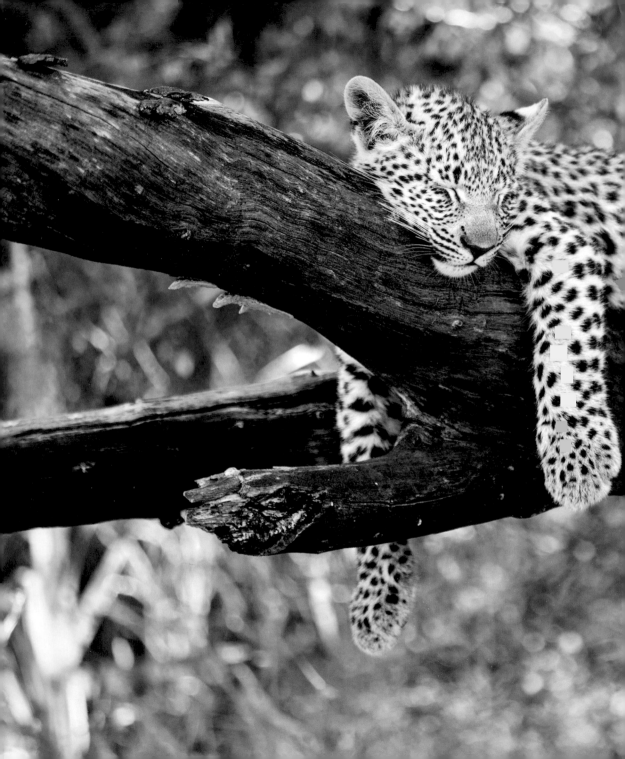

Acknowledgments

WILDLIFE PHOTOGRAPHY undoubtedly involves a lot of social isolation, but every shoot's success always rides on the help of others. I am in debt to many incredible people all over the world who have generously given me their time and support in helping me capture the images in this book. This began long ago when I was a small child, when my mother showed me the beauty of maternal love and encouraged me to follow my dreams. As a budding photographer I met my incredible mentors, Owen Newman and Amanda Barrett, who taught me how to build trust with shy animals and also how to be strong and independent in the African bush. Upon entering this profession I had the great fortune of meeting Susan McElhinney, who showed me how to be a powerful woman in what is very much a man's world. And every day I am grateful to the Minden Pictures team who champion my work (and help pay my rent).

A book like this has long been a dream of mine, and I thank Regina Ryan for believing in this project. I am visual thinker and words don't always come easy—I am deeply grateful for Jayme Moye for her invaluable assistance in writing the text.

And huge thanks to Charles Knowles, Kelly Wilson, and the entire team at the Wildlife Conservation Network for supporting this endeavor, and for working tirelessly to save wildlife.

Jungle & Rainforest: Dr. Richard Wrangham, Dr. David Watts, Dr. Jessica Hartel, Irene Spencer, Dr. Nancy Briggs, Dr. Birute Galdikas, Sam Nayebare, Helen Buckland, Darma Pinem, Thomas and Eddy, Thai Van Nguyen, Hsuan-yi Lo, Dr. Rebecca Cliffe, Regina Ribeiro, Francy Forero, Rosamira Guillen, Felix Medina.

Mountain & Forest: Diane Nicholas, Heidi Perryman, Cheryl Reynolds, Deb Tabart, Katherine Feng, Philip He, Darren Rumble, Androo Kelly, Imogen Taylor, Doris Duncan, Danielle Mattos, Katie Woolery, Alison Hermance, Melanie Piazza, Shelly Ross, Jak Wonderly, Rajvardhan Sharma, Anit Singh, Ravi and Gurmeet Kalra, C. K. Patil.

Polar & Ocean: Nick Lunn, Bob Wilson, Mike and Morris Spence, Lindsey Bogachus, Agnès Brenière, Samuel Blanc, Dr. Frances Gulland, Nancy Black, Chuck Bancroft, Yohn Gideon, Joe Mancino, Mark Carwardine, Craig Matkin, Ash Lambert, Herwig Haunschmid, Michelle Stern, Alex von Wichman.

Savanna & Grassland: Dr. Laurie Marker, Cathy Kays, Kambango Sinimbo, Jared Zeelie, Steve Turner, Aadje Geertsema, Paul and Louise White, Belinda Low, Brian Heath, Craig and Janet Wickham, Janet Kleyn, Kelly and David Evans, Tico McNutt, Moto.

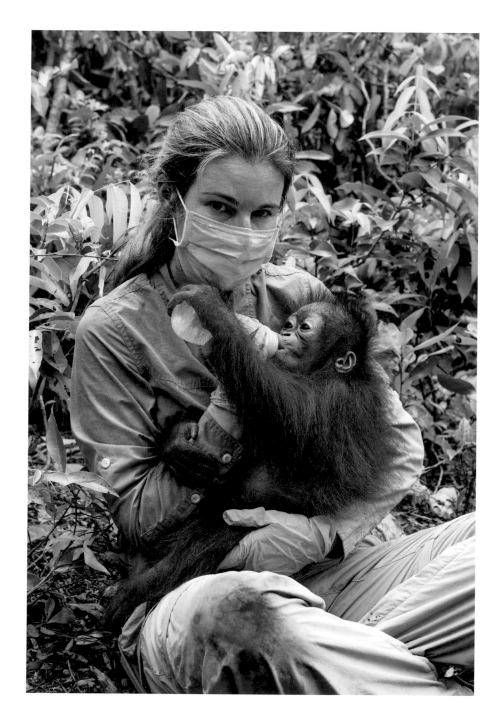

About the Author

SUZI ESZTERHAS is an award-winning wildlife photographer best known for her work documenting newborn animals and family life in the wild. Suzi's unique ability to earn the trust of her subject leads to touching imagery including groundbreaking work with tiger cubs at a den in India, newborn cheetahs on the African savanna, and brown bear cubs seeing the world for the first time in the Alaskan wilderness. She has photographed over 100 magazine covers and feature stories in publications such as *Time, The New York Times, Smithsonian, BBC Wildlife, Ranger Rick*, and *National Geographic Kids*. As an author, Suzi has 21 books in print. Her books have been featured on GoodMorningAmerica.com and TodayShow.com.

Suzi has won awards in many competitions, including the Wildlife Photographer of the Year, and for seven years has served as the jury chair for the California Academy of Science's prestigious Big Picture Natural World Photography Competition.

Recognized as a conservationist in her own right, Suzi is a trustee of the Sloth Conservation Foundation, and actively raises funds and awareness for the Wildlife Conservation Network, Sumatran Orangutan Society, Cheetah Conservation Fund, Pandas International, Center for Animal Protection and Education, and other organizations.

Suzi is also the founder and executive director of Girls Who Click, a nonprofit dedicated to encouraging young women to enter the male-dominated profession of wildlife photography.

She is a passionate advocate for connecting kids to the natural world and her print shop—www.BabyAnimalPrints.com—specializes in nursery and children's room décor.

Suzi shares her knowledge and exclusive access to incredible locations in her wildlife photography tours. She has a loyal following of photographers of all levels who join her in expeditions to Borneo, Botswana, Australia, Indonesia, and many other exotic destinations.

When not traveling, Suzi can be found hiking trails in northern California. To learn more about Suzi's work, visit www.suzieszterhas.com.

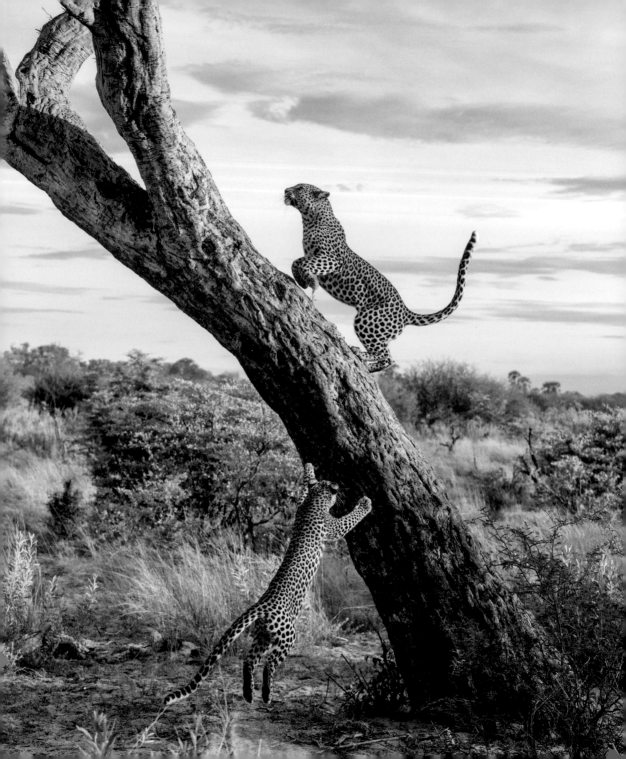

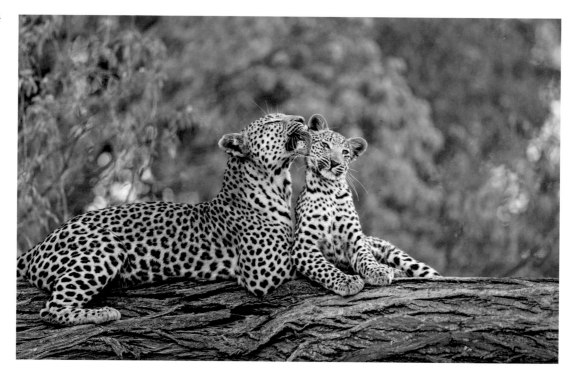

(Right) Here, mom is running up a tree to get some space from cub. With both her cubs having recently celebrated their first birthdays, mom was spending noticeably less time in close proximity. She no longer ate side-by-side with the cubs at kills. Instead, everyone took turns. Mom was beginning to wean the cubs from her constant presence so that in another six months they'd be fully independent and ready to start their solitary lives. I dream of a day when I get to see her cubs' cubs, and hope to document the next generation of this gorgeous leopard family.

(Pages 340-341) One of the behaviors I find really endearing is when baby animals act like proper adults, which is what's happening here. Leopards are among the most arboreal of big cats; meaning they spend a lot of time in trees. They'll climb to avoid predators like lions, hyenas, and wild dogs. They'll also haul fresh kills up into trees to avoid having their meal stolen. And like this cub is demonstrating, they'll sleep in trees. I'd watched him carefully climb up and pick a comfy spot on a shaded bough for his nap. It was certainly cooler up there.

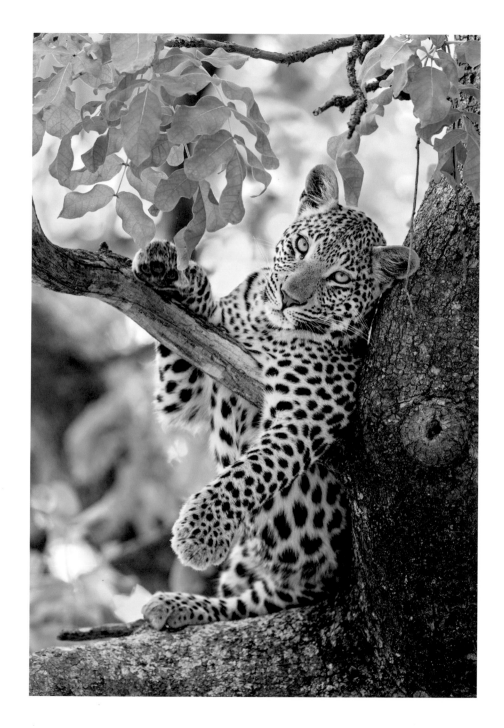

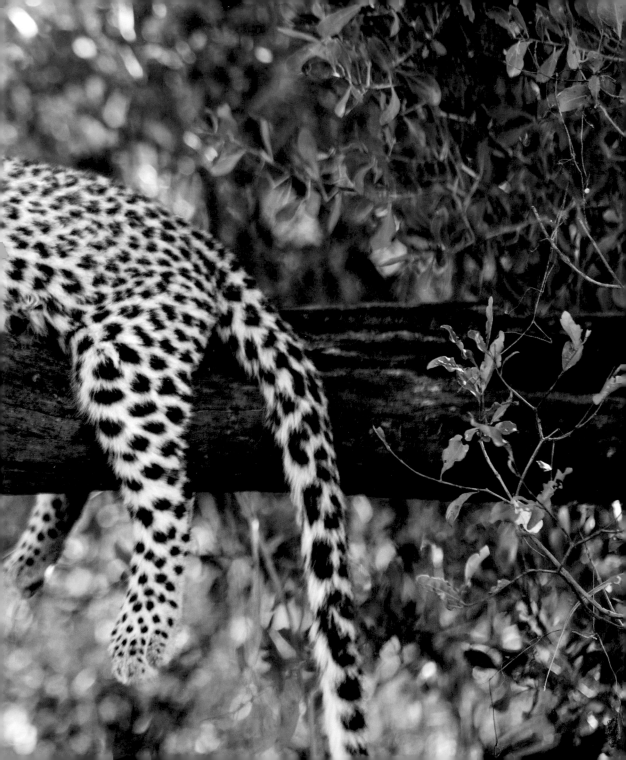

EARTH AWARE

An Imprint of MandalaEarth
PO Box 3088
San Rafael, CA 94912
www.MandalaEarth.com

Find us on Facebook: www.facebook.com/MandalaEarth
Follow us on Twitter: @MandalaEarth

Library of Congress Cataloging-in-Publication Data available.

ISBN: 978-1-64722-142-3

Publisher: Raoul Goff
VP of Licensing and Partnerships: Roger Shaw
VP of Creative: Chrissy Kwasnik
VP of Manufacturing: Alix Nicholaeff
Designer: Lola Villanueva
Editor: Katie Moore
Managing Editor: Lauren LePera
Senior Production Manager: Greg Steffen
Senior Production Manager, Subsidiary Rights: Lina s Palma

ROOTS of PEACE REPLANTED PAPER

Mandala Publishing/Earth Aware Editions, in association with Roots of Peace, will plant two trees for each tree used in the manufacturing of this book. Roots of Peace is an internationally renowned humanitarian organization dedicated to eradicating land mines worldwide and converting war-torn lands into productive farms and wildlife habitats. Roots of Peace will plant two million fruit and nut trees in Afghanistan and provide farmers there with the skills and support necessary for sustainable land use.

Manufactured in China by Insight Editions

10 9 8 7 6 5 4 3 2 1

Behind the Scenes

(Page 348) Being able to bottle-feed an orphaned baby orangutan at Orangutan Foundation International's Care Center in Borneo was truly a privilege.

(Left top) While living in an African bush camp, I raised an orphaned serval kitten and returned him to the wild. This is the day he arrived, 2 weeks old, scared and exhausted.

(Left bottom-left) I often work with highly skilled local guides and trackers. Kambango Sinimbo was my partner in my leopard project and become a good friend.

(Left bottom-right) While working with biologists that were taking blood samples of a polar bear family, I was asked if I could hold an anesthetized cub for a moment.

(Above) I use long lenses so I don't have to get close to my subjects. But when animals, such as this ring-tailed lemur, are very used to people, they don't always keep their distance from me.